December, 1998
To Steve, from
Mother

LIGHTHOUSES OF IRELAND

LIGHTHOUSES
OF IRELAND

Kevin M. McCarthy

Illustrations by William L. Trotter

PINEAPPLE PRESS, INC.

Sarasota, Florida

Inquiries should be addressed to:
Pineapple Press, Inc.
P.O. Box 3899
Sarasota, Florida 34230

LIBRARY OF CONGRESS CATALOGING IN PUBLICATION DATA

McCarthy, Kevin.
 Lighthouses of Ireland / by Kevin M. McCarthy ;
illustrations by William L. Trotter. — 1st ed.
 p. cm.
 Includes bibliogrpahical references and index.
 ISBN 1-56164-131-6 (hardbound : alk. paper)
 1. Lighthouses—Ireland. I. Title.
VK1076.5.M33 1997
387.1'55'09415—dc21 96-37699
 CIP

First Edition
10 9 8 7 6 5 4 3 2 1

Design by Carol Tornatore
Printed in Hong Kong

IRISH LIGHTHOUSES AND LIGHTSHIP
FEATURED IN THIS BOOK

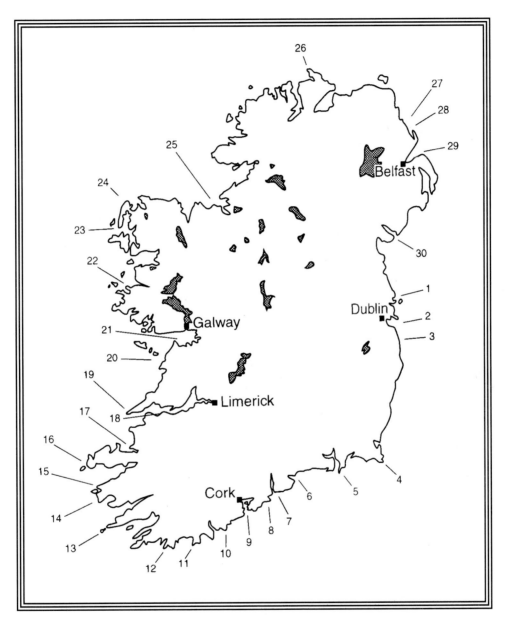

1. Baily
2. Dublin Lightship
3. Kish Bank
4. Tuskar Rock
5. Hook Head
6. Ballinacourty Point
7. Youghal
8. Ballycotton Island
9. Roche's Point
10. Old Head of Kinsale
11. Galley Head
12. Fastnet Rock
13. Bull Rock
14. Skelligs
15. Cromwell Point
16. Inishtearaght
17. Little Samphire Island
18. Tarbert
19. Loop Head
20. Inisheer
21. Blackhead (Clare)
22. Inishgort
23. Blacksod
24. Eagle Island
25. Blackrock (Sligo)
26. Inishtrahull
27. Maidens
28. Ferris Point
29. Mew Island
30. Haulbowline

CONTENTS

1. Baily
2. Howth
3. Kish Bank
4. Dun Laoghaire West
5. Dun Laoghaire East
6. Muglins
7. Wicklow Head
8. Tuskar Rock
9. Hook Head
10. Dunmore East
11. Ballinacourty Point
12. Minehead
13. Youghal
14. Ballycotton Island
15. Roche's Point
16. Charlesfort
17. Old Head of Kinsale
18. Galley Head
19. Fastnet Rock
20. Copper Point
21. Crookhaven
22. Mizen Head
23. Sheep's Head
24. Roancarrigmore
25. Castletownbere
26. Ardnakinna Point
27. Bull Rock
28. Skelligs
29. Cromwell Point
30. Valencia Directional Lights
31. Valencia Leading Lights
32. Inishtearaght
33. Little Samphire Island
34. Loop Head
35. Kilcredaun
36. Scattery Island
37. Inisheer
38. Straw Island
39. Eeragh
40. Blackhead (Clare)
41. Cashla Bay
42. Slyne Head
43. Inishgort
44. Achillbeg
45. Blackrock (Mayo)
46. Blacksod
47. Eagle Island
48. Broadhaven
49. Blackrock (Sligo)
50. Lower Rosees
51. Metal Man
52. Oyster Island
53. St. John's Point (Donegal)
54. Rotten Island
55. Rathlin O'Birne
56. Aranmore
57. Ballagh Rocks
58. Tory Island
59. Fanad Head
60. Buncrana
61. Dunree
62. Inishtrahull
63. Inishowen
64. Rathlin West
65. Rathlin East
66. Rue Point
67. Maidens
68. Chaine Tower
69. Blackhead (Antrim)
70. Mew Island
71. Donaghadee
72. Angus Rock
73. St. John's Point (Down)
74. Green Island
75. Vidal Bank
76. Haulbowline
77. Dundalk
78. Drogheda East
79. Drogheda West
80. Rockabill

NAVIGATIONAL AIDS UNDER THE AUTHORITY OF THE COMMISSIONERS OF IRISH LIGHTS

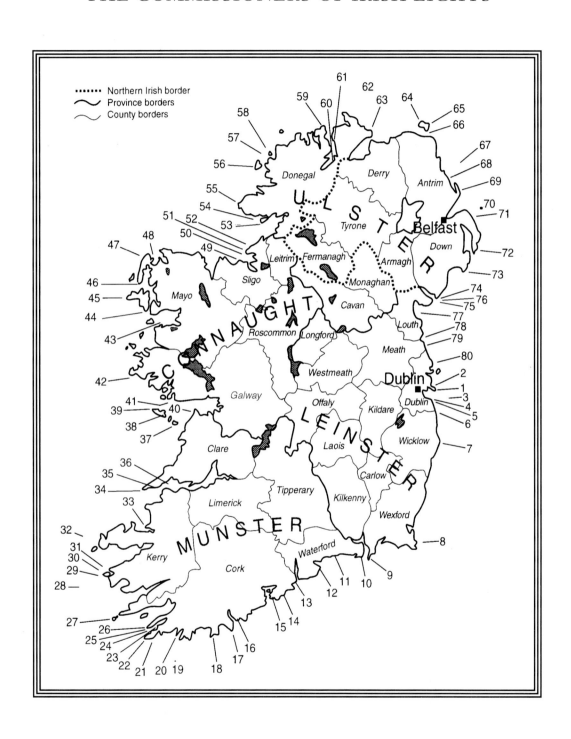

AUTHOR'S PREFACE

From the time when Greek sentinels lit fires on the tops of mountains for the use of mariners at sea, through the operation of the Colossus of Rhodes and the Pharos of Alexandria to modern times, lighthouses have helped thousands of sailors on European waters. One country in particular has relied on such navigational aids. Because Ireland is an island, it has relied on the sea for its first settlers, much of its commerce and defense, and its determination to be independent and free.

How and why I took on this project of profiling thirty of the country's lighthouses began on a cold, wet day on the west coast of Ireland. While photographing the Blackhead Lighthouse in County Clare that June day, I turned to my wife and asked an innocent-enough question: "What would you say to a tour of Irish lighthouses?" With rain pouring down her face and the wind whistling off the surging ocean below the cliff, she did not seem particularly enthusiastic at that point. But she changed her mind, and we drove around the country, read as much as we could find about the maritime history of this great nation, and examined blueprints, old postcards, and hundreds of documents profiling Ireland's many navigational aids.

Part of my motivation for doing this book is that my ancestors emigrated from Ireland in the nineteenth century. I wanted to try to relive what it must have been like as they left Ireland for good, catching a final glimpse of their homeland by its lighthouse at Roche's Point near Cork or at Fastnet Rock. Having grown up on an island (Long Beach Island) with its own lighthouse (Barnegat Lighthouse) off New Jersey and having written about the lighthouses, shipwrecks, and pirates of Florida, I wanted to see how a much older country has aided navigators using its waters.

What I found was a fascinating history of eighty lighthouses, many of them still working, although most were automated and demanned. Read on to learn about beacons maintained by nuns and monks. Of a lighthouse (Hook Head) that has been guiding mariners almost continuously for an amazing 1,500 years. Of a queen who appeared bare-chested in the court of Queen Elizabeth I. Of cursing stones. Of the origin of the phrase "by hook or by crook." Of dynasties of lighthouse keepers who passed on the knowledge and love of faithful service to children and grandchildren. Of tremendous feats of engineering. Of Ireland's maritime history.

I chose the following twenty-nine lighthouses and one lightship because they are representative of all Irish lighthouses, have individual stories and a significance to the country's or region's history. They are spread out along the whole coast of Ireland and have an important role in the maritime history of that country. We will examine what the different sections of the coast were like before lighthouses were built, what the keepers might have seen on certain days (submarines, transatlantic airplanes landing nearby, ships wrecking), and what future role such silent sentinels can play in the revival of the country's economy. Interestingly enough, the current president of the Republic of Ireland, Mary Robinson, has in her official residence in Dublin a light glowing constantly from an upper-floor window to let Irish emigrants know that their country has not forgotten them. That light, like the many lighthouses that dot the Irish coast, is a beacon in the night that reassures, that beckons, that warns all to beware of hidden dangers in life.

I dedicate this book to my wife, Karelisa, who accompanied me on our tour of Irish lighthouses, and to my four children: Katie, Brendan (named after St. Brendan the Navigator, one of the great Irish mariners), Erin ("from Ireland"), and Matthew.

Once again it has been my privilege to work with William Trotter, the artist who painted the paintings reproduced here; those wishing more information on purchasing these and other maritime paintings should contact him at The Lighthouse Museum, Box 50186, Jacksonville Beach, Florida 32240, USA. And I thank those who helped in the research of this book: Hibbard Casselberry, Ann and Larry Higgins, Erin and Susan and Harold Nugent, Danella and Richard Pearson, John Van Hook, the patient staff of the University of Florida's Interlibrary Loan Office and the Irish Maritime Museum, and the Irish Lights Commissioners, especially David Bedlow. I am particularly grateful to Dr. John de Courcy Ireland, the dean of Irish maritime historians, for his suggestions and help in the final draft.

Kevin M. McCarthy

University of Florida
Gainesville, Florida, USA

FOREWORD

It is a privilege to have been asked to write a foreword for a book about the most celebrated lighthouses in my country, written by the distinguished author of the fascinating and beautifully produced *Florida Lighthouses* published by the University of Florida Press in 1990.

The vigour, imagination, and determination with which Dr. McCarthy went about writing this book, entailing, incidentally, visits to some of the least easily accessible spots on the rock-strewn, sandbank-haunted, wind-battered, and sea-torn two-thousand-mile coast of this island on the western fringe of the great Eurasian Continent, recalled irresistibly another McCarthy acquaintance whose writings came my way some twenty-five years ago.

The McCarthys originated in the sea-going population of County Cork in the south of Ireland. Many went to sea. I can think of a score who made names for themselves, exiles serving at

sea under the flag of France. More than one of the clan lost his life at sea in the 1939–45 war in the merchant fleet of neutral Ireland.

The earlier McCarthy whose style of writing and attitude to life reminds me of this fine author was Oscar McCarthy. Born in 1815, the grandson of a ship owner, he was known as *l'éminence grise du Sahara* for having penetrated further into the great desert (armed only with a theodolite, barometer, and thermometer) than any other European. He later designed the Algerian railway system and crowned his active life by designing the modern port of Algiers, paying special attention to port-lighting and preservation of the city's ancient lighthouse. He ended his days a hundred years ago as head of the City of Algiers Library, now the National Library of Algeria. The spirit of Oscar is very discernible in the author who found the sites and discovered the history of the lighthouses as lovingly described here.

Dr. John de Courcy Ireland

The Maritime Institute of Ireland

LIGHTHOUSES OF IRELAND

INTRODUCTION

The History of Lighthouses
in Ireland

So to night-wandering sailors, pale with fears,
Wide o'er the watery waste, a light appears,
Which on the far-seen mountain blazing high,
Streams from some lonely watch-tower to the sky.

— Homer,

The Iliad, XIX,
translated by Alexander Pope

Fom Homer's "night-wandering sailors" to today's mariners on ultra-modern tankers, the appearance of a well-placed light has been a most welcome sight. European beacons of light have guided mariners for several thousand years, from crude fires on mountaintops to state-of-the-art towers with sophisticated electronic machines that rely on satellites circling the globe and sensitive probes on the ocean floor. Whereas all countries with a seacoast make use of such navigational aids, islands like Ireland depend on them for much of their livelihood.

The fact that Ireland is an island has done much to shape its history, culture, and language; indeed, almost every aspect of Irish life. What courage and skill must have guided the first brave souls as they sailed across the Irish Sea 10,000 years ago in their skin boats, primitive currachs. What hardy men and women they must have been to leave the security of their homes to venture onto a volatile sea in search of new hunting lands

or fish or even flint! They probably chose days when the Irish Sea was not its usual blustery, threatening self, but even then, the weather could change quickly, usually for the worse. Visitors to Dublin's National Museum can still see some of the log-boats found in County Wexford and can marvel at the courage of those early Mesolithic sailors.

This Emerald Isle has looked to the sea for all of its original settlers, some of its livelihood, much of its defense, and many of its troubles with invaders like the Vikings and the Normans. Before the advent of airplanes, all of the country's exports and imports traveled by sea, as did its people traveling to and from its shores. Ireland might have become a great maritime nation on the pattern of small countries like Portugal, the Netherlands, and England, but history shows how other nations, especially England, dominated the island and prevented the development of its maritime resources. Many of Ireland's great seamen sailed

1

under flags of foreign nations and went on to fame and fortune with other countries; for example, John Barry (1745–1803) founded the U.S. Navy, and other Irish seamen founded the navies of Argentina (William Brown from County Mayo) and Ecuador (Thomas Charles Wright of Drogheda). Some of Ireland's greatest engineers developed the submarine (John Philip Holland) and the marine steam turbine (Charles Algernon Parsons), but many of these accomplishments occurred far from the Irish shore.

Ironically, despite the fact that Ireland is an island and has relied upon the sea for commerce and protection, the country has taken an ambivalent attitude toward maritime matters, an attitude that differs greatly from that shown in the histories of England, Norway, and Greece. Because England controlled Ireland for so long and because Ireland has traditionally been an agricultural country, when the Irish finally achieved independence in 1921, they seemed quite reluctant to become a maritime power. They still have not established a coast guard. Even when the country became responsible for its seaward defense in 1938, it did not establish a coastal navy or a deep-sea fishing industry, partly because the cost would have been very high and partly because the people seemed to believe that the sea was the domain of their long-time rulers, the British.

The history of lighthouses in Ireland begins with beacons and towers along the coast. The country has long been known for its towers: the famous round ones associated with medieval monastic sites, the Martello towers that dot the coast, the huge rock pillars in Tramore that mariners used for guidance, and, finally, the seven dozen–plus lighthouses, beacons, and harbor lights operating along the coast. Those towers had several purposes. The round towers at Clonmacnois, Devenish Island, and Glendalough served as places of refuge where the community could withdraw with their holy treasures during attacks by the Vikings or even their fellow countrymen. Other towers could be used as lookout posts, allowing those on land to see what was approaching from the sea or as guideposts for

those at sea to take land bearings.

The first lighthouses in Ireland were private towers, situated in isolated places along the coast and operated by individuals for the use of mariners. In the 1660s, King Charles II of England gave permission to Sir Robert Reading to construct six lighthouses along the Irish coast: two at Howth near Dublin, one at the Old Head of Kinsale, one at Barry Ogee's Castle near Kinsale, one at Hook Tower in County Wexford, and one at Magee in County Antrim. If Reading had conscientiously built and maintained those lighthouses instead of trying to extract as much money as possible from seamen, he might have been able to build more towers and increase the safety of those navigating Ireland's ocean waters. Instead, he neglected the towers and jeopardized the lives of those who depended on them.

In 1704, a group of commissioners established by Queen Anne took over the duties of overseeing the lighthouses in Ireland. Four years later, Dublin Corporation, through Parliament, established a committee called the Ballast Board, which was succeeded in 1786 by the Corporation for Preserving and Improving the Port of Dublin, a group which eventually became the Commissioners of Irish Lights, the group in charge of Ireland's lighthouses today. The number of commissioners, which used to be twenty-two, was later reduced to sixteen: the Lord Mayor of Dublin, three aldermen elected annually by the Municipal Corporation of Dublin, and twelve members appointed by the Board when vacancies occur.

Irish Lights is in charge of lighthouses in both northern and southern Ireland. One centralized group being in charge of a country's lighthouses eliminates the problem of locally controlled and situated structures, towers which might be good for the local mariners and fishermen, but not necessarily of benefit to those of other counties and countries. A centralized authority with financing provided by the country's parliament can also hire the best people to man the towers, whereas local governments would have to hire much less qualified keepers.

Not everyone in the country has favored lighthouses over the years. For example, those who relied on shipwrecks to supplement their meager supplies resented the towers. In the eighteenth century, when acts of the British Parliament greatly restricted Irish fishing, Irishmen living near the sea came to depend on wrecks. Interestingly, while British acts greatly hampered Irish fishing, they did not have a similar effect on Irish shipping, a rare sphere where Catholics could prosper and own their own ships. Throughout the eighteenth century, Irish shipping grew and flourished.

Some coast dwellers have even been accused of waving lanterns to lure ships into nonexistent harbors and then pouncing on the helpless wrecks. But such accusations cannot be proven and may be simply the weak excuses used by inexperienced, careless, and unlucky mariners wishing to blame others for their own incompetence. Smugglers of contraband liquor also resented lighthouses, for example those who used Tuskar Rock (see Chapter 4) to hide their contraband from customs inspectors. But law-abiding citizens and most mariners saw the need for dependable navigational aids and petitioned for more of them.

In addition to lighthouses, the Board also placed lightvessels to mark offshore dangers at places such as Coninbeg off County Wexford and South Rock off County Down. The financial backing for the navigational aids came from the "Light Dues" paid by shipping companies using Irish ports, the amount determined by the tonnage of the vessels. Today, the headquarters for Irish Lights is at 16 Lower Pembroke Street, Dublin 2. The chief workshops and stores of the body are in Dún Laoghaire, County Dublin.

Irish Lights uses a helicopter for maintaining offshore lighthouses and operates a service tender, the *Granuaile* (pronounced "gran-YOU-whale"), to inspect buoys and deliver oil and equipment to the country's lighthouses on an annual basis. The list of facilities the Commissioners of Irish Lights operate and service is impressive: 80 (1 manned, 79 unmanned) lighthouses, 119 lighted buoys, 26 unlighted buoys, 2 lighted beacons, 17 unlighted beacons, 1 lighted perch, 28 unlighted perches, 1 fog-signal station, 2 Large Automatic Navigational Buoys (LANBYs), 3 Control/ Monitoring and Communications Relay Stations, 7 helicopter landbase pads with refueling facility, 18 Radar Beacons (Racons), and 8 radio beacons.

This book features the one remaining manned light (Baily), twenty-seven representative unmanned lighthouses, one discontinued light (Ferris Point), and the now-defunct Dublin Lightship. (There are, in fact, no lightships functioning in Ireland today.) One of the lighthouses described here (Tarbert) is under the jurisdiction of Limerick, not the Commissioners. Each featured light is pictured as it looks today, with the exception, of course, of the Dublin Lightship, which is shown as it looked when it was in service. Each of the remaining fifty navigational aids is described in the chapter that covers the featured light nearest it.

All of these are necessary for an island that is 303 miles long by 140 miles wide. Although Ireland is about the size of the state of Maine and is slightly smaller than Iceland or Portugal, its coastline stretches for more than 2,000 miles.

Despite the fact that Northern Ireland and the Republic of Ireland and have frequently been at odds, the Commissioners of Irish Lights, who are based in Dublin, are responsible for the maintenance of lighthouses and navigational buoys around the coasts of both sections of the island. Although the tender of the Commissioners of Irish Lights flies the tricolor flag of the Republic of Ireland, it has never been harassed in Northern ports. In fact, when the *Granuaile* was recently in need of repairs, she was very efficiently repaired in the North.

At a time when countries around the world, including England, are discontinuing their lighthouses and other aids to navigation because of budget cutbacks and a reliance on more advanced technology on board ships, many mariners, despite their use of on-board navigational aids, advanced radar, and links to satellites, still rely on

the surety of a flashing light from a land-based tower to take compass bearings.

Some may say that the demanning of the lighthouses in Ireland and elsewhere will lead to an increase in shipwrecks and will therefore be very expensive in the long run. That may well be. On the other hand, more advanced technology in the unmanned lighthouses, in the ships that ply the world's waterways, in the satellites overhead and the navigational aids in the waters will surely help mariners avoid dangers. If so, there should be fewer shipwrecks and therefore fewer lives lost and cargo destroyed.

As Irish-registered ships decline in number in favor of ships registered in foreign ports, pressure increases for governmental bodies to reduce the lighthouse budget, especially since fishing vessels, warships using Irish waters, and pleasure yachts do not pay for the service on which they often depend. How Ireland and other maritime nations cope with the dual demands of becoming more cost-efficient, while at the same time maintaining navigational aids that thousands need, will be a challenge for years to come.

The Commissioners of Irish Lights are determined to fulfill the motto of the lighthouse service: *In Salutem Omnium* ("For the Safety of All"). Their use of automation and advanced technology should make the seas safer and friendlier to mariners in the new electronic age. All hope that the modernization of the lighthouse service, from the automation of lighthouses to the installation of solar power in buoys, will lead to a more efficient use of resources and greater safety on the high seas.

Further Reading

de Courcy Ireland, John. *Ireland and the Irish in Maritime History*. Dublin: Glendale Press, 1986.

"How Irish Lights Are Financed," *For the Safety of All*. Dublin: Commissioners of Irish Lights, 1996, 12.

"Irish Lights," *Leading Lights* [The Journal of Pharology, Pilotage and Seamarks, Milford Haven, Pembrokeshire, Wales], vol. 1, no. 1 (1995), 32-34.

"Life on the Granuaile," *For the Safety of All*. Dublin: Commissioners of Irish Lights, 1996, 11.

"Some Facts About Irish Lights," *For the Safety of All*. Dublin: Commissioners of Irish Lights, 1996, 7-10.

"Who Are the Commissioners?" *For the Safety of All*. Dublin: Commissioners of Irish Lights, 1996, 23.

CHECKMATE

The following radio conversation at sea was released by the U.S. Navy and reprinted in the *Maritime Journal of Ireland* (Winter 1995-96, p. 13):

1st caller: Please divert your course 15 degrees to the north to avoid a collision.

2nd caller: Recommend you divert your course 15 degrees to the south to avoid a collision.

1st caller: This is the captain of a U.S. Navy ship. I say again, divert your course.

2nd caller: No, I say again, divert your course.

1st caller: This is the aircraft carrier *Enterprise*. We are a large warship of the U.S. Navy. Divert your course now.

2nd caller: This is a lighthouse. Your call.

BAILY LIGHTHOUSE

1

County Dublin

Nine miles northeast of Dublin lies Baily Lighthouse, flashing a white light across Dublin Bay that can be seen fifteen miles at sea. Next to Hook Head Lighthouse on Ireland's southern coast, the oldest lighthouse in Ireland has guided ships in and out of the Dublin port for over three hundred years. Howth Head, a grassy headland that rises 560 feet above sea level, on whose eastern tip the lighthouse sits, offers a high landmark for the many ferries traveling between Dublin and Holyhead in Wales, sixty-five miles across the Irish Sea. The height of the promontory makes a very tall tower unnecessary, in fact, detrimental to its being seen in foggy weather. Several rings of a special gas in the lantern make up the light so that during foggy weather additional rings can be lit, depending on how much light the situation demands.

The agricultural richness of the land immediately inland has long increased the importance of the port at Dublin Bay, a major natural inlet along the coast. Once the Vikings, who began

To steer his course the sailor scans the stars,
Yet does not fail to see the rocks and bars.

— Irish proverb

their invasion of Ireland in A.D. 795 on Lambay Island to the north, established a settlement on the banks of the Liffey River, the site surpassed other would-be ports north and south. The Vikings liked the bay because they could use its shallow, sandy beaches for their narrow longboats and then could travel up the Liffey for access into the interior of the country.

The centuries-long importance of Dublin Bay necessitated a care for the mariners' needs from an early age, beginning probably with a simple fire of some sort on built-up rocks on the part of Howth Summit known as "The Green Baily." Under the present lighthouse, archaeologists unearthed in 1912 remains of medieval beacons, including cinders. During the Middle Ages, members of religious houses maintained such beacons, which might have been simply braziers or bonfires. Although those beacons were inadequate compared to today's lighthouses and were easily extinguished by poor weather conditions or human neglect, they served to warn mariners of

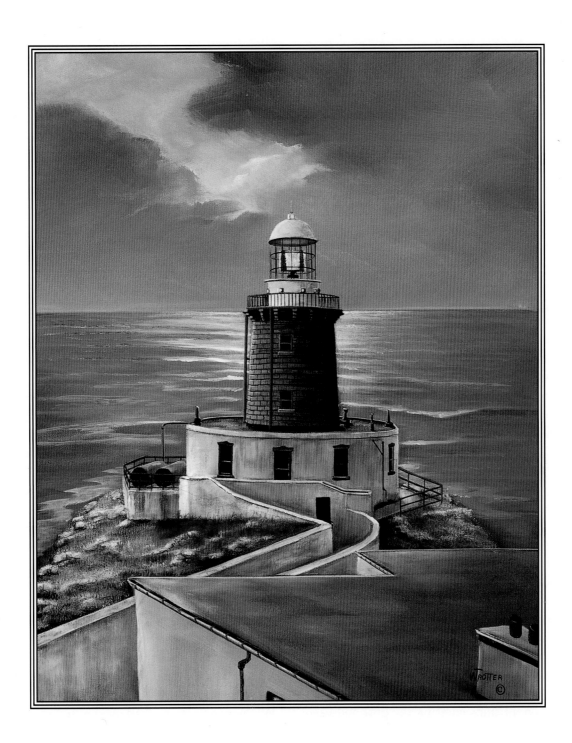

dangers and probably saved the lives of many at sea. Early in the nineteenth century, concern for the needs of mariners led to the establishment at Dublin Bay of Europe's first organized lifeboat service, manned by local fishermen.

In 1665, King Charles II granted a patent to Sir Robert Reading to build six coal-fire lighthouses, the first of which was constructed in 1668. Two of these were to be at Howth — one to mark the land, the second to help ships pass over the bar. Published engravings from 1799 show the vaulted cottage that Reading built and, at a height a little higher than the cottage, a squat tower on the top of which was a brazier. Also in the engraving is a propped-up pile of fuel, probably turf or peat, although coal became the fuel of choice as time went on.

In place of the second structure, the one that would guide ships over the bar, officials opted for some type of buoy, to be supplemented in 1735 by a lightship. The problem with Reading's lighthouse service was that he was more interested in collecting unauthorized fees from passengers and fishing boats than in tending his coal fires, which he allowed to deteriorate. He eventually had to give up the patents he had for his lighthouse monopoly to more reliable people. Another problem concerning those early Irish lighthouses was that they had only naked fires, a dangerous and inadequate practice, one that would be superseded in another hundred years by candles inside covered lanterns.

In 1707, an Act of Parliament established a Ballast Board and took away control of the port of Dublin from the Corporation of Dublin. The Ballast Board, originally formed to control the dumping of ballast by ships into the bay and to maintain and develop the Dublin port, levied tonnage dues on all ships entering the port and used that income to upgrade the harbor. The income was also used to improve the channel and to build the four-mile-long South Wall, one of the longest seawalls in Europe and the site of the Poolbeg Lighthouse, completed in 1768 after fifteen years of construction. Workers later rebuilt the Poolbeg Lighthouse in 1820.

Officials in 1786 established the Corporation for Preserving and Improving the Port of Dublin, later called the Port Authority. Four years later, Thomas Rogers, soon after he had come to Ireland from England, built a new lighthouse, a small round tower similar in height to Reading's structure, at the site of the old Baily structure and replaced the old coal fire with a new lantern that he developed. Rogers, responsible for inventing a new type of illumination called catadioptric lights, went on to become the country's "Lighthouse Contractor and Inspector" and built lighthouses at other Irish sites, but he did not succeed as well as expected. In order to earn more profits from his lighthouses, Rogers hired too few workers, paid them poorly, and allowed them to engage in other business — all of which led to a deterioration in the service. In desperation, the British Parliament in 1810 put the country's lighthouses in control of the Port of Dublin Authority, also called the Dublin Ballast Board.

Because the Baily Lighthouse that Rogers built proved to be too high, it was frequently obscured by mist and clouds. His successor, George Halpin Sr., was entrusted by the Dublin Ballast Board with the erection of a new lighthouse lower on the promontory. This new lighthouse, finished in 1814, is officially known as Howth Baily, unofficially as the Baily Lighthouse. After several serious wrecks near the lighthouse in heavy fog, officials had a powerful fog-bell installed (1853), to be replaced by a reed-horn signal using compressed air (1867), by a siren (1879), and by a diaphone (1926), a fog-signal consisting of a piston driven by compressed air and emitting a very distinctive sound.

The Baily Lighthouse became the site of a revolutionary new lighting design by John Wigham, a Scot who had lived in Ireland for many years and who became one of history's greatest lighthouse engineers. In 1865, he substituted gas for the oil lamps in the towers, eliminating glass chimneys, which had dimmed the light and sometimes even broken in the heat of the flame. Wigham's gas light consisted of five concentric rings, ranging from an inner ring of twenty-eight

jets to an outer ring of 108 jets, adding up to a total of 340 separate jets, all of which had a mica chimney that drew up the draft. This multi-jet burner provided a more powerful beam in foggy weather and saved fuel on fair nights by being more easily controlled.

Wigham increased the strength of that light in 1872 from three thousand to nine thousand candle-power, creating a beam which could produce a light of a half million candle-power when focused. That light, almost ten times more powerful than any other, led to more lighthouse contracts for Wigham's company, which eventually changed its name to F. Barrett. Visitors to the Maritime Museum in the former Mariners Church in Haigh Terrace at Dún Laoghaire can see one of the Baily optics. That one million–candlepower optic, weighing some thirteen tons, was built in 1901, was put into operation at the Baily Lighthouse in 1902, and was finally replaced there in 1972. The museum also has a lightship model collection and exhibits that include the story of Irish lighthouse engineering, with particular reference to Dublin's Barrett & Company, which sent many of its buoys and lights to ports around the world.

The Baily Lighthouse was one of the best sites for a keeper to be stationed since Dublin was nearby and the families could live in comfortable houses, unlike at the more remote stations. Keepers at such land stations would earn twenty-eight days of annual leave, which could increase to thirty-five if they had to double up the watches in fog. The Baily also served as the first training site for initiates in the lighthouse service, who would begin as Supernumerary Assistant Keepers (SAK). During their apprenticeship, they would learn radio-telephony and other methods in telecommunications and would then serve for several years at different stations around the country before becoming Assistant Keepers (AK) at a shore station or an island station. With normal progress they would rise to the rank of Principal Keepers (PK), perhaps beginning at the more difficult rock stations until they finished up at a shore station at the retirement age of sixty.

As happened so often in Ireland and elsewhere, it took serious shipwrecks with great loss of life for the lighthouse service to install new towers and foghorns and for an adequate life-saving service to come into being. The official bureaucracy moved very slowly, sometimes taking years to act on recommendations by its engineers. Their delay allowed even more lives to be lost. For many decades mariners had to rely on their own skills and knowledge of the coast until structures like the Baily, strategically placed at intervals along the coast, began to alleviate the dangers of navigating Irish waters.

Finally, we should mention the small lighthouse on the pierhead at Howth Harbour. The lighthouse, which is under the jurisdiction of the Irish Lights Commissioners, was finished in 1818 and continues to guide ships into and out of the port there.

Further Reading

Corry, Geoffrey. "The Dublin Bar — the obstacle to the improvement of the Port of Dublin," *Dublin Historical Record*, 23, 4 (July 1970), 137-52.

de Courcy Ireland, J[ohn]. "The Fight for Safety in the Approaches to the Port of Dublin," *The Mariner's Mirror* (London, Society for Nautical Research), 72, 4 (1986), 455-63.

de Courcy Ireland, John. *Wreck and Rescue on the East Coast of Ireland*. Dublin: The Glendale Press, 1983, esp. 77-78.

Hague, D.B. "Irish Brazier-Lighthouses," *The Keeper's Log*, 7, 1 (fall 1990), 24-25 [about the first light house at the Baily].

Hague, Douglas B. and Rosemary Christie. *Lighthouses: their architecture, history and archaeology*. Llandysul Dyfed, Wales: Gomer Press, 1975.

Long, Bill. *Bright Light, White Water: The Story of Irish Lighthouses and Their people*. Dublin: New Island Books, 1993, 29-34.

Wilson. T.G. *The Irish Lighthouse Service*. Dublin: Allen Figgis, 1968.

DUBLIN LIGHTSHIP

2

County Dublin

A life on a ship is like a life in prison, with the chance of being drowned.

— Dr. Samuel Johnson,
English essayist and lexicographer

While the Irish proverb, "Often has a ship been lost close to the harbour," is true for many of the world's ports, including Dublin's, Irish officials determined in the seventeenth century to do their best to prevent the loss of as many lives and ships as possible in and around the country's major port. To warn mariners of the dangers there, officials placed a lightship offshore, as they had at several sites along the coast before they could build lighthouses. Actually, long before most of the country's lighthouses were built and even after they were in place, lightships played an important role with lights and fog signals in warning passing ships of unseen dangers. Some experts have even suggested that lightships be placed all around the British Isles in place of land-based towers since some locations offer almost insurmountable difficulties in the construction of massive towers.

Also, because sandbanks can change their positions, more movable lightships would be better to mark the site. Lightships are relatively inexpensive to build and maintain and might even be used as mooring posts for smaller ships to ride out a storm. However, a lighthouse with three keepers is still cheaper to maintain than a lightship with a twelve-person crew, and large floating beacons can be moved around to mark sandbars. As more and more lighthouses become automated and cheaper to maintain than before, lightships will become a relic of the past, but what a memorable and distinguished past.

Dublin early became an important port, not only because its bay is the only major natural inlet along this part of the east coast of Ireland, but also because it serves the rich agricultural countryside that lies behind it. Fishermen were long attracted to the bay because of the vast quantities of herring, but they had to contend with a body of water that offered the unwary mariner formidable dangers. In the ninth century, the Vikings arrived and chose for their stronghold the black pool (in Irish "Dubh linn," hence "Dublin") where the Liffey met the

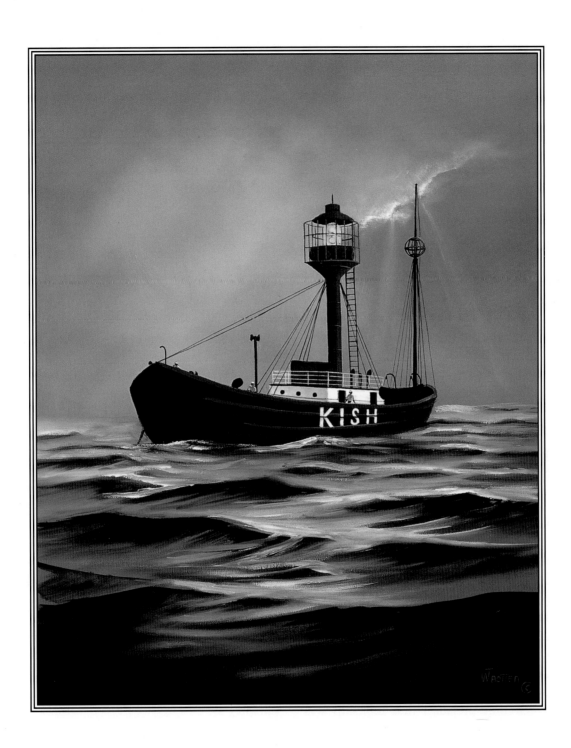

Poddle Stream because they could easily draw their longboats up onto the shore. The uncertainties and dangers of Dublin Bay did not offer such ships much trouble in clear weather because the ships had such a shallow draft. From there the Vikings could make raids inland and build the port, which grew from the ninth to the eleventh centuries to become the center of a small Scandinavian kingdom that extended down to Wicklow.

Dublin Bay has always offered challenges to those who would use it. For example, meteorologists estimate that it experiences gale-force winds about thirty-five days each year, a forty-seven-foot-high wave every ten years, and a sixty-four-foot wave every century. A reporter from *The Irish Times* in 1861 called the bay "one of the most angry scraps of water in the kingdom." All of these factors made engineers design sturdy structures for the bay, including a lightship and several lighthouses. Part of the problem with Dublin Bay in the early days was that ships had to anchor outside the bar to await a favorable tide or an open berth and were, therefore, subject to the sudden squalls that arose.

As previously mentioned, the patent that King Charles II granted to Sir Robert Reading allowed him to build six coal-fire lighthouses in the 1660s, including a light to help ships cross the Dublin Bar. However, instead of building a lighthouse near Dublin Bar, Reading put a buoy and some kind of perch there. Partly because of his negligence in maintaining the structures he built, special commissioners were appointed in 1704 to operate the lighthouses on Ireland's coast, but those commissioners also seem to have neglected their obligations.

In the 1730s, authorities finally authorized the building of the South Wall out into Dublin Bay, at which time Ireland's first lightship was moored near the end of the piles where the present Poolbeg Lighthouse stands. The lightship, which burned fire in braziers, marked the seaward extremity of the South Wall, the longest such wall in Europe, extending as it does for four and a half miles from O'Connell Bridge to the Poolbeg Lighthouse. Workers originally constructed it by

making baskets of sally willows, filling the baskets with stones, and sinking them to form a wall. Nevertheless, the South Wall, while somewhat effective, could not prevent huge waves from breaching its height and rushing into Dublin.

Because the Irish word for a basket is "kish," local people called this lightvessel "the lightship at the kishes" or simply "the Kish." A fierce gale in 1743 drove the ship onto the rocks at Dunleary and wrecked it, but another one soon took its place and served until 1782, when the lighthouses on either side of the Liffey entrance replaced it. Dublin Bay was made more accessible when Dún Laoghaire (called Kingstown for one hundred years, beginning in 1820, to honor the visit of King George IV) had lighthouses installed on its two piers in the mid-1800s. The Dún Laoghaire port had been begun in 1817 as a result of an outcry of public opinion against the continuous loss of life by shipwrecks in Dublin Bay.

That bay continued to see very serious wrecks during the nineteenth century. For example, in 1807 the *Prince of Wales* was lost with over one hundred people drowned, and the *Rochdale* foundered with a loss of 265 men, women, and children. Four years later, in order to warn ships of the dangerous entrance to the bay, authorities placed on the Kish Bank its first lightship, a converted Dutch boat called a galliot. The vessel's crew would strike a gong during fog and fire a gun twice every fifteen minutes when the mail-boat from Holyhead was expected; the packet boat would signal its arrival near the lightship by firing a single shot. Even with those precautions, the mail-boat collided with the Kish lightship three times and sank it once. Despite those mishaps, a lightvessel kept faithful watch there for 150 years, to be replaced by the Kish Bank Lighthouse (see Chapter 3).

While the original lightvessels were converted merchant ships without rigging and carried large lanterns on masts, later vessels were designed for their particular work. They were usually painted red or black to make them more visible during daylight hours and in recent years have been made of steel, a far sturdier material than

the earlier wood. The ships are built with water-tight bulkheads to protect the vessels from sinking after a collision, a frequent occurrence even in modern history. The ships at different locations carried different numbers of lights to make them more identifiable at night; the Kish Lightship, for example, had three lanterns placed in a triangle.

Early lightships had a large mast amidships with a six-foot-wide lantern that could be raised or lowered for maintenance. Life on the vessel was usually very uncomfortable and cramped, especial-ly as compared to life at shore-based towers or on the new Kish Bank Lighthouse in the bay. A sur-prising number of lightship crewmen lost their false teeth overboard because of the continual rolling of the ships. While the lightship's four-ton anchor attached by a quarter-mile of cable made sure the vessel did not stray from its position, the ship still had very little mobility and, in fact, did not run for cover during fierce storms, but delib-erately stayed on post in order to be of service to other vessels. The crew would serve four weeks on and two weeks off, a generous practice prompted by the difficult living conditions. An unexpected

danger was the U-boat torpedo, such as that which sank the Arklow lightship in 1916 off the Irish coast. Modern lightships are more comfortable, longer (145 feet), wider (25 feet), and heavier (500 tons) than older ships, but the future of such ves-sels is limited because of technology and expense. Lightshipmen used to pass the endless hours, especially when they were off duty, at hobbies that ranged from putting model ships in bottles to making rope mats and models. When television sets were placed on the ships in the 1960s, the daily habits of the men changed as they were able to take advantage of the new entertainment.

In 1965, Ireland had nine lightvessel stations, a number that fell to two in June 1976: one off County Down and one off County Wexford. They became automatic lightfloats monitored by shore-based equipment at Mew Island Lighthouse and Hook Point Lighthouse, respectively. One can see the *Guillemot* lightship, which was built in 1922 and serviced many stations around Ireland before becoming a maritime museum, at Kilmore Quay in County Wexford.

Further Reading

Bardon, Jonathan and Stephen Conlin. *Dublin: One Thousand Years of Wood Quay*. Belfast: The Blackstaff Press, 1984.

Blaney, Jim. "Skulmartin" [about the lightvessel stationed there and about the men on such lightvessels], *Beam*, 24, 1 (December 1995), 29-32.

Christensen, Arne Emil. "Vikings in the Irish Sea," in *The Irish Sea: Aspects of Maritime History*, edited by Michael McCaughan and John Appleby. Belfast: The Institute of Irish Studies, 1989, 12-18.

Corry, Geoffrey. "The Dublin Bar — the obstacle to the improvement of the Port of Dublin," *Dublin Historical Record*, 23, 4 (July 1970), 137-52.

Costeloe, M.P.L. "Dun Laoghaire," *Beam* [Journal of the Irish Lighthouse Service], 7, 1, 31-34.

Daly, Mary E. "Dublin in the Nineteenth Century Irish Economy," in *Cities and Merchants: French and Irish Perspectives on Urban Development, 1500-1900*, edited by P. Butel and L.M. Cullen. Dublin: Trinity College, 1986, 53-65.

de Courcy Ireland, J[ohn]. "The Fight for Safety in the Approaches to the Port of Dublin," *The Mariner's Mirror* (London, Society for Nautical Research), 72, 4 (1986), 455-63.

de Courcy Ireland, John. *Ireland and the Irish in Maritime History*. Dublin: The Glendale Press, 1986, 171, 245.

de Courcy Ireland, John. *Wreck and Rescue on the East Coast of Ireland*. Dublin: The Glendale Press, 1983.

Flood, Donal T. "Dublin Bay in the 18th Century," *Dublin Historical Record*, 31, 4 (September 1978), pp, 129-41.

Long, Bill. *Bright Light, White Water: The Story of Irish Lighthouses and Their People*. Dublin: New Island Books, 1993, 39.

Pearson, Peter. *Dún Laoghaire, Kingstown*. Dublin: O'Brien Press, 1991.

Wilson, T.G. *The Irish Lighthouse Service*. Dublin: Allen Figgis, 1968, 83-88: "Lightships."

KISH BANK LIGHTHOUSE

3

County Dublin

The construction of the Kish Bank lighthouse in Dublin Bay represented a spectacular development in the use of telescopic caissons. Twice the size of any tower hitherto built by this method, it ranks as one of the most daring feats of modern engineering.

— Patrick Beaver,
A History of Lighthouses

December 1963: In various pubs around Dublin Bay, the workers who had just finished building the new Kish Bank Lighthouse were celebrating a job well done. Even as they lifted their mugs to toast the strange-looking caisson after round-the-clock shifts, a jealous Poseidon must have heard their celebration. Suddenly a monstrous storm rushed into the Inner Harbour at Dún Laoghaire, damaged the lighthouse beyond repair, and sent it to the bottom of the sea.

It took another year and a half for the workers to rebuild the structure and prepare it for its slow haul to the Kish Bank eight miles off the coast. Several tugs carefully towed the seven-thousand-ton concrete lighthouse, which drew thirty feet of water, and all seemed ready for the final placement, but once again Mother Nature let everyone know what forces were in charge.

Suddenly a dense fog closed down visibility and a force-four gale blew up, snapping one of the mooring lines and forcing engineers to sink the caisson several hundred feet south of where they had wanted to place it. Tilting at a perilous angle, the structure seemed about to topple into the sea, lost forever.

But the engineers were not to be outdone by the sea that day. They refloated the structure, towed it to the right location, sank it to the proper depth, and filled in the lower parts with sand, stones, and concrete for balance. Even then, the Irish Sea tried to have the final say when, just before the lighthouse commissioners took control of the tower, the waters rose up and swept concrete equipment, pump, compressor, and twenty tons of cement overboard. The fact that so much of the work had been prefabricated in the safety of the port prevented even worse damage on

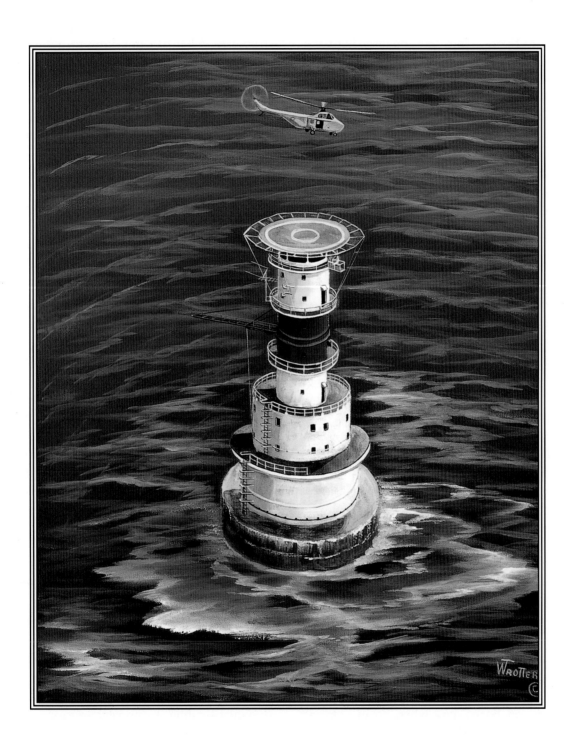

the open sea that day. In November 1965, the work was finally done to the satisfaction of the Lighthouse Board, and the modern lightship, which had served the sea lanes there so well, was towed away.

The Kish Bank, several miles long and very shallow at times (part of it is actually dry at low tide), is a unique geological feature that has plagued ships heading to or from the Port of Dublin or the ferry terminal at Dún Laoghaire for centuries. Because vessels must pass clear of the northern edge of the sandbank or risk serious harm and loss of life, officials had tried buoys in the area in the second half of the eighteenth century, but storms would blow them — to the peril of ships sailing the area. In 1811, the lighthouse service placed a lightship there, and that worked well (see Chapter 2).

Around 1840, the Ballast Board decided to replace the Kish Lightship with a more permanent structure: a lighthouse built on the sand. The problem was that the sandbank is at least eighteen-feet deep at high water and is swept by fast tides. Alexander Mitchell (1780–1868), the brilliant, blind engineer from Belfast who had designed a screw-pile structure that would twist down into the sand, tried to install one at Kish Bank, but it failed primarily because a strong gale in November 1842 effectively damaged the piles beyond repair.

Even after the lightship was stationed on the Kish Bank, the occasionally dense fog caused some serious accidents. In 1902, for example, the mail steamer collided with the lightship *Albatross* and sank it. The area where the lightship was anchored could also be a dangerous one during wartime, as when a U-boat torpedoed and sank RMS *Leinster* in 1915, causing the loss of 501 of the approximately 687 on board, and when enemy aircraft near the Kish Lightship fired upon the RMS *Cambria* in 1941. The last lightship to serve there was the 136-foot *Gannet*, which arrived in 1954.

In the 1960s, the Commissioners of Irish Lights again decided to replace the lightship with a lighthouse because of the cheaper maintenance costs (about one-third the cost of maintaining a lightship) and the greater stability of the larger structure. When it came time to design the new tower, officials decided to build a relatively new type, one based on the oil rigs that worked in places like the Gulf of Mexico. Engineers designed a telescopic caisson, a new concept which would reduce maintenance costs, ensure long life to the structure, offer spacious accommodations inside, and allow much of the tower to be prefabricated in the safety of a harbor.

The principle behind this type of tower is to build two closed-bottom caissons, one within the other, big enough for the whole structure to float out to its site. Once towed to its final position, the whole unit is sunk to the level sea bed. When water is pumped below the inner caisson, it will float up and be fastened to the one below it. The outer caisson, acting as the foundation, will be filled with sand, stones, and concrete to make it firm on the bottom.

Engineers discovered that the sea bed at Kish Bank consisted of a fifty-foot top layer of fine sand, another layer of silt, and finally rock three-hundred feet down. Because the site and proposed ultra-modern tower were so unique among the world's lighthouses, extensive tests were carried out on scale models at the Coastal Engineering Laboratory of the Technical University of Denmark. Engineers chose to use concrete for the structure rather than steel because the former would last longer and need less maintenance. In the end they steadied the structure by placing a level foundation of gravel nine inches deep on the sea bed. Because the Irish Meteorological Office estimated that strong winds would buffet the area and that high waves were also a problem, workers surrounded the tower's base with a massive amount of rubble to prevent erosion at the base and to add more weight to the sand to increase its bearing capacity. Assuming that the highest wave would not be more than forty-five feet helped determine the height of the tower.

Prefabricating the structure in the shelter of a harbor eliminated many of the problems long

associated with lighthouse building: danger to the workers, long weather delays, work limited to the summer, and communication problems from site to shore. A project that might take four years in the mid-ocean could take as little as four months in a protected harbor. Even so, boats still have to tow the structure out to the site, a procedure creating many sleepless nights for those in charge.

The Kish Bank Lighthouse, standing in fifty-four feet of water at low tide and sixty-eight feet at high tide, more than doubles the size of similar structures built in the past. It consists of a huge concrete outer drum or caisson that is about one-hundred feet in diameter, inside of which, in another caisson, the telescopic lighthouse caisson rests. Unlike the construction of other lighthouses, no lives were lost in the building of the Kish, no one suffered a serious accident, and no engineering problem remained insurmountable.

At night the tower exhibits a two million candle-power light, which can be seen for almost twenty miles, compared to the 820,000 candle-power-lamp that the lightship had. Even so, at times the fog is so thick around the Kish Bank Lighthouse that watchmen in the tower cannot see the water down below. Furthermore, this lighthouse is unique among Irish structures because of the helipad on top, its size, its look, and the luxurious living quarters: separate bedrooms for the three individual keepers, a modern kitchen, dining room, games room, and television lounge — all a far cry from the spartan quarters so many keepers had experienced in the past. The Dún Laoghaire lifeboat station even made a practice of bringing Christmas parcels out every year to the keepers.

However, for their daily constitutional, the keepers had to make endless circles around the catwalk of the lantern house because the helipad is too exposed for safe walking and the tower rests on the sea bed and thus had no rock which the keepers could walk on for exercise on calm days. The keepers left the tower for good when it was auto-mated in 1992, at which time officials transferred the Kish's radio-beacon to the Baily Lighthouse. One has to worry, though, about the possible times in the future when ships in trouble around the Kish sandbank will have no one from the lighthouse looking out for them and guiding them to safety.

Three small lighthouses in the vicinity should be mentioned here because they are under the jurisdiction of the Commissioners of Irish Lights: Dún Laoghaire East, Dún Laoghaire West, and Muglins. The first, built at the end of the East Pier at Dún Laoghaire in 1847, and the second, built at the end of the West Pier in 1852, were demanned (in 1930 and 1955 respectively), but have continued to provide guidance for those ships using the busy port. Two miles southeast of Dún Laoghaire is Dalkey, the former port of Dublin. Offshore lie the Muglins, very dangerous rocks which present major hazards to shipping. A beacon was built on the rocks in 1880, and it has continued to warn mariners of the treacherous rocks there. Nearby is the site where officials once erected gallows, from which they would hang the bodies of executed pirates as a warning to any-one who might consider piracy as a means of making a living.

Finally, this is a good place to mention two Irish mariners who were born south of the Kish on the Irish coast: Robert Halpin (1836– ?) of Wicklow and Ernest Henry Shackleton (1874–1921) of Castledermot in County Kildare west of Wicklow. Halpin, who served on the cable-laying vessel, *Great Eastern*, was responsible for the laying of 26,000 miles of cable that connected numerous countries, including the first cable between Ireland's Valentia Island and Newfoundland in 1866. Shackleton, one of the greatest polar explorers, performed one of the most remarkable rescues in the history of South Pole exploration when he saved his crew after ice had crushed his ship, *Endurance*.

Further Reading

Beaver, Patrick. *A History of Lighthouses*. London: Peter Davies, 1971, 116-27: "The Telescopic Principle" [about the Kish's use of telescopic caissons].

de Courcy Ireland, John. *Wreck and Rescue on the East Coast of Ireland*. Dublin: The Glendale Press, 1983.

Hansen, Frode. "Design and Construction of Kish Bank Lighthouse," *Transactions of the Institution of Civil Engineers of Ireland*, 92 (1965-66), 248-83, 295-99.

Harding, John. "Kish Lighthouse," *Beam*, 24, 1 (December 1995), 34.

Long, Bill. *Bright Light, White Water: The Story of Irish Lighthouses and Their People*. Dublin: New Island Books, 1993, 38-46.

Martin, A.D.H. "Kish Bank Lighthouse: Mechanical, Electrical and Radio Equipment," *Transactions of the Institution of Civil Engineers of Ireland*, 92 (1965-66), 284-94.

Pearson, Peter. *Dún Laoghaire, Kingstown*. Dublin: O'Brien Press, 1991.

Taylor, Michael. "Kish Bank Lighthouse - 25th Birthday," *Beam* [Journal of the Irish Lighthouse Service], 19, 1 (December 1990), 18-20.

Wilson, T.G *The Irish Lighthouse Service*. Dublin: Allen Figgis, 1968, 25-28, 120-26, 173+.

TUSKAR ROCK LIGHTHOUSE

4

County Wexford

The bad deed turns on its doer.

— Irish proverb

Seven miles off the southeastern tip of Ireland stands the lighthouse that thousands of Irish emigrants saw as they left the ports of Rosslare Harbour and Wexford for a new life elsewhere: Tuskar Rock Lighthouse. And while Tuskar Rock in St. George's Channel provides a good foundation for the lighthouse, the fact that the rock is close to the direct route between Rosslare and South Wales and France has accounted for many shipwrecks. Although a seemingly wide thirty-five miles separates Tuskar Rock from the Welsh coast to the east, the fierce winds that plague the area have wrecked many vessels, especially sailing ships. The tidal currents are so unpredictable because the eddies run back toward the rock. The whole rocky, southern coast may be the most dangerous in all of Ireland's waters.

The sea between Carnsore and Tuskar is so treacherous that it has taken a huge toll of ships, even after the lighthouse was built. Sometimes ships disappear without a trace as happened to the *Lismore* in 1924. In 1940, during World War II, many ships sank off the Wexford coast, including the SS *Ardmore*, possibly after having hit the British minefield or a mine that tore loose from its mooring. That same year German aircraft sank the Irish Lights tender *Isolda*, on her way from Rosslare to relieve the *Barrels* Lightvessel, despite the presence of huge letters indicating "LIGHTHOUSE SERVICE" on each side of the ship. The next year, a drifting mine hit Tuskar Rock and exploded, disabling the light for nine days and injuring two Assistant Keepers, one of whom died the next day from his wounds despite having been rushed to a mainland hospital by the Rosslare lifeboat.

When an 1807 survey of the Wexford coast noted how many ships were sunk there, officials suggested that three fixed lights be built on the Saltee Islands to the west-southwest of Tuskar Rock and much closer to the port of Waterford. However, authorities decided three years later to build a 113-foot-tall lighthouse on the rugged Tuskar Rock, reasoning that the Hook Head Lighthouse to the west was sufficient for

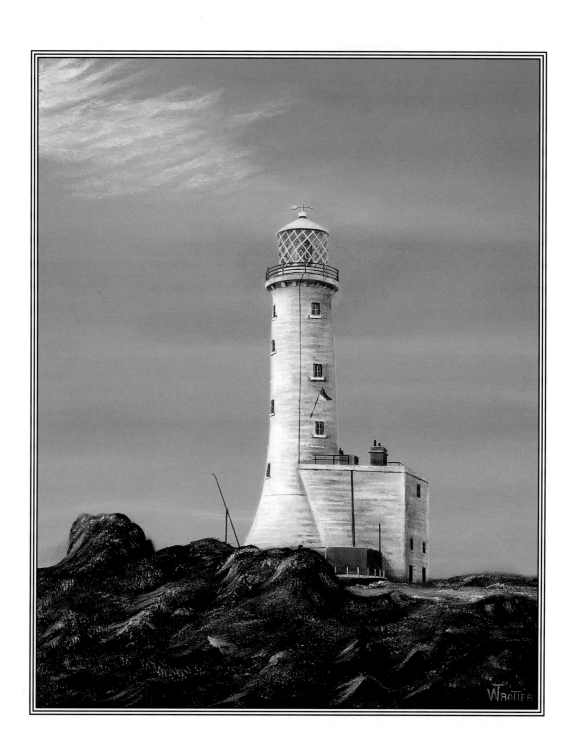

Waterford. During the construction of the Tuskar tower, one of the worst tragedies in Irish lighthouse history occurred.

In 1812, two dozen workers were busy constructing the tower on the flat rocky islet when a powerful storm hit the area at the height of a spring tide and swept ten of the men away. The survivors were left clinging to the uneven rock surface without food or shelter for two very long days and nights. When the storm died down, a relief force from the mainland finally reached the rock and took them to safety. Instead of giving up such dangerous work and opting for mainland jobs, the survivors later returned to Tuskar to finish their task and then went on to build other lighthouses, including the one at Inishtrahull (see Chapter 26).

The government was less than generous to the families of the drowned: each widow or mother received the paltry sum of six pounds per annum, and each child up to the age of sixteen received three pounds per annum. One of the survivors, who had to have his leg amputated, was awarded ten pounds per annum. Tragedy struck again just as the tower was being finished when a stone-cutter fell to his death from a height of seventy-two feet. The granite tower with its oil-wick lamps was finally completed in 1815 after four difficult years of construction. It may have been the greatest accomplishment of the lighthouse service's renowned engineer, George Halpin Sr., because of the great physical difficulties he and the workers had to overcome.

Nine years later an incident occurred that might have had disastrous results for ships. Early one morning, when one of the many smugglers who used the nooks and crannies of the Wexford coast to bring in contraband liquor and salable commodities noticed that customs officials were patrolling the area, he landed at Tuskar Rock. The smuggler explained his predicament to the two lighthouse keepers on duty and promised them some of the goods if they helped him elude the authorities and hide his contraband on the rock. Whether greedy or stupid or daring, they agreed to help him.

When the smuggler returned to the lighthouse several days later to retrieve his contraband, the tower was darkened, the most serious breach of a lighthouse keeper's duty. He found the two keepers stone drunk, having partaken of some of the hidden liquor. The smuggler then packed up what was left of the smuggled goods and took off for the mainland, unconcerned about the fate of the two keepers left behind.

By chance, that was the night that King George IV was sailing by Tuskar in his *Royal Yacht* on his way to Kingstown. Finding the lighthouse unlit during that rainy night, the king's crew was forced to head across the channel for Milford Haven, Wales. In a subsequent inquiry into the fiasco, the two lighthouse keepers were demoted and sent elsewhere. One of the men, Michael Wisheart (or Wishart), was sent to the isolated Skelligs Lighthouse, where he later died after falling off the precipitous rock there while cutting the grass. The second guilty person, Charles Hunter, returned to his former trade, that of a blacksmith. *A Manual for Lightkeepers* (1873) reprinted the whole story (28–32) with the warning:

> Smuggling and other illicit practices should be always discountenanced by lightkeepers; and, to their honor be it said, the keepers of the Irish Light Service have been singularly free from any imputation on this score. (28)

Despite the new lighthouse, wrecks continued to occur in the vicinity, as detailed in a year-by-year description in John de Courcy Ireland's *Wreck and Rescue on the East Coast of Ireland.* Sometimes mistaking a lightship for a lighthouse led to disaster, as when the pilot of the three-masted, full-rigged *Pomona*, on her way from Liverpool to New York in 1859 with many Irish emigrants, mistook the Blackwater lightship for the Tuskar Rock Lighthouse around midnight. The ship struck Blackwater Bank north of Tuskar, eventually sinking, with the loss of most of the 416 people on board. What happened became clear when the third mate, Stephen Kelly, later testified in Wexford:

At midnight a strong breeze, ship under close-reefed topsail, lying in. Made [for] a revolving light, and supposed it to be Tuskar; squared away with the ship, and steered a west course. Very soon after she struck; could not tell where, but proved afterwards to be Blackwater Bank, where the sea soon made a complete breach over her.

Only twenty-three were saved, twenty of whom were the crew who had deserted the passengers and crowded into lifeboats. Part of a ballad written about the tragic shipwreck tried to describe the scene: "With her rigging and her bulwark and steerage torn away/O wasn't that a dismal sight to see in Wexford Bay?"

Bodies washed up along the shore from Curracloe to Raven Point for several days afterwards. What happened then was one of those despicable acts abhorred by civilized people. A woman on shore who came upon a body from the shipwreck stripped the corpse of its clothes. The corpse-robber and her accomplice husband were later each sentenced to six months' hard labor as a deterrent to other would-be plunderers.

The keepers at Tuskar Rock sometimes helped in the rescue of shipwrecked sailors and provided food and shelter to those who made it to the rock through the seas. In 1872, three of the crew from the sunken barque *Euphemia* made it to the lighthouse after a long struggle with the fierce sea. The lifeboat crews along the coast also did their best to rescue those from wrecked ships, sometimes risking their own lives to save others.

Although helicopters were used at other isolated Irish sites, the lack of a landing space at Tuskar prevented such use. Finally, in the mid-1970s workers built facilities so that helicopters could land, and the place became much more accessible. Such a facility in 1968 might have been of some use when an Aer Lingus airliner, *St.*

Phelim, sent its last despairing message: "One Thousand Feet and Spinning Rapidly." It then plunged into the sea near Tuskar Rock, killing all sixty-one aboard, only the second fatal crash of an Aer Lingus plane. The Tuskar Rock Lighthouse was finally demanned in 1993.

North of Tuskar Rock is Wicklow Head, the site of a lighthouse that guides the busy maritime traffic between English ports and this part of the eastern Irish coast. The first lighthouse at Wicklow Head, built in 1781, was too high and therefore occasionally obscured by fog. Two new lighthouses, one high on the cliff and the other lower down, were built in 1818. In 1863, use of the upper light was discontinued, and a lightvessel, the *Wicklow Swash*, was moored off Wicklow Head. The lighthouse received a radio beacon in 1978 that made the site even more important, but, like other stations along the Irish coast, the tower was eventually automated and demanned.

Offshore to the northeast of Wicklow Head is the Codling Large Automatic Navigational Buoy (LANBY). Arklow Large Automatic Navigational Buoy (LANBY), a similar navigational aid, is to the southeast of Wicklow Head. Such floating aids to navigation are much cheaper to operate than manned lightships and, when used in conjunction with other modern technological advances like radio beacons, perform commendably for many different kinds of passing ships.

One final note about the maritime history of Ireland. Just to the west of Tuskar Rock is the small town of Tacumshane, the birthplace of John Barry (1745–1803), the father of the American Navy and a man who is honored by a bronze statue on the Crescent Quay in the Irish town of Wexford. The United States government presented the statue to Wexford in 1956 in recognition of Barry's many accomplishments in establishing the American Navy, including capturing the first ship of war.

Further Reading

"Ancient Irish Mariners" [about John Barry], *Beam* [Journal of the Irish Lighthouse Service], 7, 2 (no date), 23-24.

Costeloe, Michael. "Tuskar Lighthouse," *Beam*, 22, 1 (December 1993), 7-8.

de Courcy Ireland, John. *Wreck and Rescue on the East Coast of Ireland*. Dublin: The Glendale Press, 1983.

Dillon, Jim. "The Barry Connection" [about John Barry], *Beam*, 18, 1 (December 1989), 25-26.

Long, Bill. *Bright Light, White Water: The Story of Irish Lighthouses and Their People*. Dublin: New Island Books, 1993, 53-59.

O'Maidin, Padraigh. "Smuggling on the Tuskar Rock," *Cork Examiner*, Nov. 18, 1974, reprinted in *Beam*, 7, 1 (no date), 18.

Roche, Richard. *Saltees: Islands of Birds and Legends*. Toronto, Canada: Macmillan, 1977, 60-71 [about the many shipwrecks to the west of Tuskar Rock].

"The Sinking of the S.S. 'Isolda,'" *Beam*, 19, 1 (December 1990), 25-26.

Sloane, John S. *A Manual for Lightkeepers*. Dublin: J. Goggins, 1873.

Wilson, T.G. *The Irish Lighthouse Service*. Dublin: Allen Figgis, 1968, 28-32.

HOOK HEAD LIGHTHOUSE

5

County Wexford

By hook or by crook

— English saying

On an ocean-battered headland in County Wexford stands one of the four oldest lighthouses in the world and the oldest one in the British Isles, having been established as a primitive beacon in the fifth century A.D. by St. Dubhán of Wales. This great man, the uncle of Saint David of Wales, came to the eastern shore of Waterford Harbour looking for solitude and remoteness, both of which he found on this isolated piece of land surrounded on three sides by the roaring ocean with its heavy fogs and swift currents. He built his cell toward the southern end of the peninsula where the ruined church of St. Saviour at Churchtown over Hook now stands.

Tradition has it that St. Dubhán, who might be considered the patron saint of the Irish lighthouse service, grew tired of removing so many drowned bodies of shipwrecked sailors from the rocks nearby that he finally built a crude stove on a mound of stones and tended a fire at night for those ships passing to and from Waterford. For fuel he could have used turf or charcoal or even the driftwood from wrecked ships strewn up near his cliff. He may have had built for him a huge iron basket, a "chauffer," which he hung from a mast near the edge of his cliff. He would light a fire in that basket at dusk and tend it through the night, even during wet and windy weather, when mariners offshore needed to see the light. For those shipwrecked sailors who were still alive, he set up a small hospital to tend to their physical needs.

The place used to be called *Rinn-Dubhain* in Irish, which meant "point or cape of Dubhán," but because *dubhán* in Irish also meant "a fishing hook," in time the area became known simply as the Point of the Hook. As others joined the saintly Dubhán for prayer and solitude, they too helped him in maintaining the beacon on which sailors came to depend. After St. Dubhán died, members of his small community took over the task of maintaining the light. Later records indicate that the

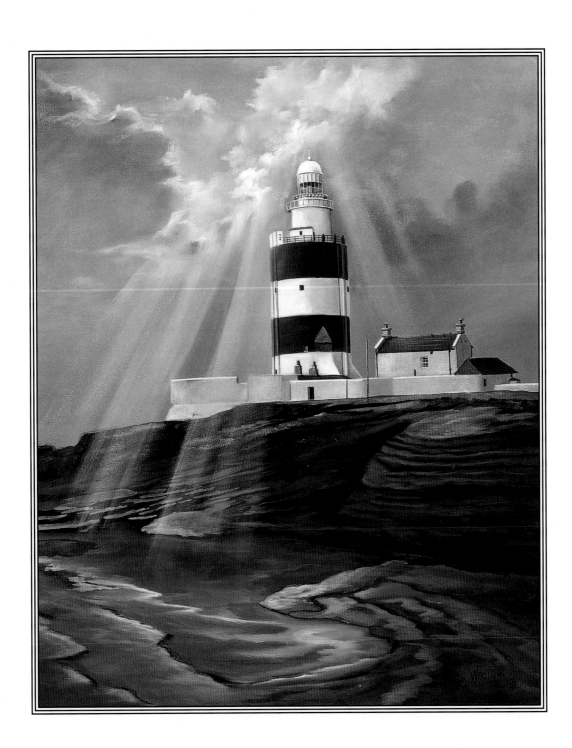

monks, in promising to maintain the beacon, earned the right to collect tolls from ships entering Waterford.

The rules of such a community made them ideal guardians, in contrast to some of the more austere and enclosed orders who were unable to undertake secular duties. Because the monks took care of this lighthouse, some scholars refer to it as an ecclesiastical light. One advantage of having such a light is that the monks could encourage others to support the structure financially with the promise of indulgences granted to the donors.

As time went on, however, the monks had a much more imposing structure to look after than St. Dubhán's primitive beacon, for soon after the Anglo-Norman invasion in 1169, in the period between 1170 and 1184, the Normans built the present massive stone tower/fortress to protect their conquered land. The monks left the tower sometime before the Dissolution of the Monasteries in Ireland in the sixteenth century, but laypeople replaced them and continued manning the tower.

The structure's walls are nine to thirteen feet thick, and the tower has three stories with windows in each. The top of the tower is eighty feet above the ground at the end of the two-mile-long peninsula. The lowest story was originally the place for storing fuel, the next was living quarters for the assistant keeper, and the top story accommodated the principal keeper. Today, storerooms fill these three floors. From time to time, those who lived at the tower, other than the monks, also used it for the counterfeiting of money. The isolation of the tower and its command of an unobstructed view of the surrounding plain — and therefore of any raiding party — enabled its inhabitants to hide signs of their counterfeiting operations when officials approached. The presence of the three keepers and their families meant a great deal to the local economy as farmers could sell their milk and vegetables to the families, and local shopkeepers could supply them with the necessities of life.

The light has not shone uninterruptedly in the last eight hundred years, but has been darkened during insurrections and civil wars. It remained unlit and uninhabited for about twenty-five years in the early 1600s until King Charles II granted Sir Robert Reading a patent for establishing six coal-fire lighthouses around the Irish coast. Around 1677, when workers re-established the light there, they replaced the old, coal-burning beacon with a safer lamp. Coal fires were dangerous because of the suffocating fumes of the fire and the inconsistency of the fire's brightness: bright on the windward side, but smoky on the lee side. During stormy weather, when the light was sorely needed, the keepers were sometimes hesitant to stoke the fires for fear of having the fire spread out of control.

In the early 1790s, Thomas Rogers came to Ireland from England and established a lantern with twelve lights at Hook Tower. As time went on, Rogers was given control of more Irish lighthouses and hired keepers to help in the task. However, in order to amass the largest profits possible, he kept to a minimum the maintenance of the towers and the hiring of workers. He hired unreliable keepers, paid them an average of only fifteen pounds per annum, and allowed them to keep unburned candle-ends, to use their dwelling as taverns, and to carry on various trades. The Hook Tower keeper, for instance, lived with his family in the tower and worked as an herb doctor.

Another major problem in the eighteenth century was the ease with which mariners mistook the Hook Head Lighthouse for the Eddystone light off Cornwall in southwestern England, especially after a long transatlantic passage or during fog. They then sailed into Ballyteigue Bay under the mistaken idea that they were going up Plymouth Sound. In 1803, eleven large sailing vessels wrecked east of Hook Head because of that navigational error.

The area to the east of Hook Head over to Tuskar Rock, a section that mariners call the "Graveyard of a Thousand Ships," is dangerous because it lacks sheltered bays for ships to seek during storms, the tidal currents are particularly strong, and the prevailing southerly and southwesterly winds can blow vessels onto the rocks of

the Saltee Islands. Because so many ships use this major trade route on their way to and from some of the busiest ports of Ireland and Britain, officials wanted to build a lighthouse on the Saltee Islands in order to warn mariners away from the treacherous Ballyteigue Bay. The problem is that, in order to be most effective, such a lighthouse would have to be situated on the highest point of the islands, for example at Big Head on Great Saltee, but the height of that hill might obscure the lighthouse during heavy fog or low clouds. As a compromise, the Lighthouse Board finally stationed the Coningbeg lightship near the Coningbeg (or Coney) Rock for many years, beginning in 1824 with the placement of the *Seagull*. The Coningbeg lightship has since been replaced by the Coningbeg Automatic Lightfloat (ALF), a floating aid to navigation moored to the ocean floor. The *Barrels* lightship also eased the situation between Tuskar Rock and Hook Head, where a gigantic buoy is now situated.

Over time, workers increased the height of the tower at Hook Head by some eighteen feet and the diameter by ten feet. The fuel changed from oil to coal-gas (1871), vaporized paraffin (1911), and electricity (1972). Families were finally taken off the site in 1977 and moved to more comfortable lodgings inland. Having a fog signal there proved difficult since ringing the bell by hand for long foggy days and nights was tedious for those assigned the task, something that was made considerably easier when an automatic bell-ringer was installed (1850s). When the bell was replaced by a gun (1872) and then explosive charges (1905), a new problem arose from those who would raid the lighthouse in order to steal the explosives for use in making bombs. This temptation necessitated the substitution of compressed air for the signal.

The area may have given rise to the popular expression "by hook or by crook," meaning "by this means or that." Attributed to invaders like Strongbow in 1170 and Oliver Cromwell in 1649, it referred to Hook Head on the eastern shore of Waterford Harbour and to the small village of Crooke on the Waterford shore, that the attackers would invade Ireland by Hook or by Crooke.

A visitor center is in the works at the lighthouse, a center that will allow the 15,000 anticipated yearly visitors a chance to see an almost-intact medieval lighthouse. Plans call for increased parking facilities for cars, adequate safety precautions for the expected visitors, and the development of the keepers' house into a reception area, a facility for audio-visual presentations, and a shop. Officials also hope to have guided tours available to the public. With the preservation and development of the lighthouse facility, more people will be made aware of the importance of lighthouses in Ireland's history, and a means for bringing tourism to the area will help the economics of many people involved in the project.

Nearby, the Dunmore East harbor light guides ships using Waterford Harbour. This light has been operating since 1825 and served the early mail-boats operating between this port and Milford Haven in Wales. The fluted Doric column made of local red sandstone and cast-iron lattice balcony give this lighthouse a striking appearance.

Further Reading

Funk, Charles Earle. *Heavens to Betsy! And Other Curious Sayings.* New York: Warner Paperback Library, 1955, 174 [for the origin of "by hook or by crook"].

Hague, Douglas B. and Rosemary Christie. *Lighthouses: Their Architecture, History and Archaeology.* Llandysul Dyfed, Wales: Gomer Press, 1975, 14-16.

Long, Bill. *Bright Light, White Water: The Story of Irish Lighthouses and Their People.* Dublin: New Island Books, 1993, 60-67+.

Roche, Richard. *Saltees: Islands of Birds and Legends.* Toronto, Canada: Macmillan, 1977, 60-71 [about the many shipwrecks to the east of Hook Head].

Taylor, Michael. "Proposed New Hook Lighthouse Visitor Centre," *Beam*, 24, 1 (December 1995), 7.

Tweedy, Tucks. "From Dubhán to Datac" [about the author's association with Hook Head Lighthouse], *Beam*, 24, 1 (December 1995), 5-7.

Walton, Julian. "The Merchant Community of Waterford in the 16th and 17th Centuries," in *Cities and Merchants: French and Irish Perspectives on Urban Development, 1500-1900*, edited by P. Butel and L.M. Cullen. Dublin: Trinity College, 1986, 183-92.

Wilson, T.G. *The Irish Lighthouse Service*. Dublin: Allen Figgis, 1968.

BALLINACOURTY POINT LIGHTHOUSE

6

County Waterford

Dungarvan Harbour along Ireland's southern coast has a good location with Waterford to the northeast and Cork/Cobh to the southwest. The town of Dungarvan (population about 7,000) lies near the Colligan estuary above the harbor. The local museum, located in the town's Municipal Library and open during the summer months, stresses the maritime history of the area, including the many shipwrecks like that of the *Moresby* in 1895 (loss of twenty lives), that have plagued the coast for centuries. The relative isolation of the peninsula due south of the town has allowed the West Waterford Gaeltacht, an Irish-speaking area, to thrive with its center at Ringville (population 265).

Centuries ago, long before lighthouses dotted the Irish coast, mariners would have had to rely on landmarks or the stars to make their way. The Irish coast was poorly charted for years, although many of the Spanish Armada pilots knew the coast well with the help of the maps that

The maiden who hops on one foot completely around the base of the Metal Man tower three times will find a good husband within twelve months.

— Irish superstition

Italian, Portuguese, and Breton cartographers had made in the sixteenth century. Mariners often relied on portulan maps or portulans (notes of distances between sites and also the bearings of the ocean from previous trips). Early English books of sailing directions, called rutters, were of some help to someone who had already sailed the coast, but were too general for the newcomer. Foreign ships coming to Ireland for the first time often carried pilots who claimed to know the ports and hidden rocks well. Less reliable than the maps was the weather, something that the pilots of the Spanish Armada discovered, when fierce, unexpected winds blew them into the Irish coast.

Although Dungarvan was just a small town in the early seventeenth century, even at that time its fishermen were able to do well in the offshore waters, exporting hake, herring, and salmon for a value of one thousand Irish pounds each year. Some people, in fact, complained then, as they do

29

now, that exporters were sending so much Irish-caught fish abroad that not much was available in the country itself. As time went on, the fishing declined, perhaps because the fish migrated elsewhere.

The excellent location of Dungarvan helped establish a successful maritime business with English and European ports in the first part of the nineteenth century. The lack of any kind of lighthouse to help ships enter and exit the port spurred local merchants to petition the authorities for help. Finally in 1851, the Cork Harbour Commissioners were able to have lighthouses established on Ballycotton Island near Cork and at Mine Head due south of Dungarvan. The red sandstone structure at Mine Head, at 285 feet, has the highest elevation of any lighthouse in Ireland and shines forth from very inaccessible cliffs. It definitely helped to light up the coast, but Dungarvan merchants were still insistent on having their own lighthouse.

In what was a relatively short time, compared to the decades of waiting that some coastal towns experienced, the Ballast Board took just seven years to approve a light for Dungarvan Bay. The Board chose Ballinacourty Point on the northern shore of the Bay, and the great architect of Irish lighthouses, George Halpin, designed one using local limestone rock, finishing the tower in 1858. The squat, white tower contrasts nicely with the limestone cottage next to it and the Comeragh Mountains behind it. The location of the cottage next to the tower contrasts sharply with outposts at rock-towers. Those isolated sites demanded a certain kind of keeper who did not mind loneliness, isolation, and living with the threat of fierce storms coming up quickly.

Observers near the Ballinacourty Lighthouse during the last several years may have noticed a ship other than the *Granuaile* from Irish Lights servicing the tower and other lighthouses. In the 1990s there has been a close cooperation between the lighthouse service of Ireland and that of other countries, especially England and Scotland, primarily because Irish Lights sold her vessel *Gray*

Seal and, therefore, had only one vessel left, *Granuaile*, to cover the long Irish coast. As a result, Trinity House (in charge of lighthouses in England, Wales, the Channel Islands, and Gibraltar) sent her *Mermaid* vessel, and the Northern Lighthouse Board (in charge of lighthouses in Scotland and the Isle of Man) has sent her *Pharos* to help in the annual servicing of Irish lighthouses and buoys, the former along the south and west coasts, and the latter on the north and east coasts. Such close cooperation among countries that are often rivals on the high seas points out the altruistic spirit of securing the safety of mariners of all nations. The *Granuaile*, for its part, has helped with casualty buoy work on the west coast of England.

In its goal of making its lighthouse tender as modern and efficient as possible, Irish Lights has fitted out the *Granuaile* with a new, highly sophisticated navigational package which allows it to pinpoint with great accuracy the location of ships, lightvessels, and buoys. The technology is so advanced that the *Granuaile* can position a ship within five meters, with the result that the service's navigational buoys can be placed exactly where they should be and where the nautical maps say they are. The lighthouse tender can now also make extremely accurate and extensive sea bed and wreck surveys.

Somewhat related to lighthouses, because of their usefulness to mariners, are the towers of Tramore to the east of Ballinacourty Point. While technically not lighthouses, the five towers, three on the west headland and two on the east headland, provide a valuable service to orient the mariner offshore as to the location of Tramore Bay. These seamarks or caution towers date to 1824. On top of the middle tower on the west headland stands the Metal Man, a twelve-foot-high figure of a sailor, dressed in the late eighteenth-century uniform of Admiral Horatio Nelson's day, with his arm extended as a warning to ships' pilots to mind the coast.

The Metal Man attracts not only tourists, but also eligible maidens who, according to local

legend, if they want to find a good husband within twelve months, have to hop on one foot completely around the base of the Metal Man tower three times. The eighty yards of uneven ground to be hopped have prevented many a maiden from completing the task. While painters touch up the Metal Man every three or four years, the five towers have been allowed to weather naturally. To stand on the headland, especially the more isolated east headland, beneath the giant towers and experience a strong wind blowing in from the ocean can be an unforgettable experience.

Several tales of the country's rich folklore deal with Saint Déaglán, a monk who founded the monastery of Ard Mhór at Ardmore southwest of Dungarvan. Living in the late fifth and early sixth centuries, the holy man received in Rome a little black bell that supposedly descended to him from heaven. When he wanted to return to Ireland with a companion, to whom Déaglán had entrusted the little bell, he could not find a ship to take them to England and then Ireland. Suddenly an empty ship miraculously appeared and ferried them across the English Channel.

On their way to Ireland, the saint's companion mislaid the little bell on a rock. When they were out at sea and before reaching Ireland, the young man remembered the bell on the rock and told the saint, who then prayed to God. According to the story, the rock floated out to sea, and the two men then followed it to Ireland, where the saint built his monastery. Later, when a hostile fleet approached the monastery with the intention of sacking it, the holy emissary sent from Saint Déaglán raised his left hand against the fleet, which suddenly sank into the sea. The sailors were turned into stone and, according to legend, are the rocks that lie off Ardmore. Some think the bell's rock rests on two other stones on the shore at Ardmore, and sick people have been known to crawl in the passage between the rocks in order to become healed.

Further Reading

de Courcy Ireland, John. *Ireland's Sea Fisheries: A History*. Dublin: The Glendale Press, 1981.

Long, Bill. *Bright Light, White Water: The Story of Irish Lighthouses and Their People*. Dublin: New Island Books, 1993, 73.

hOgain, Dr Daithi O. *Myth, Legend & Romance: An Encyclopedia of the Irish Folk Tradition*. London: Ryan Publishing Co., 1990, 152-54:"Déaglán."

O'Neill, Timothy. *Merchants and Mariners in Medieval Ireland*. Dublin: Irish Academic Press, 1987, 114-16 [about portulans and rutters].

Rowe, David. "The Slobs of Wexford" [about the silting up of the Wexford area], *Ireland of the Welcomes*, 45, 1 (January-February 1996), 26-30.

"Tramore Beacons," *Beam* [Journal of the Irish Lighthouse Service], 3, 1 (April 1971), 22-25.

Youghal Lighthouse

7

County Cork

The sea has never been friendly to man. At most it has been the accomplice of human restlessness.

— Joseph Conrad,
English novelist

Taking its name from the Irish word for yew, a type of tree common in the surrounding area in medieval times, the town of Youghal (pronounced "yawl") had a strategic position along Ireland's southern coast that was both a blessing and a curse: a blessing because its closeness to the sea enabled its sailors to venture forth in search of fish and commerce; a curse because that same closeness to the sea led to attacks by the Vikings in the ninth century A.D., Anglo-Normans in the twelfth century, and Cromwellians in the seventeenth century. Its fortunes, which have fluctuated dramatically over the centuries, were so good in the fourteenth century that authorities requisitioned it in 1301 to help supply an expeditionary force that English King Edward I was using to invade Scotland. Medieval Youghal, in fact, was more important than Cork because of contacts with Portugal and Bordeaux.

Youghal looked to the sea from an early age for its livelihood, especially because its location on the River Blackwater enabled it to serve as a port for the produce of the Blackwater Valley and for grain-producing regions. According to L. M. Cullen's *Economic History of Ireland since 1660*, Youghal joined Cork and Kinsale as a powerful port in the southwest. The agricultural land made available after deforestation there led to increased exports of wool, cattle, and butter. Nearby is the farm where Sir Walter Raleigh, who was mayor of the town in 1588, possibly planted the first potatoes grown in Europe and introduced the tobacco plant into Ireland.

During more peaceful times the town developed a strong maritime tradition and a port from which as many as 150 sail-powered schooners ventured forth in the late nineteenth century. Its sailors became famous for the distinctive whistle they developed whereby they could recognize one another throughout the world. One of its most famous sailors was Captain George Farmer (1732–1779) of the British Navy, Horatio Nelson's

33

first captain and commander of the *Seahorse* frigate. To maintain its fortifications, the English king in the thirteenth century allowed Youghal in its city charter to tax herring, salmon, and other fish caught nearby.

The town's reliance on the sea was hurt in the twentieth century with the silting up of the nearby estuary and the building of steam-powered freighters that could pick and choose their ports of call rather than relying on the wind to determine where they would land. Like many small ports throughout the world, Youghal has suffered from the worldwide tendency of tradesmen to abandon the smaller harbors in favor of a few large ports with modern docks and facilities. Also, the expansion of the railways in the second half of the nineteenth century and the increasing reliance on road transport to haul heavy goods made coastal ports like Youghal obsolete; whereas, up to then they had thrived since large goods could be transported more cheaply by sea than by land. Today, one can see in the harbor area reminders of the town's varied maritime tradition in the memorial to the *Nellie Fleming*, the last old sailing vessel from the town, and also Moby Dick's Pub with its many photographs of local filming of the 1954 movie, *Moby Dick*.

Located on the western shore of the estuary flowing out from the River Blackwater and between the counties of Cork and Waterford, Youghal might have developed into a more important port except for several negative factors: the failure in the nineteenth century to complete a canal network for barges up the Blackwater to Mallow, forty-eight miles away; the presence of the bar in the estuary that would not allow large ships to use the port; and the delay in the building of the railway until 1860. The dangerous bar near the harbor has effectively prevented the town from competing with Cork to the west, and today the port, which does have a celebrated lifeboat station, has only a few fishing boats, a small remnant of the many ships that used to sail in and out of the harbor.

The section of coast from Waterford to Cork was long the site of shipwrecks, especially because the people at the mid-point, around Youghal, could not agree on what kind of navigational aids they should install, resulting in a darkened coast. One of the ships destroyed there in 1847 was the *Sirius*, which in 1838 had been the first steamship to cross the Atlantic westward completely under steam. An investigation into its total loss recommended that lighthouses be built along that treacherous coast.

As early as 1190, Maurice Fitzgerald had built what he called a "Light Tower" at the site where the present tower stands. He gave enough money to the nuns in the local Convent of St. Anne to maintain the light, which they did for the next 349 years, faithfully keeping the torches burning at night for passing ships. Communities of nuns could be expected to be very conscientious in the maintenance of what are called ecclesiastical lights and could take great comfort in how much they were benefiting the local town by a service that did not require them to leave their convent. Local church officials could ensure the continuous support of such ecclesiastical lights by promising indulgences to laypersons who supported the lighthouse keepers. Such a promise would have been particularly important for the nunnery at Youghal since the nuns might have had difficulty collecting tolls from ships passing in and out of the harbor. When their community was dissolved in 1542 at the time of the Dissolution of the Monasteries, the light was extinguished for the next 310 years.

As Youghal's trade increased in the nineteenth century and the local fishing fleet reached 250 vessels, local merchants and some as far away as Cork began demanding that authorities place a lighthouse near the port. Instead of wanting a tower at the site of the old nunnery light, the merchants wanted one on Capel Island at the western edge of Youghal Bay. When lighthouse officials from Dublin argued for one at the old nunnery, a twenty-year battle ensued over the best place for the structure. Dublin officials finally agreed in 1847, somewhat reluctantly, to construct a tower on Capel Island.

However, when the tower had reached a

height of six feet above the cut-stone base, the local merchants, who had been haranguing officials for twenty years to build such a lighthouse on Capel Island, changed their minds and asked for, not one, but two lighthouses, neither of them on Capel Island. Dublin officials objected to this turnaround, but in the end agreed to return to their original plan of building lighthouses at Mine Head and Ballycotton and installing a smaller light at the entrance to Youghal Harbour. Workers then built the present lighthouse on the site of the old convent, and the half-finished tower on Capel Island became a beacon used for navigation purposes and for bird-watching. Youghal Lighthouse exhibited its new light for the first time in 1852.

The lighthouse there did not completely prevent wrecks, but it no doubt lessened the carnage. One wreck that occurred eight years after the lighthouse was finished in 1852 was quite unusual. A brig, the *Echo*, on its way to Liverpool was rammed with such force at one o'clock in the morning by an unknown ship that the brig sank immediately. In violation of all international maritime rules and courtesy, "the stranger," as reported in *The Irish Times*, "continued her voyage without attempting to render the least assistance, and those who had been on board the *Echo* were left struggling in the waves." A passenger, the captain, and the second mate were drowned, but a small boat rescued the others and took them on to Youghal. The identity of the guilty ship could not be determined.

The granite white tower, overlooking the entrance to Youghal Bay and on the main highway from Waterford to Cork, has three floors, stands forty-three feet high to the top of the dome ventilator, and rises seventy-eight feet above high water. The structure, which was electrified in 1964, is considered an unwatched light, not because such lights are not carefully tended, but because they are not maintained in what the lighthouse service calls "watches," four hours on and eight hours off, as are the more important lights. Drivers coming along the highway outside the town may be surprised at what first looks, at a distance, like a miniature lighthouse on the sea-front with its nearby dwelling house. As they draw closer, they will see that the building is just off the highway overlooking the bay.

Different railway companies have tried to buy some of the lighthouse ground in order to run rail lines into Youghal, but lighthouse officials have successfully fended off their attempts, reasoning that trains might cause damage to the lighthouse structure. Because the railway station, therefore, had to remain about one mile south of the town, the suburban area developed, but the growth of the main part of the town to the north was thwarted. In the 1950s, the establishment of a textile industry in Youghal revitalized the town, but even the financial benefits of that industry will probably not lead to a great boom. The town still has basically one main street, albeit a picturesque one.

Further Reading

Beharrell, Christopher H. "A Microcosm of Munster: Youghal, Co. Cork," *Country Life*, 162 (July 14, 1977), 88-90; "Reprieve for an Irish Cinque Port: Youghal, Co. Cork," *Country Life*, 162 (July 21, 1977), 180-82.

Costeloe, M.P.L. "Capel Island," *Beam*, 3, 3 (December 1971), 2+; "Youghal," *Beam*, 4, 1 (August 1972), 27+.

Cullen, L.M. *An Economic History of Ireland since 1660*. New York: Harper & Row, 1972.

Hague, Douglas B. and Rosemary Christie. *Lighthouses: their architecture, history and archaeology*. Llandysul Dyfed, Wales: Gomer Press, 1975, 14-16.

Long. Bill. *Bright Light, White Water: The Story of Irish Lighthouses and Their People*. Dublin: New Island Books, 1993, 74-78.

"Running Down of a Ship, and Loss of Three Lives," *The Irish Times*, February 21, 1860, 4.

BALLYCOTTON ISLAND LIGHTHOUSE

8

County Cork

Far-off cows have long horns.

— Irish proverb

Just to the east of Roche's Point and southwest of Youghal is Ballycotton, the site of a lighthouse warning ships to keep away from the dangerous shores that wrecked many vessels up into the mid-1800s. Like many areas in Ireland, Ballycotton has had fluctuations in its economy, often depending on political and military conditions in southern Ireland. The Ballycotton area differed from other coastal sites in that it did not have a port that could equal Waterford or Wexford or even the smaller Youghal and Kinsale, although its geographical position between rich agricultural lands and prime fishing grounds increased the traffic of ships offshore. The three nearby towns of Cork, Kinsale, and Youghal prospered as important ports because of the agricultural holdings on their landward side, land that was converted from forests to farms with a resulting increase in the export of large amounts of wool, cattle, and butter, all of which increased the importance of the waters in the Ballycotton Island area. Those waters became famous for some of the largest fish caught in the British Isles, including halibut, cod, skate, and blue shark, while its fishermen, for some unknown reason, became known for their total abstinence from liquor.

More recently the offshore waters have been used by ships from the Royal Naval facility at Haulbowline Island in Cork Harbour. After the Royal Navy transferred the facility there to the Irish government in 1938, maritime officials made good use of it. During World War II, even though Ireland remained neutral, the Irish government established the Marine and Coastwatching Services in 1940, took over the old Royal Naval Repair and Victualling Yard and Naval Hospital on Haulbowline Island, and sent out her ships to patrol the area, protect navigational aids, enforce the country's fishing limits, rescue shipwreck survivors, and ward off unfriendly ships. And that area, as well as other Irish sites, had its share of such ships. In the first weeks of the war, a German U-boat sank the Cunard passenger liner SS *Athenia* two hundred miles off the west coast of Ireland, and another U-boat sank the British air-

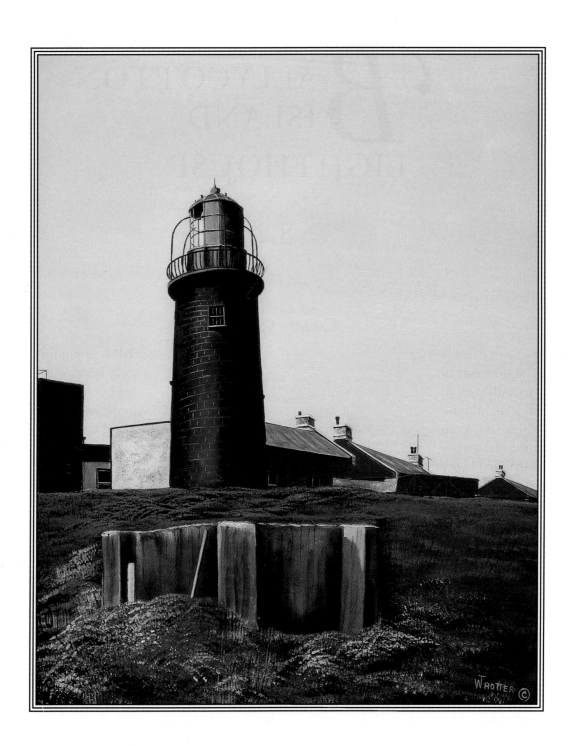

craft carrier HMS *Courageous* off the southwest coast. Many Irish came to realize how their island status made them particularly vulnerable to outside forces. Since World War II, Haulbowline Island has been the operational base, dockyard, and training center of the Irish Naval Service (as the improvised wartime Marine Service became in 1946) and also the site of Ireland's only steelworks, all of which made the southern waters busier.

In 1847, four years before the lighthouse was built at Ballycotton, the steamship *Sirius* ran aground west of there in dense fog and, in attempting to refloat her on a high tide and run her into Ballycotton Harbour, the captain managed to wreck the vessel on the nearby coast. That well-known steamship, which in 1838 had become the first to cross the Atlantic Ocean westward completely under steam, led to recommendations that two lighthouses be built in the area: one at Ballycotton and one south of there. As is true throughout the history of Ireland and other maritime countries, different factions argued strongly for officials to establish lighthouses at many different places along the coast. Local harbor officials and mariners and politicians, interested in serving the people but also saving money, all had their own agendas. In the end the lighthouse officials had to decide what was best for the country as a whole. The increased use of ships along this southern coast led to many requests for lighthouses, and officials finally built two of them, which began operating on the same day in June 1851: the Mine Head northeast of Youghal and the Ballycotton.

Two of the owners of Ballycotton Island were the Bishop of Cork and the Archbishop of Dublin, both of whom received one shilling in the sale of the island to the Ballast Board of Dublin. The great Irish designer of such towers, George Halpin Sr., designed the Ballycotton Island Lighthouse and the keepers' quarters. Partly to save money and because locally obtained raw materials might be better expected to withstand harsh conditions, officials used red sandstone that workers quarried on Ballycotton Island itself. Engineers were also able to take advantage of the latest developments in lighting apparatus and installed a multiple-wick oil lamp whose powerful beam was visible for eighteen miles in clear weather. The tower is fifty feet high, while the light is 195 feet above high water.

The importance of that sea area is such that a lightvessel with a red flashing light was stationed there even after the lighthouse was built. The lightships stationed there included the *Gannet*, the first one there (in 1874) which collided with a ship in 1883; the *Puffin*, which sank with all hands lost during a storm in 1896; and the *Daunt* (named in honor of the nearby dangerous Daunt Rock), which was torn from its moorings by fierce storms in 1936. When that last lightvessel was torn off its moorings, it posed a great danger to ships expecting the lightvessel to be in a certain place and to the eight men aboard the *Daunt*. At great risk to themselves, a lifeboat crew from Ballycotton spent three harrowing days before successfully rescuing the lightvessel's crew.

The color of the Ballycotton Island Lighthouse changed from a natural stone color to one with a black band around the middle to a completely black paint job over the entire tower with white walls around it. Painting the tower all black was done to ensure that mariners did not confuse the tower with others in the vicinity, especially the Capel Island beacon. The use of an all-black tower is somewhat unique for lighthouses, but using an all-white structure against the sky would make the tower less visible and identifiable to mariners at sea.

In looking at the Ballycotton Island Lighthouse site, some people may have thought that living on the island was easy, but it had its difficulties. Several families living in confined quarters (the keepers' houses on a small island) subject to fierce weather (storms, unrelenting wind, incessant rain, huge waves) and frequent isolation is difficult indeed. As Tony Parker described in his *Lighthouse* (13), the time to visit such a site would be ". . . not in the summer like the visitors when they come out in the pleasure boats to take pictures of us like we were performing animals in a circus; [you should visit] in the winter so you'd get the proper

picture." A fierce storm in 1894 finally convinced authorities to allow the families of the four keepers to live on the mainland, something which led to a well-deserved improvement in their living conditions and to better school attendance by the keepers' children who used to make the trip to the mainland school every day, weather permitting.

In 1963, the Ballycotton's keepers rescued four Dutch fishermen whose boat was swept into the rocks there. With great difficulty and some risk to their own lives, the keepers reached the fishermen and carried them up the steep slope to the safety of their residence. In 1975, workers converted the light to electric and built a helicopter pad so that access to the light would not be limited by rough seas. The tower became fully automatic in 1992, at which time the keepers packed their goods and left the island, a scene recorded on the cover of Pádraig ÓLoingsigh's *The Book of Cloyne*. Today an attendant who lives on the shore visits the tower twice a month. The lighthouse service sold three of the keepers' houses in 1973, but kept the fourth house for a staff holiday house for use in the summer.

While the lighthouse was an important aid to navigation, mariners also felt the need for a fog bell in the vicinity, especially because of the heavy fogs that blanketed the area. In 1856, workers installed a fog bell, which lasted until 1909, when a reed-horn signal replaced it. In 1924, an "A"-type diaphone replaced the reed-horn signal, but kept the same character as the reed horn: six blasts every two minutes.

Another structure in the vicinity that has helped mariners was a lighthouse without a light: Power (or Poer) Head to the west. Before it closed in 1970, this station did not have a light, the only manned post in the Irish lighthouse service without one. From its founding in 1879, it remained a very effective, although (to those living on the landward side) a noisy, fog-signal station.

Finally, Ballycotton is the site of author Patrick Galvin's poem, "The Wall," concerning a mythical wall around which the villagers would gather to share the news and gossip, to comment on the weather, and to tell stories. People would place a stone on the wall when someone from the village died: a small pebble for a child, a stone for a man, and two stones for a woman. Some people drew faces on the wall, names, small boats, storms, even a picture of a lighthouse, perhaps the one that beckons in the distance.

Further Reading

Costeloe, Michael. "Ballycotton," *Beam*, 20, 1 (December 1991), 5-7.

Cullen, L.M. *An Economic History of Ireland since 1660*. New York: Harper & Row, 1972.

Galvin, Patrick. "Ballycotton" [about the poem, "The Wall"], *Ireland of the Welcomes*, 36 (1987), 19-20.

Langmaid, Captain Kenneth. *The Sea, Thine Enemy: A Survey of Coastal Lights and Life-boat Services*. London: Jarrolds, 1966: 148-55 [the *Daunt* lightship].

Long, Bill. *Bright Light, White Water: The Story of Irish Lighthouses and Their People*. Dublin: New Island Books, 1993, 78-81 [Ballycotton], 81 [Power Head].

McIvor, Aidan. *A History of the Irish Naval Service*. Dublin: Irish Academic Press, 1994, 71-72 [about Haulbowline Island].

Loingsigh, Pádraig Ó. *The Book of Cloyne*. Midleton, Litho Press, no publisher, no date. See Sheila Egan,"Ballycotton," 201-15, and R.H. Mahony, "The Daunt Rescue," 219-28.

Parker, Tony. *Lighthouse*. New York: Taplinger Publishing Company, 1975.

ROCHE'S POINT LIGHTHOUSE

9

County Cork

The estuary of the River Lee in southern Ireland forms Europe's largest natural harbor, a fact that helped Cork become Ireland's third largest city (after Dublin and Belfast). The area's long maritime history includes Viking raids in 860 and an Anglo-Norman invasion in 1172. In 1669, William Penn sailed from Cork Harbour to America to begin the settlement that would honor him: Pennsylvania. In the 1770s, many ships of England's Royal Navy assembled near Cork for the long trip across the ocean to fight in the American War of Independence. In 1838, the Cork-owned steamer *Sirius* became the first scheduled steamship to carry passengers across the Atlantic Ocean. Although the ship was wrecked near Ballycotton nine years later, she helped to pioneer the fast, engine-powered transportation of thousands of Irish emigrants to the New World. Cork's port is Cobh (pronounced "Cove"), once known as Queenstown, which used to be the calling port for such big liners as the *Lusitania*,

In consequence, Cork became one of the most important ports of call in north Europe. . . .

— John de Courcy Ireland,
Ireland and the Irish in Maritime History

Mauritania, Titanic, Olympic, and *Celtic,* especially during the 1900–39 period.

The maritime economy of many Irish cities, including Cork, has fluctuated greatly, often depending on what happened elsewhere, especially in London. Time and time again, English commercial lobbies in London were able to put restrictions on Irish trade that damaged Irish commerce. One time, though, the exact opposite occurred. When a ban on cattle exports to Britain took effect in 1663, resourceful entrepreneurs in Ireland slaughtered the animals and salted the meat in Irish communities, thus averting the export of live animals. Cork, in particular, profited immensely from this practice as ships stopped there before long voyages to stock up on the salted meat.

Part of Cork's maritime history in the eighteenth century involved smuggling, both because the city was distant from the tighter British patrols of the Irish Sea and possibly because customs officials were easily bribed. In any case, Cork mer-

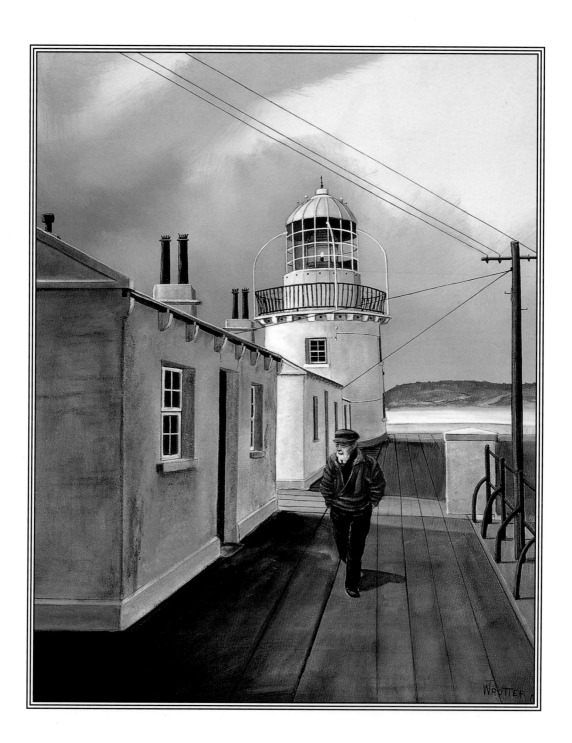

chants made huge profits by illegally importing products like tea, tobacco, and wines. Part of the advantage that Cork and other Irish cities had was that, while technically subject to trade regulations passed in London, the Irish Parliament in fact controlled its own tariff schedules and its own laws dealing with customs administration and enforcement. One Irish jury dismissed a charge of smuggling against a local person on the grounds that the defendant had violated an English law, not an Irish one, showing that Ireland sometimes enjoyed greater freedom from English laws than did overseas colonies.

Cork merchants devised many means to smuggle goods, such as wool. One favorite method was to use an innocent person, one not suspected by coastal patrols of being a smuggler, to be the nominal captain to clear Cork Harbour with ballast. Once outside the harbor, the real captain would take charge, run the ship into a coastal village for a supply of wool, and proceed to France with the illegal cargo. Another method was to bribe the commander of a patrol ship to ignore the smugglers or to actually help in the smuggling. In at least one instance, an Irish mob attacked a customs officer, dragged him through the city with a rope around his neck, cut out his tongue, nailed it on the Cork Exchange, and threw the man into the river — all of which led to the man's death and the probable discouragement of other customs officials in their attempt to stop smuggling.

The city's economic fortunes have fluctuated greatly in the last two hundred years. Thousands of Irish emigrants left Cork for better prospects elsewhere, including Dublin, and factories have closed. The Ford factory set up by Henry Ford (who was born in Ballinascarty southwest of the city) as his first overseas factory (1917) closed in 1980, as did the Dunlop Tire plant, and the city lost its important shipbuilding industry in the 1980s. The Royal Naval facility at Haulbowline Island in Cork Harbour brought much commerce to the area in World War I, but its later withdrawal resulted in the loss of many jobs. With a population of 140,000, one-eighth that of Dublin, Cork

has struggled to maintain its own identity. High-tech firms have recently been established there, especially in pharmaceuticals and electronics, and its location on the southern coast on the ocean has made it attractive for foreign investment. Funds from the European Union have helped the city build new ring roads and start building a tunnel under the River Lee, giving hope to those seeking an economic revival in the region. The city would suffer a great blow, however, if it were to lose its steelworks, the only one in Ireland.

As Cork Harbour grew in importance, it became clear that the area needed a lighthouse. King Charles II granted a patent to Sir Robert Reading in 1665 to build six lighthouses, one of which was at the nearby Old Head of Kinsale. To build and maintain these lighthouses, Sir Robert and other patent holders were allowed to levy a charge of two pence (2d) per ton on all vessels entering or leaving the affected ports. The patent holder, after paying twenty pounds per year to the exchequer, could levy the fees for thirty years after first paying the fee.

Historians have pointed out that those fees were certainly collected in Cork because in 1780 the local officials, in petitioning Parliament for lighthouses in the harbor, stated that they had collected 160 pounds per year for the maintenance of lighthouses. Such a petition indicated that the harbor must have already had some lighthouses, but that local merchants wanted a better lighting system for the port. At any rate, as happened so often, Parliament did nothing to alleviate the situation for many more years, despite the fact that Cork continued growing in importance as a port. Cork may have been the major Irish import center for wine from Europe, and it was the export city for huge quantities of butter shipped to Portugal and other continental countries from the seventeenth century through the early nineteenth, which explains the presence of so many Irish and their descendants in Portugal to this day.

In petitioning for a more powerful lighthouse, local officials could point out that the entrance to the harbor already had a tower: the

thirty-five-foot-high Roche's Tower on Roche's Point; its base stood forty-six feet above the water, high enough for a relatively low-powered light to be seen by ships entering and leaving the area. Apparently, either Edward Roche or his father had built the tower as part of a banqueting, pleasure house; they could use the tower to keep track of ships sailing in and out of Cork Harbour. To get permission to install a lantern in the tower, officials tried with much difficulty to contact the watchtower's owner, Edward Roche of Trabolgan, who lived in Italy, possibly as a prisoner after being a soldier of fortune. Negotiations took several years; finally in 1815 workers were able to begin building a new tower whose lantern was ninety-two feet above high water.

When officials determined that the increased traffic of the harbor made the lighthouse inadequate, workers built the present lighthouse in 1835, dismantled the old one three years later, and removed it stone by stone to Duncannon North, where it fit well. Three years later, the first steamship to cross the Atlantic westward, the *Sirius*, left Cork. The success of the *Sirius* in the transatlantic trip was used in the mid-1800s to support the idea of a Cork line to America, and many emigrants used that line to seek better opportunities. The Roche's Point Lighthouse was automated in 1995, at which time the lightkeepers were withdrawn and most of the buildings on the site were sold at public auction. An electric fog signal with a range of four nautical miles replaced the old, pneumatic fog signal, an action that did not please the local residents, who had grown attached to the old familiar signal.

Also under the jurisdiction of the Commissioners of Irish Lights is the Charlesfort light, which has helped mariners leaving and entering the harbor of Kinsale since the sixteenth century.

One of Cork's fascinating maritime customs is "the throwing of the dart" by Cork's mayor. Held every three years as a way to show the jurisdiction of the mayor and other officials over the port and harbor, the ceremony consists of the officials going out to the mouth of the harbor and throwing a four-foot-long arrow into the water.

Finally, the maritime history of Cork/Cobh helps explain the reluctance by Ireland for so many centuries to take better advantage of the sea. Much of Irish history has revolved around agriculture, partly because the Irish long depended on England for protection from sea invasion and, therefore, tended to develop their farms rather than their fishing. Also, so many Irish emigrated by sea that those left behind looked on "the wretched sea" as something which took many Irish away. Some scholars also believe that the isolation that Ireland willingly chose in the 1920s and 1930s led to a suspicion of the outside world, including that which the sea brought in.

Further Reading

de Courcy Ireland, John. *Ireland and the Irish in Maritime History*. Dublin: The Glendale Press, 1986.

Donnelly Jr. James S. *The Land and the People of Nineteenth-Century Cork*. London: Routledge and Kegan Paul, 1975.

Fahy, Angela. "Residence, Workplace and Patterns of Change: Cork 1787-1863," in *Cities and Merchants: French and Irish Perspectives on Urban Development, 1500-1900*, edited by P. Butel and L.M. Cullen. Dublin: Trinity College, 1986, 41-51. See also John B. O'Brien, "Merchants in Cork Before the Famine," 221-30; and Maura Murphy, "Cork Commercial Society 1850-1899: Politics and Problems," 233-44.

James, F.G. "Irish smuggling in the eighteenth century," *Irish Historical Studies*, 12, 48 (September 1961), 299-317.

Long, Bill. *Bright Light, White Water: The Story of Irish Lighthouses and Their People*. Dublin: New Island Books, 1993, 82.

Mould, Daphne Pochin. "Full Steam Ahead!" [about the *Sirius*], *Ireland of the Welcomes*, 37 (1988), 23-27.

O'Sullivan, William. *The Economic History of Cork City from the Earliest Times to the Act of Union*. Cork: Cork University Press, 1937, esp. p. 211 about the local lighthouse.

OLD HEAD OF KINSALE LIGHTHOUSE

10

County Cork

The captain of the *Lusitania* maneuvered his Cunard liner close to Ireland's Old Head of Kinsale peninsula in order to take his bearings, although being that close to the Irish coast was not safe in May of 1915. The tall, stately lighthouse, representing as it does for many security and safety, would witness one of the worst maritime disasters ever and one that would have a great impact on World War I. The area, in fact, has seen more than its share of tragedies on both sides of the peninsula, the seaward and the landward. In 1601–1602, when the Spanish occupied Kinsale in preparation for an invasion of England but were beaten by the English army during a long siege, an army of Irish soldiers under Hugh O'Neill tried unsuccessfully to lift the siege; their defeat was the start of the decline of Irish power and led to the long domination of the Irish by England. Later that century, in 1689, James II

At 1:30 P.M. First Officer Hefford and Albert Bestic finished lunch and went to the bridge to relieve Jones and Lewis. The distinguishing marks on the lighthouse were now plainly visible, and they identified the outline of the Old Head of Kinsale.

— Des Hickey and Gus Smith,
Seven Days to Disaster: The Sinking of the Lusitania

(1633–1701) landed there in an unsuccessful bid to regain his English kingdom, which he had lost by an unpopularity compounded by his conversion to Catholicism. If either of those invasions had been successful, the history of England (and Ireland) would have been quite different.

Like many peninsulas along the coast of Ireland, the Old Head of Kinsale juts out into the sea and offers both danger to the unwary and the site of a welcome lighthouse. Visitors in the nineteenth century noted that the local churchyard had many gravestones inscribed only with the fact that the interred had washed up on shore. Long before then, in the fifteenth century, Kinsale had become infamous as a pirate hangout and a market where pirates could dispose of their stolen goods.

The steep, rocky cliff on the peninsula is the site of an old Celtic settlement, no doubt chosen

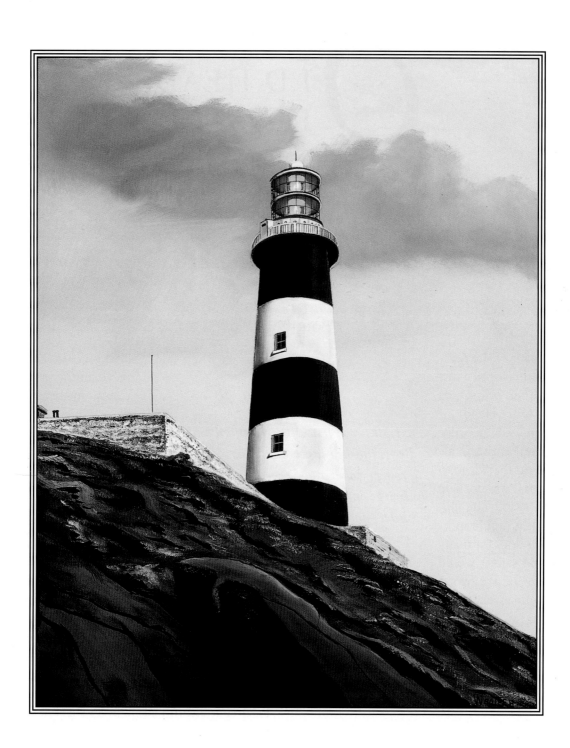

for its remoteness. Two older lighthouses, one from the seventeenth century and the other from the eighteenth century, stand behind the present one. An earlier pre-Christian beacon on the site may also have warned ships to keep away or, according to local legend, may have lured unsuspecting ships onto the rocks — to be stripped by wreckers.

The seventeenth-century tower, like many of the first lighthouses in the British Isles, was privately owned. In 1665, King Charles II had granted a patent to Sir Robert Reading, a member of the Irish Parliament in the 1660s, to build six coal-fire lighthouses, one of which was at the Old Head of Kinsale. Entrepreneurs built such lighthouses near busy harbors, not only because many ships used those ports, but also because the owners of the towers could more easily collect tolls and operating fees from mariners using the port rather than trying to collect the money from ships passing offshore.

Instead of conscientiously maintaining his new, coal-burning towers and charging a reasonable fee, Reading neglected the structures, but still insisted on exorbitant fees from boat passengers and fishing boats. When the ship owners of Chester and Liverpool complained that the dues imposed on them to maintain the lighthouses were a great burden, the British Parliament exempted English and Irish shipping from paying the dues, but granted Reading five hundred pounds a year compensation. However, so many people complained that Reading eventually had to give up his patent, and the Kinsale lighthouse was allowed to deteriorate, especially as the port there declined in importance. After concerned citizens complained in 1703 that the lighthouse had not been working for the previous twenty years, state commissioners took over the running of the lighthouses and brought order to the maintenance of navigational aids.

What's left of the peat-burning lighthouse about a mile north of the present lighthouse on that remote peninsula is the best extant example of such buildings. The architecture of the building resembles the early Irish oratories, especially in their stone-vaulted roofs. The house itself had three rooms, one of which stored the fuel. The stone-vaulted keeper's cottage had stone stairs leading up to a small platform on the roof where the attendant burned coal, peat, turf, or wood in an open fire. Wood was the first fuel used in lighthouses because of its availability, but the wet conditions in Ireland must have made wood-burning a difficult task. Also, the windy conditions on the peninsula would have made the fire burn more rapidly and intensely.

Coal became a more popular fuel because of its great availability in Europe and because of the ease in igniting it in comparison to damp wood. Mariners preferred coal-burning beacons over wood-burning ones because the former had a greater range of visibility. Candles later became popular for lighthouse use because of the illuminant-value for their weight and because they were relatively cheap and easily portable, although they did burn down quickly. From 1703 to 1714, the keepers at Kinsale substituted candlelight for the open fire, but found the candles unsatisfactory and eventually returned to the open fire.

The Ballast Board in the early 1800s determined that the site needed a better lighthouse and had its great designer, George Halpin Sr., build one. The new structure began working in 1814 and could be seen twenty-three miles away in clear weather, but, as time went on and mariners realized that fog and low clouds could obscure the 294-foot-high light, officials determined that the tower was too high. In 1853, workers built a new 95-foot-tall lighthouse and lowered the older tower so as not to confuse pilots offshore. Forty years later a fog signal was installed along with a fog-signalman. The light and fog signal were upgraded over the next century, and in 1987, the light became unwatched automatic. An attendant, who lives at the site, takes care of the mechanism today.

Near the lighthouse was a signal station operated by Lloyd's of London until 1922. At a time when few ships had radios and, therefore,

depended on visual signals from the shore while they were at sea, Lloyd's had set up this signal station in order to have spotters record the passage of all ships offshore and to signal necessary information or directions to the pilots. Ships would sail close to shore to signal their identity, their port of departure, and their eventual goal, and would receive any important information by flag signals, semaphore, signal lamp, or Morse code. Those onshore would telegraph the London headquarters of Lloyd's as to the identity and direction of each ship passing offshore.

On May 7, 1915, the *Lusitania*, on her way from the United States to England, sailed nearer the Irish coast than was safe, but the captain was determined to find out exactly where he was by taking a bearing from the lighthouse. When the officers sighted the three-mile-long peninsula and its reassuring lighthouse, they knew that the port of Queenstown (Cobh) was only thirty miles away. They felt much safer, but lurking beneath the water was a German U-boat with a deadly mission. When the German captain sent a torpedo into the unsuspecting ship and sank it, over eleven hundred people lost their lives, a tragedy that helped galvanize American opinion to enter the war against Germany. That sinking also made clear to many how important Ireland's waters were in the maritime history of the world and how necessary were navigational aids.

The principal keeper at the lighthouse re-ported the sinking of the liner to the admiral in charge of Queenstown (Cobh), who mobilized rescue boats to save as many as possible. Today, one can see in Casement Square of Cobh a memorial to the victims of the sinking, many of whom are buried in the old church cemetery in Kinsale. The liner lies at the bottom of the sea about twelve miles south of the lighthouse in 320 feet of water, and divers should be aware of legal claims on the ship before attempting the difficult dive. Interestingly enough, after the U-boat returned safely to Germany, the man who had torpedoed the *Lusitania*, Raimund Weisbach, returned to the sea and, in 1917 off the southwest coast of Ireland near Fastnet Lighthouse, was captured by the British after one of their submarines had torpedoed his new submarine, *U81*. Albert Bestic, one of the junior officers on board the sinking *Lusitania* swept overboard by the inrushing water, later in World War II survived an attack by German aircraft on the Irish Lights ship, *Isolda*, off the Irish coast.

Today, students enrolled at the nearby Kinsale Vocational School might be expected to rely on the lighthouse as they learn how to maneuver in their training vessel, *Solveig*. And if the Kinsale area has lost its importance in trade and commerce, yachtsmen and sailors off the coast continue to rely on the tall, black-banded white tower that rises majestically from the surrounding rock.

Further Reading

Costeloe, M.P.L. "Old Head of Kinsale," *Beam*, 18, 1 (December 1989), 22-23.

"From Open Fires to Headlamp Arrays," *Country Life*, 181 (April 30, 1987), 134-35 [about the old peat-burning lighthouse].

Hague, D.B. "Irish Brazier-Lighthouses," *The Keeper's Log*, 7, 1 (Fall 1990), 24-25 [about the first lighthouses at Old Head of Kinsale].

Hickey, Des and Gus Smith. *Seven Days to Disaster: The Sinking of the Lusitania*. New York: G.P. Putnam's Sons, 1981.

Long, Bill. *Bright Light, White Water: The Story of Irish Lighthouses and Their People*. Dublin: New Island Books, 1993, 83-87.

Luxton, Edward J. "Life at the Old Head of Kinsale, 1917-1922" [about the Lloyd's of London signal station there], *Beam*, 12, 1, 58-60.

Nikitas, Theano. "American, British Divers Visit the *Lusitania*," *Underwater USA*, August 1994, 6-7.

O'Neill, Timothy. *Merchants and Mariners in Medieval Ireland*. Dublin: Irish Academic Press, 1987, 128-29 [piracy in Kinsale].

Silke, John J. "Spain and the invasion of Ireland, 1601-2," *Irish Historical Studies*, 14, 56 (September 1965), 295-312.

Simpson, Colin. *The Lusitania*. Boston: Little, Brown and Company, 1972.

GALLEY HEAD LIGHTHOUSE

11

County Cork

One man's meat is another man's poison.

— Irish proverb

Ireland has always been plagued by shipwrecks, especially in the days before lighthouses dotted its coast, but an attitude developed in the country long before rescue services existed that might seem callous to some. Those who saved a drowning person or came upon a live person washed up on shore were supposed to care for him, but could take the person's property for their own use. Shipwrecks played an important part in the economic life of Irish coast towns and could be the difference between a town's surviving or dying, especially during the devastating potato blight. A ship's misfortune often proved providential for nineteenth-century Irish towns. For example, in the Wexford area west of Carnsore Point when a shipwreck washed ashore in 1852, a large quantity of maize meal staved off starvation.

One place that saw many shipwrecks was Galley Head on the southern coast between the great lighthouses at Fastnet and Old Head of Kinsale. Galley Head resembles many headlands that jut out into the sea and, therefore, need to be lighted for passing ships. Although called Dundeady Island, Galley Head is actually part of the headland about five miles southeast of the town of Ross Carbery on Rosscarbery Bay in County Cork.

As at many places along the coast, it took years of petitioning by the local populace before the lighthouse service would build a tower there. The local nobleman, Lord Bandon, alerted authorities to the shipwrecks off the coast and encouraged authorities to place navigational aids in the vicinity. Finally, in the 1870s, the Engineer-in-Chief of the Commissioners of Irish Lights, J. S. Sloane, designed a tower and its nearby buildings, which were built in 1878. The tower stood sixty-nine feet high at the edge of the cliff and could be seen for nineteen miles in clear weather. In 1907, workers installed a new, more powerful light, one that could be seen twenty-four miles away at sea. The crucial position of the lighthouse convinced authorities to increase the power of the light when they converted it to electric in 1969, and mariners could then see it twenty-eight miles

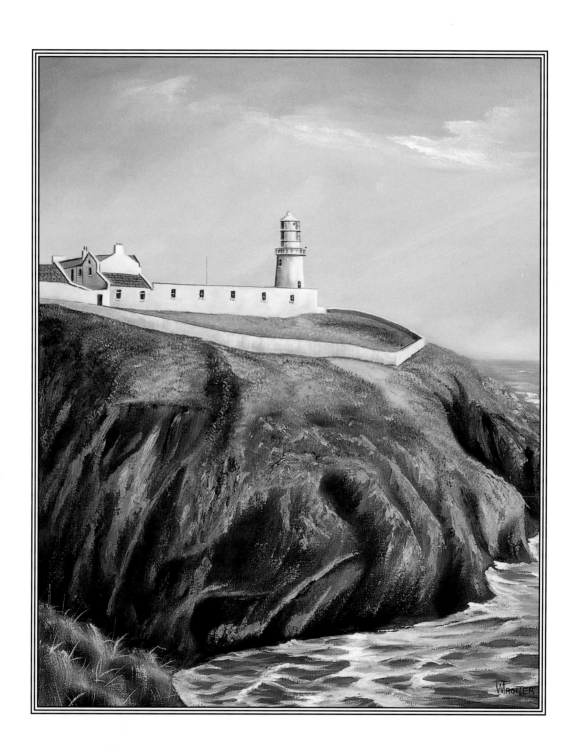

away. Finally, workers automated the structure in the 1970s as part of the Irish Lights' project of reducing costs.

When the lighthouse was first built in 1878, engineers used gas there for lighting the lantern. At that time, John R. Wigham of Dublin was experimenting with using a multi-jet burner fed by coal-gas that could be manufactured at each site. Dublin's Baily Lighthouse had first used gas successfully in 1865, after which time Wigham used several Irish lighthouses to conduct his experiments. He installed an intermittent gas light at Wicklow Head and a group-flashing light at the Rockabill tower, the success of which led to the introduction of gas lighting at lighthouses around the British Isles. The lighting structure consisted of four tiers of superimposed optics. Only one tier would be lit at first, but, as weather conditions deteriorated, additional tiers would be lit for a maximum light. Eventually, the high cost of producing the gas led to its being replaced by vaporized paraffin, but if North Sea gas again makes the use of gas feasible, engineers may return to this successful method that Wigham developed in Ireland.

One unusual point about the lantern at Galley Head is the fact that not all of its faces are darkened toward the land. Six-and-a-half faces that point toward the sea are clear, enabling the light to shine forth, and nine-and-a-half faces that point to the land are darkened, which is normal, but several of the panes in two of the faces toward the land are clear, enabling people on land to see the light. Local tradition claims that the Sultan of Turkey, while visiting Lord Carbery at Castle Freke, asked why the lighthouse did not shine onto the land at all. Lord Carbery then had workers install several clear glass panes on the land side of the tower. When the tower was converted to electric light in 1969, workers painted the clear glass panes so that the bright light would not cause a sudden blinding light for passing motorists.

Which brings us to one of the problems that most lighthouse keepers have faced: the crashing of birds into the towers at night. Because light

sources often attract birds, thousands have died when they flew into the lighthouse lanterns or structures. Those towers in the direct path of annual migratory routes are the ones that birds usually crash into. Much research has gone into the prevention of these bird collisions. The use of protective netting around the lanterns, decoy owls to frighten away smaller birds, and horizontally placed netting at the base of the tower to catch falling birds have been tried, but the problem will probably remain for the foreseeable future.

The lighthouse compound at Galley Head is an example of what many designers have wanted for their towers: a virtually self-contained village for the keepers and their families. The white wall around the outskirts of the property keeps out unwelcome visitors and protects the inhabitants, especially children and small animals, from tumbling into the sea below the sheer cliffs and also protects the enclosed gas-works from intruders. The tower itself is connected by a 125-foot corridor to a semi-detached, two-story building that housed the gas maker and gas-works behind the keepers' dwellings. The isolation of the site, away from large towns and a railway line, enables the light, which has been automated since 1979, to be clearly seen at night. At some sites, background lights from the town or a railway, for example, the signal lights on the Dublin, Wicklow, and Wexford Railway, have caused problems to navigators offshore.

The lighthouse keeper at Galley Head may have witnessed an amazing sight in 1916 when British destroyers chased a German ship disguised as a Norwegian steamer. The ship had sailed from Germany with a large cache of arms for use by Irish nationalists intending to stage an uprising that would force the English to redeploy thousands of troops from the Western Front to Ireland. When the ship failed to unload the weapons and ammunition in Tralee Bay (see Chapter 17), it sailed south around Ireland. When British destroyers intercepted it eighteen miles west of Skellig Rock, they allowed it to continue sailing east, where it passed Galley Head on its way to

Cork Harbour, near which the German commander detonated explosives that blew up the ship in a vain attempt to block the channel to ships using the naval base there.

The area along the West Cork coast has long been blessed, as has much of the Irish coast, with an abundance of fish. To take advantage of those fishing grounds and to teach more Irishmen how to succeed in fishing, the very generous Baroness Burdett-Coutts in 1887 founded at Baltimore, to the west of Galley Head, the first Industrial Fishing School ever established. The lighthouse at Galley Head would have been important to the youngsters who were learning the rudiments of fishing, seamanship, and navigation before they left the school to take up fishing in other places along the Irish coast. The school, still operating in the 1940s, trained Irish youth to engage in the profession of fishing, which had been relatively neglected over the centuries in a country surrounded by waters teeming with fish. Ireland's fishing industry had flourished in the fifteenth and sixteenth centuries and briefly in the latter part of the eighteenth, but had been cruelly hampered by British restrictions of one sort or another in the seventeenth and early nineteenth centuries.

In the 1970s, knowledgeable sea people began calling once again for the re-establishment of an Irish coast guard, which, when used in conjunction with the lighthouse system which rings the coast, would make Irish waters safer and more navigable. If the coastline had no official spotters, ships in distress might sink without anyone seeing them, as happened in February 1971, when a Greek ship off Loop Head was lost with all her crew, something which might have been prevented had there been a coast guard in the vicinity.

Finally, an incident that occurred along the southern coast of Ireland may also have been responsible for inspiring one of this century's best short-story writers to write about an Irish lighthouse. In 1860, *The Irish Times* reported that Samuel Townsend was sailing in Whitehall Harbour, west of Galley Head near the town of Skibbereen, when he saw behind his boat a sea serpent about twenty-five to thirty feet in length with large yellow scales. A group of people in another boat near Townsend also saw the same serpent, which at one point raised its neck about six feet above the water. The people in the boat were so frightened that one of them fired at it with his gun and scared it away. Writer Ray Bradbury, who lived in Dublin in 1953, may have heard of that serpent while writing his short story, "The Fog Horn," about a dinosaur that surfaces from the sea and falls in love with a lighthouse foghorn.

Further Reading

Bradbury, Ray. *The Stories of Ray Bradbury*. New York: Knopf, 1983, 266-72: "The Fog Horn."

Costeloe, Michael "Galley Head (Dun Deide)," *Beam*, 19, 1 (December 1990), 5-6.

de Courcy Ireland, John. *Ireland's Sea Fisheries: A History*. Dublin: The Glendale Press, 1981, 78-81 [about the Baltimore fishery school].

de Courcy Ireland, John. *The Sea and The Easter Rising*. Dublin: Maritime Institute of Ireland, 1966 [about the sinking of the German ship off southern Ireland].

Long, Bill. *Bright Light, White Water: The Story of Irish Lighthouses and Their People*. Dublin: New Island Books, 1993, 87-88.

McIvor, Aidan. *A History of the Irish Naval Service*. Dublin: Irish Academic Press, 1994, 31-32 [for the story of the German ship intercepted off Galley Head in 1916].

"A Sea Serpent," *The Irish Times*, August 24, 1860, 3.

FASTNET ROCK LIGHTHOUSE

12

County Cork

Conor O'Leary wrote his ballad, "The Lone Rock," after his three sons and a son-in-law had drowned at sea near Fastnet, The Lone Rock, several centuries ago. After scrambling to safety on Fastnet before being washed away, one of the sons scratched on the rudder of their wrecked boat with the buckle of his shoe their last message that the Lone Rock [Fastnet] would be their spouse forever.

Four and a half miles southwest of Cape Clear in County Cork lies the most famous of the Irish rock stations, Fastnet, often the first landfall of the voyager from America to Europe and the last for those heading west, thus its nicknames: "the eye of Europe" and "the tear-drop of Ireland." Locals point out that the next land due south is the South Pole. Fastnet actually has two rocks: Fastnet Rock proper, which rises ninety-eight feet above low water, and Little

When I climb the hill side and the sea opens wide,
And I view the Lone Rock, 'tis as if I had died.
Back at home as I bide, my tears flow like a tide,
And the Lone Rock eternal remains my sons' bride.

— Conor O'Leary,
"The Lone Rock"

Fastnet, south of the main rock and separated from it by a thirty-foot-wide channel. Fastnet Rock, an island 340 feet by 180 feet, has very deep water surrounding it with tides rising as much as twelve feet and a tidal current reaching a speed of three knots, two factors that have caused ships to crash into the rock.

Traditions and folktales about the Fastnet include two that show the awe the rock inspires among those who live in the vicinity. One local folktale says that Satan himself plucked the Rock out of a nearby mountain and threw it into the sea. Another, noting how the Rock resembles a ship under full sail, says that the Rock pays a yearly visit to the nearby Bull, Calf, Cow, and Heifer rocks.

The Fastnet Lighthouse replaced one on nearby Clear Island in the nineteenth century because the latter was too far inshore and too high

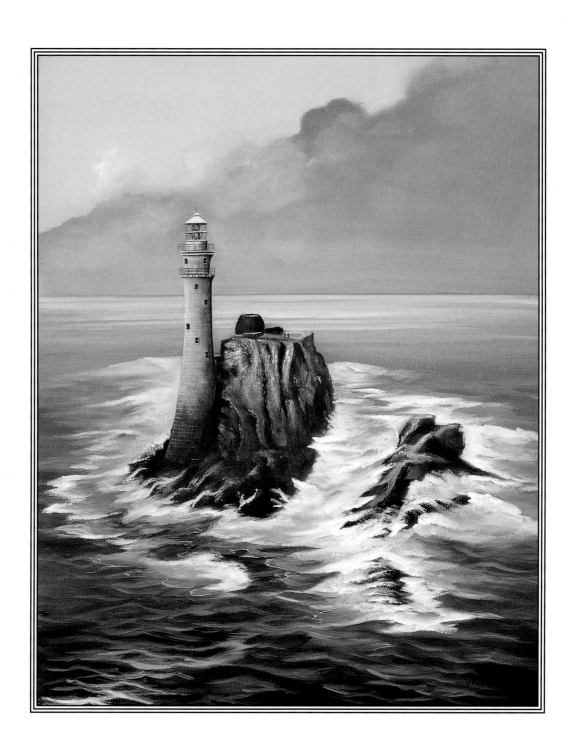

to avoid being obscured by fog and mist; ships would find themselves too close to danger by the time they saw the lighthouse on Clear Island. It took a tragedy to finally force officials to place a lighthouse in the right place to try to prevent further accidents. In November 1847, the American ship, *Stephen Whitney*, was wrecked in the area with the loss of almost one hundred lives. What probably happened was that the pilot had misread the light on Rock Island, which he apparently did not know had been built, for the Kinsale Lighthouse forty miles to the east. He sailed for what he thought was a clear path to Cork, with the result that the ship wrecked on the rocks, and many passengers and crew lost their lives. Other ships including the *Lady Flora* had wrecked there in the previous four years, but the few casualties must have deluded officials to the danger lurking beneath the turbid waters. The wreck of the *Stephen Whitney* so alarmed the country that the Ballast Board of Dublin, in charge of Irish lighthouses at that time, was forced to replace the high, ineffective Cape Clear Lighthouse.

When the decision was finally made in 1848 to build a new lighthouse on Fastnet to replace the Cape Clear one, authorities commissioned George Halpin Sr. to design the new structure. He used cast iron for the sixty-three-foot-tall cylindrical tower, which would be topped by a twenty-seven-foot-high lantern. Workers finished the oil-burning tower in 1854, soon after which Halpin died, ending a career that saw many improvements added to the country's navigational aids. The second floor of the Fastnet tower stored oil, and the keepers lived in an iron barracks, divided into three separate rooms, on the northeast side of the Rock. Three dwellings to house the lightkeepers' families were built on the mainland at Rock Island near Crookhaven. Eventually, as keepers were able to use modern transport to reach more comfortable towns inland and set up their families in more suitable lodgings than those provided by the lighthouse service, the service disposed of the lodgings at Rock Island and gave the keepers a housing allowance.

Those arriving today by helicopter at the Fastnet Rock helipad may not be able to imagine the terror felt by former visitors who had to step ashore onto the rocky ledge from a pitching boat, something which could be done successfully on only about twelve tides a year. Before the age of the helicopter, the men could be ten or more days overdue, both in going out to the Rock and in going ashore. Because of the great difficulty of bringing boats of any size alongside the Rock, workers finally built a derrick-mast, jib, and hand-winch for landing men and supplies.

In the decade after the lighthouse was built, officials realized that the structure, which was on the most exposed portion of the rock, could not long withstand the steady onslaught of the mighty Atlantic Ocean. When the seas crashed over the rock, the tower shook menacingly, huge chunks of rock dislodged from the cliff, and the keepers were sometimes unable to go from the tower to their dwelling over the external staircase. Even cups of coffee and tea on tables in the top room of the tower pitched to the floor. In one particularly fierce storm, a sixty-gallon cask of water on the top of the tower was washed away by the sea.

Instead of giving up, authorities in 1865 had workers build an external casing for the base of the tower, remove projecting parts of the rock, use concrete to fill in chasms, and make the whole structure as smooth as possible so as to offer less resistance to the waves. Workers also installed bedrooms, a living room, and a storage area in the upper part of the tower. During the repairs, in 1867, the government established a new body to take control of the country's lighthouse service: the Commissioners of Irish Lights, the organization that still maintains the country's lighthouses.

The newly strengthened tower, called "Halpin's Lighthouse" after its original designer, served mariners well for the next fourteen years. But an 1881 storm, which damaged the lens at Fastnet and destroyed the nearby tower on Calf Rock, splitting it in half along a line of bolt holes, convinced authorities that cast-iron lighthouses were not strong enough to withstand an ocean beating and that a new masonry lighthouse had to be built on the western, less-exposed part of the

Rock. It took another ten years before officials made the final decision to complete a new tower, one designed by William Douglass, Engineer-in-Chief of Irish Lights, and another four years after that before the work began. Among the preparations was the building of a shore-based headquarters at Rock Island near Crookhaven and the signing on of the steamer *Ierne* to carry the stone and other materials out to the Rock. That tender, built in Glasgow in 1898, replaced the *Moya* as the attending vessel for lighthouses along the southwestern coast and served the lighthouse service well for fifty-seven years (twice the life of the average ship) until it was replaced in 1954. The Fastnet tower was built in Cornwall from local granite, then taken apart, and refitted on the site, each granite block carefully and painstakingly joined to the next one in order to strengthen the 176-foot-tall tower against the onslaught of the sea.

Typical of the dedication of the Irish workers on that job was foreman James Kavanagh, who seldom took shore leave during the building of the tower. He set each of the building's 2,074 granite blocks in place in what was, at that time, the highest and widest rock tower in the British Isles. Such care was taken during the building of the lighthouse that no lives were lost. To ensure the longevity of the tower, workers integrated its foundation as much as possible with the rock itself and made the lower part of the tower a solid mass. They then built various levels into the tower to accommodate the keepers, the provisions, other material, and the lantern.

After many weather delays, workers turned on the new light in June 1904, and the magnificent beacon began its long history of great service. Because of the location of Fastnet Rock so near to transoceanic routes, the keepers from time to time would take on the additional duty of signalling and telegraphy to passing ships until the lighthouse was automated in 1989.

The lighthouse keepers there had a ringside view of one of yachting's most famous races, the Fastnet Race, a 605-mile run from the Isle of Wight in southern England to Fastnet and back to Plymouth. Begun in 1925, the biennial event held in August attracts around three hundred yachts. In the 1979 race, a sudden storm caused extensive damage to many of the yachts and drowned fifteen of the racers, reminding all that the ocean there was still unpredictable and highly volatile.

Finally, life at such a rock station on the western and southern coast of Ireland is presented in a play, *The Rock Station*, by Ger Fitzgibbon. The play deals with a missing lighthouse keeper, gun-running, the use of a new incandescent lighting apparatus, and the imminent arrival of the inspector. The two-man play has been well received by audiences, including lightkeepers who have experienced life at such remote outposts. Today, one can learn more about Fastnet by visiting the Mizen Head Signal Station Visitor Centre near Barley Cove to the northwest of Fastnet Lighthouse.

The Mizen Head Lighthouse, Copper Point Lighthouse, and Crookhaven Lighthouse are all under the Commissioners of Irish Lights. The first one, also known as The Mizen, began as a fog signal station (1909), then as a radio beacon (1931) and finally a lighthouse (1959). Although automated and demanned (1993), the tower between Barley Cove and Dunmanus Bay is very strategically located. A prefabricated, concrete footbridge links the lighthouse to the mainland. Copper Point Lighthouse on Long Island in Roaringwater Bay was established in 1977 and became an official lighthouse four years later. Crookhaven Lighthouse is on Rock Island facing the Fastnet. Established in 1843 at the mouth of Crookhaven Harbour and well-known to yachting people, this tower provides a great service to those seeking shelter from the fierce Atlantic storms that buffet the coast.

Further Reading

Fitzgibbon, Ger. *The Rock Station*. Cork: Meridian Theatre Co., in association with the Collins Press, 1992.

Knights, Jack. "An Awesome Warning From the Sea" [about the yachting tragedy in the Fastnet race], *Sports Illustrated*, 51 (August 27, 1979), 16-20+.

Long, Bill. *Bright Light, White Water: The Story of Irish Lighthouses and Their People*. Dublin: New Island Books, 1993, 89-106.

O'Sullivan, Donal, editor. *Songs of the Irish*. New York: Bonanza Books, 1960, 83-85: "The Lone Rock" by Conor O'Leary.

Scott, C.W. *History of the Fastnet Rock Lighthouses*. County Cork: Schull Books, 1993.

Wilson, T.G. *The Irish Lighthouse Service*. Dublin: Allen Figgis, 1968, 35-43.

Bull Rock Lighthouse

13

County Cork

Perched on top of this impressive boulder is a lighthouse [Bull Rock] that defies imagination. How the hell did they ever get the construction material up its vertical sides, constantly smacked by thunderous surf?

— Walter Schulz,
"Shannon River Pilgrimage"

Beara Peninsula is one of five fingerlike extensions into the Atlantic Ocean in the southwestern part of Ireland, the others being Dingle, Kerry, Sheep's Head, and Mizen. Beara Peninsula points toward four dangerous rocks in the ocean with very unsealike names: The Bull, The Calf, The Cow, and The Heifer. The largest is the Bull, three hundred feet above sea level and six hundred feet in diameter, which has a tunnel at water level that seems large enough to let a large boat pass through. Some say that an American destroyer actually went through it by mistake during World War I.

Among the legends associated with the four rocks is one involving Donn, one of the sons of Mil who came to Ireland in ancient times, was stricken with disease, died, and had his body placed on a high rock (Bull Rock) so as to prevent his disease from infecting Ireland. Another mythical story has Fastnet Rock visiting each of the four rocks each May Day to pay its respects before settling down for another year. What do visit there today and for the past hundreds, maybe thousands of years, are many, many nesting seabirds, especially gannets and petrels seeking isolation and safety from predators. The four rocks, sometimes barely above the waterline, have long presented a serious danger to unsuspecting ships, whether passing around those five dangerous fingers or going up Bantry Bay to the tanker terminal at Whiddy Island just northwest of Bantry or to Bere Island's former Royal Navy base, which closed in 1938.

The nearby waters of southwestern and western Ireland have steadily grown in importance since the Middle Ages when the arrival of the herring shoals brought some degree of prosperity to fishermen. As other European countries have

58

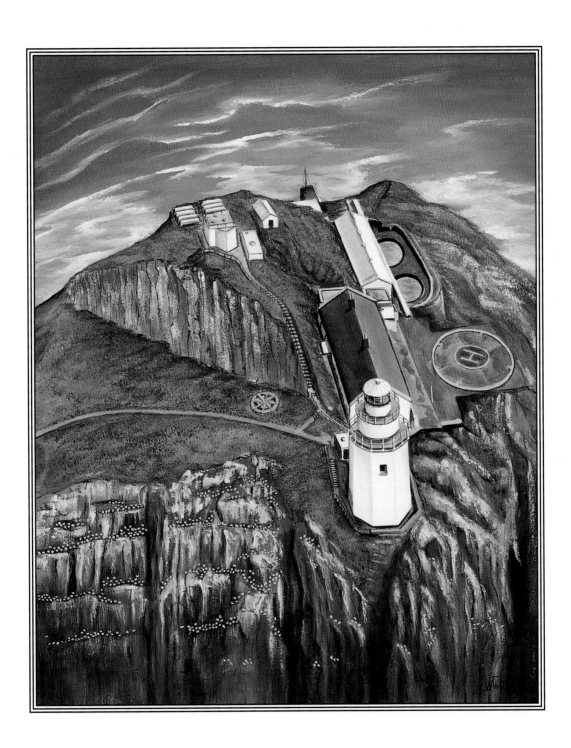

discovered this century, the ocean off Ireland's west coast teems with fish in waters that have not been polluted by factories and poor sewage facilities. Instead of relying on the export of agricultural products, subject to disease and fluctuations in the weather, Irish port towns were able to grow with the increased prosperity from the sea, but that also meant that the ships using the waters were subject to wrecking from storms and hidden rocks and sandbars.

Those who knew the area's dangers requested from an early age that some kind of lighthouse be built on one of those rocks. The history of the lighthouses there, however, is one of much delay. The builder of the first tower predicted that it was on the wrong island and would be washed away by the sea. Officials, having decided to build the first lighthouse on Calf Rock because that site is lower in height than the others, told the builder to mind his own business and build the tower. He completed the structure on Calf Rock in 1864, but it took almost another two years before he could install the light on the relatively small island, just one-half acre in size and seventy-eight feet high.

The cast-iron tower was one hundred two feet high and had a door nine feet above the ground to make it more accessible, with the help of an outside spiral staircase, during storms. Inspectors later discovered that the workers had actually built the storm shutters on the inside of the tower rather than on the outside; the large plate-glass windows shattered during a storm in the mid-1860s.

During a very bad 1869 storm, which destroyed much of the tower's balcony, railing, and sheds, the assistant keeper, who was on the mainland, misread the flag signals at the Calf and had six men row him out through high seas to the rock. When he found that the keepers there were fine, he and the six boatmen turned to go back to shore, but a huge wave capsized the boat and drowned all seven men. When the lighthouse commissioners met to decide how to recompense the families of those lost in that accident, they voted to grant one-time payments of thirty pounds to the assis-

tant keeper's widow, twenty-five pounds to each of the widows of the boatmen, five pounds to the widowed mothers of two of the boatmen, and five pounds to each child. The small amounts pointed out the helplessness of keepers' families in those days and the total inadequacy of such payments for the loss of breadwinners.

It took two more years to complete the repairs to the damaged Calf Rock Lighthouse, but the tower seemed to do well in the frequent storms that buffeted the area. However, a very bad storm in 1881 destroyed the lighthouse once and for all. The men, who fortunately had been in the lower, safer part of the tower when the upper part was torn away, painted in red on the white part of what was left of the tower the plea: "NO ONE HURT. WANT TO LEAVE THE ROCK." It took another two weeks before rescuers could reach the men and take them off the battered site. Officials gave the keepers three weeks' paid leave to recuperate from their traumatic experience and then had them resume their duties elsewhere. One can still see the ruins of the cast-iron lighthouse atop the Calf Rock, a reminder to all concerned that authorities in distant offices need to pay more attention to engineers and workers on the actual site.

Those in charge, who learned at great expense and trouble that the lower elevation of Calf Rock led to the destruction of its lighthouse, finally heeded the old prediction of the lighthouse builder that the lighthouse on Calf Rock was on the wrong island, and they agreed to build a new one on the higher Bull Rock. While work was progressing on the new tower, workers placed a temporary light from an old lightship on the western edge of Dursey Island. Finally, in 1889, the new light shone for the first time on Bull Rock, a site much higher than the one on Calf Rock, but one still subject to bad storms. In 1937, one washed over the summit of the Rock, dislodging rocks that stove in the roof of the keeper's house.

Keepers there in July 1943 might have seen or heard a German Luftwaffe Junkers plane, which was scouting out the area, crash in fog on

the nearby Crow Head to the east; all four crewmen died. Those keepers may also have worked as submarine spotters, as many keepers did around the country. The Bull Rock keepers also served as relayers of messages from those on Skellig Michael sixteen miles away. In the days before radio and telephones allowed immediate access to the mainland, the keeper at Skellig would stand before a large, white-washed rock and use long-handled semaphore signal devices to send a message to the Bull Rock keeper, who would use a telescope to read the message before relaying it ashore by semaphore by way of Dursey Island just east of Bull Rock.

Since the days of difficult, if not impossible, boat landings on the Bull Rock, a helicopter pad on the green level area at the top of the rock has made landings much easier and safer for the inspectors on their annual tour. In the construction of that helipad in 1979, a worker slipped on the wet concrete and was swept toward the edge of the overhanging pad by the downdraft of a helicopter's whirling blades. The assistant keeper, Ronald O'Driscoll, risked his own life to reach the workman, who by that time was barely hanging on to the scaffolding. For his bravery in saving the workman, the Commissioners of Irish Lights awarded O'Driscoll a Gold Medal, its highest award for members of its service.

More modernization resulted from the installation of a nearby powerful fog-signal station (1939), electricity (1974), and automatic controls to replace the keepers (1991). Today the Bull Rock Lighthouse still has the largest lens in Ireland, possibly in all of the British Isles.

Many mariners rely on the Bull Rock Lighthouse today, including the skippers of trawlers using the large fish processing plant, a joint Spanish-Irish venture, at Castletownbere in Bantry Bay. Even so, serious shipwrecks in Bantry Bay and elsewhere continue to happen. In 1979 the French tanker *Betelgeuse* blew up and polluted

the local fishing waters. Irish Lights maintains a directional light in the Castletownbere area on the northern shore of Bantry Bay, as well as a helicopter base from which it can service the offshore lighthouses.

Because the Bull Rock Lighthouse was categorized as a relieving, non-dwelling station, as were the Blackrock Mayo, Fastnet, and Eagle Island lighthouses, the lighthouse service provided accommodations in the compound itself or at a close place on the mainland, where children could attend schools and spouses could shop in stores. As elsewhere, those dwellings were often in out-of-the-way places with poor facilities. The lodgings for the families of the keepers of Bull Rock Lighthouse were at Dursey Sound to the east of Bull Rock, and, although quite handsome, were near a steep slope above the sea that was dangerous for the children playing there. As time went on and keepers received lodging allowances and could take advantage of fast transporting facilities, they chose to find their own quarters more suitable for their families away from Dursey Sound. The lighthouse service then disposed of the facilities that the keepers' families once used.

The Irish Commissioners of Lights maintain three other lighthouses in the area of Bantry Bay. Ardnakinna Point at the western tip of Bere Island has had a working lighthouse since 1965 to protect shipping in the Castletownbere vicinity. Begun in 1850 as an unlit beacon tower, the white structure throws a light over the nearby Piper Rocks. Roancarrigmore Lighthouse to the east of Bere Island has operated since 1847 and has warned countless mariners on small fishing boats, battleships, oil tankers, and Russian factory ships of the dangerous rocks there. Finally, Sheep's Head Lighthouse, a recent addition to the towers in the area, was built by Gulf Oil in 1968 to aid the giant oil tankers going into and out of Bantry Bay from the large oil terminal on Whiddy Island.

Further Reading

Healy, James N. "The Sun Over Beara," *Ireland of the Welcomes*, 22, 3 (September-October 1973), 13-18.

Long, Bill. *Bright Light, White Water: The Story of Irish Lighthouses and Their People*. Dublin: New Island Books, 1993, 112-17.

Myles-Hook, C. "Teach Duinn - The Bull Rock," *Beam*, 6, 1 (no date), 3-4.

O'Neill, Timothy. *Merchants and Mariners in Medieval Ireland*. Dublin: Irish Academic Press, 1987, 131 [about the herring shoals off the southwestern coast].

Schulz, Walter. "Shannon River Pilgrimage," *Yachting*, 157, 2 (February 1985), 46+.

Somerville-Large, Peter. "The Beara Peninsula," *Ireland of the Welcomes*, 37 (1988), 28-33.

"Teach Dhoinn, Calf Rock," *Beam*, 2, 2 (no date), 9+.

Wilson, T.G. *The Irish Lighthouse Service*. Dublin: Allen Figgis, 1968, 44-52, 105-06.

Skelligs Lighthouse

14

County Kerry

. . . the Skelligs are inhabited only by lighthouse men and wild birds.

— Thomas H. Mason,
The Islands of Ireland

Looking out from Valencia Island on a clear day, one can make out two islands rising vertically like sandstone and slate pyramids from the ocean, tips of giant mountains reaching up from the bottom of the sea. That site, eight miles off the southwestern coast of County Kerry, receives the brunt of the Atlantic storms and the main tidal fluctuations, providing mariners many navigational problems. The two islands are Skellig Michael (or Great Skellig), named in honor of St. Michael the Archangel, the patron saint of high places (its twin peaks rise to over seven hundred feet above the water), and, two miles away, Little Skellig, an island home to twenty to forty thousand gannets that rises almost 450 feet from the ocean.

Although only lightkeepers have lived on the forty-acre Skellig Michael in the recent past, it used to have a sixth-century monastery on the broader section at the northeastern end of the island where ascetic monks would retreat from the world. That settlement, which may be the finest preserved ancient monastic site in Europe, represents just one of many that monks established on the offshore islands along Ireland's coast. It consisted of six beehive cells and two oratories, housing probably no more than one abbot and a dozen monks at a time.

The temperate Gulf Stream offshore kept frost away to some extent, thereby helping to keep the stonework of the oratories intact. Those monks who made the perilous eight-mile trip from the mainland in their little, hide-covered boats lived on the island year-round until the thirteenth century, when the expansion of the polar ice cap brought much colder weather and very harsh sea storms, forcing even the hardy monks to seek refuge on the mainland.

The remoteness of the island did not save it from the Vikings, who sacked the monastery at least four times: in A.D. 812, 823, 833, and 839. When the Vikings attacked a place, they destroyed everything, and in the case of Skellig Michael carried off some of the people living there, including

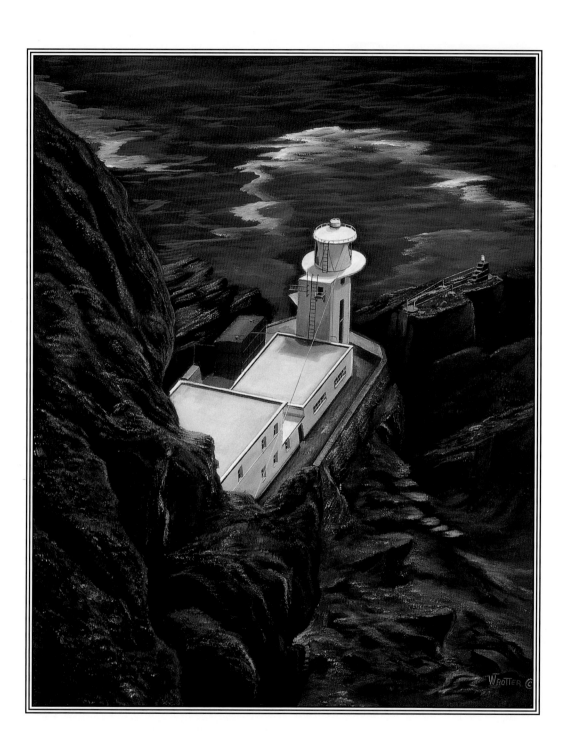

the monastery's abbot, who eventually died of starvation in captivity. Not all of the Vikings were so cruel, however. In 993, a Skellig hermit baptized Viking Olav Trygvasson, who later became King of Norway and sired Olav II, who became the patron saint of Norway.

At the southwestern end of Skellig Michael is the high, perilous peak where monks built small structures for prayer. The monks called the dip between the peaks on the island Christ's Saddle, a name still used there because of its resemblance to a saddle. To communicate with the mainland and to engage in sea fishing, the monks had to have knowledge of the tides, boat-building, and weather, which they passed on from generation to generation of monks. From the early days of that monastic settlement, the devout made pilgrimages to the island. Later, the practice of having single men and women spend Holy Week there in prayer evolved into a courting ritual, causing priests to ban all pilgrimages to Skellig Michael.

Monks controlled the island until the sixteenth century, when the English monarch dissolved the monasteries. At that time the island passed into private, secular hands and remained so until the Corporation for Preserving and Improving the Port of Dublin (succeeded later by the Commissioners of Irish Lights) bought it in 1820 and built two lighthouses on the Atlantic side: one at a height of 175 feet on the west and one at 375 feet on the south. Up until that time there had been no lighthouse between Loop Head on the River Shannon and Cape Clear in County Cork: 111 miles of treacherous coast. The great engineer of Irish lighthouses, George Halpin Sr., first built the cliff-clinging road from Blind Man's Cove to the present lighthouse and on to the second lighthouse, later converted to a fog-signal station, a building that cannot now be reached without peril because of the collapse of the pathway. During the erection of the towers, which were built of local stone, the workmen sometimes slept in the beehives rather than make the perilous trip back to the mainland. In 1825, during the building of the lighthouses, a laborer was killed in a rock-blasting accident. When his widow asked the lighthouse board for monetary compensation, the board awarded her the small pension of six pounds a year and three pounds for each of her children under the age of sixteen.

Six years later, in 1826, the lighthouses were finally completed, and the keepers and their families were able to live in semi-detached houses on the desolate rock. Tensions must have arisen from time to time, as evidenced by the fact that the keeper of the lower lighthouse was dismissed in 1865 after becoming drunk and beating up the keeper of the upper lighthouse. In 1889, the local parish priest on the mainland, noting that the lighthouse keepers on the Great Skellig were also supposed to take care of the religious structures on the island, requested that the lighthouse board replace the Protestant keepers with Catholic ones. The board politely refused, but assured the priest that the keepers, whatever faith they were, would do their best to keep watch on the monastic remains.

The keepers' families tried to raise goats, which supplied milk — if the keepers could catch the elusive animals. The families brought rabbits over to the island to keep a meat supply, but, once the families left, the number of rabbits increased hugely; officials later introduced ferrets to control the rabbits, but the ferrets mysteriously disappeared.

Life there was very hard for the families and even dangerous. At least three boys lost their lives falling from the cliffs, as did Michael Wisheart, a lighthouse keeper who had been banished to that remote island after having allowed his Tuskar Lighthouse to stay dim one night (see Chapter 4). Wisheart died when he fell off the precipitous rock there while mowing the grass. The local Skellig cemetery, the final resting place of some of the keepers' children, has one gravesite whose wording only hints at the anguish of the parents who had to bury their sons at such a young age:

To the Memory of
Patrick Callaghan
Who Departed this Life on
The 3rd Dec. 1868 Aged 2 Years & 9 months

Also his Beloved Brother
William
Who departed this life on the 17th
March 1869 Aged 4 Years & 9 months
May They Rest in Peace.

Their father then requested a transfer from that tragic site, noting that he had buried two of his children on the island and another one was very sick.

Weather occasionally cut the families off from all communication with the mainland, something they had to get used to. At such times, because the island has no source of wholesome water, living conditions became quite difficult. Even during decent weather, landing a boat on the island required great skill. A helicopter pad near Blind Man's Cove greatly alleviated that problem, and new derricks allowed the men to lift the large barrels of fuel for the lighthouse generators up the cliffs directly from the supply boats in the cove below. Workers made those towers more accessible by building a better landing on the east side and blasting a road out of the southern part of the island. In the 1880s a schoolteacher lived on the island for three years and taught the young children of the keepers, but in 1901, the authorities moved the families to Valencia Island, where they could join other lighthouse keepers' families for a less dangerous lifestyle. A day-visitor in 1910 was playwright George Bernard Shaw, who marveled at the fact that the local man who rowed him out and back wanted only newspapers and literature as payment for the trip.

The higher light was discontinued as a sea light in 1866. Over the years large pieces of stone kept tumbling down the rock. In December 1951, the lantern of the lower structure was flooded and the light, at a height of 175 feet above sea level, was extinguished by an enormous wave that also swept the lightkeeper down the stairs. The light was out of action for the rest of that night, but the keepers relit it in twenty-four hours. Over the years, the keepers took in marooned sailors from their wrecked ships and witnessed the crashes of aircraft during World War II, but they were often unable to find those pilots lost in the nearby sea.

Finally, in 1966, the lower light was taken down and replaced by a new, reinforced concrete tower and modern engine room, which began operating in May 1967. New facilities there allowed the last keepers to enjoy the luxuries of electric light, central heating, and hot and cold water. In 1987, an era passed when the lighthouse, known in the service as Skelligs Lighthouse, was automated and demanned, thus bringing to an end official habitation on one of Ireland's most isolated islands. Visitors can still get to the island for a one-day trip by boat out of nearby Valencia Island, where a visitors' center presents a history of the Skelligs in illustrated panels and three-dimensional tableaux, but many environmentalists feel that large numbers of people traipsing over the rocks can do immense harm to the delicate environment there. A visitor looking out into the mist at the two islands offshore has to marvel at the courage, ingenuity, and persistence of the monks and the lighthouse keepers and their families that made Skellig Michael their home.

Further Reading

Costeloe, Michael, "Skelligs Lighthouse," *Beam*, 21, 1 (December 1992), 7-10.

Horn, Walter, Jenny White Marshall, Grellan D. Rourke. *The Forgotten Hermitage of Skellig Michael*. Berkeley: University of California Press, 1990.

Lavelle, Des. *Skellig: Island Outpost of Europe*. Montreal: McGill-Queen's University Press, 1976.

Lavelle, Des. "Skellig Michael." *Ireland of the Welcomes*, 25, 5 (Sept.-Oct. 1976), 10-15.

Lavelle, Des. *The Skellig Story: Ancient Monastic Outpost*. Dublin: The O'Brien Pess, 1993.

Mason, Thomas H. *The Islands of Ireland*. London: B.T. Batsford Ltd., 1950, 107-15.

Murphy, R.K. "The Skelligs Fog Signal," *Beam*, 14, 1 (March 1985), 16-17.

Wilson, T.G. *The Irish Lighthouse Service*. Dublin: Allen Figgis, 1968, 53-58.

CROMWELL POINT LIGHTHOUSE

15

County Kerry

While I have sailed most of the American coast from Halifax, Nova Scotia, to the Caribbean, I was not prepared for the magnitude of the mountains, cliffs, and rock formations in southwestern Ireland.

— Walter Schulz,
"Shannon River Pilgrimage"

North of Skellig lies Valencia (or Valentia) Island, the most westerly settled community in Europe and the site of an important link in the history of global communications. Joined to the mainland at Portmagee by a bridge in the early 1970s, the island, which is seven miles long and two miles wide, has one main village: Knight's Town (or Knightstown), so called after the Knight of Kerry, a former landowner. Located on the eastern end of the island, the village has about two hundred residents and, on the main street, an anchor from a four-masted barque, the *Crompton*, which wrecked off the island in 1910.

To the northwest of Knight's Town the lighthouse can be seen from the slate quarry, which closed in 1954 after a very successful operation that supplied high-quality slate and flagstone to craftsmen around the world. Visitors to the island can learn about the history and geology of the land from the information center near the pier, where boats can take visitors to the Skelligs offshore. Displays relate the prehistory of the place, especially thebeehive-shaped dwellings and stone tombs scattered over the island.

The island lies at the tip of the Iveragh Peninsula, around which the Ring of Kerry runs. Near the island on the mainland is the town of Caherciveen, where the great Irish liberator, Daniel O'Connell (1775–1847), was born. That part of County Kerry is a windswept peninsula whose clawlike pincers at St. Finan's Bay look as if they will attack the Skelligs offshore. Some scholars, including Niall Fallon, believe that at least one ship of the Spanish Armada, the *Trinidad*, wrecked near there in 1588. A 1585 Spanish astrolabe that some fishermen found in Valencia in 1845 was part of the evidence for that conclusion.

Living so close to the sea enabled the

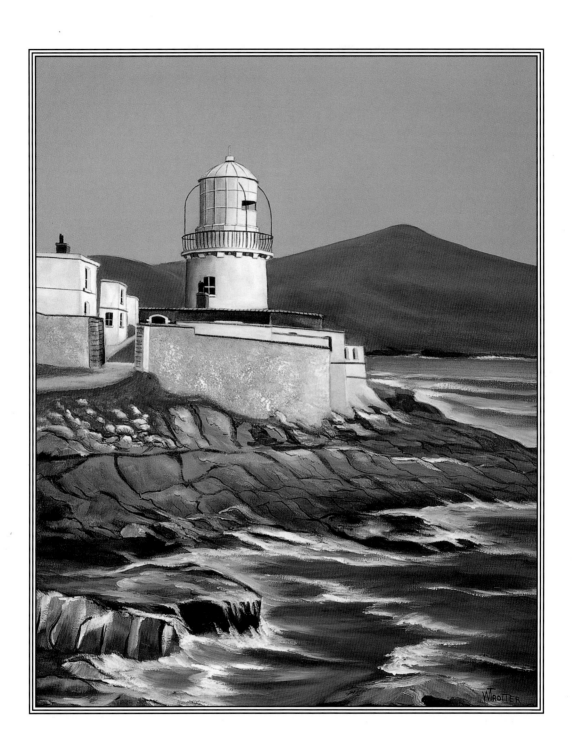

islanders to take advantage of the many kinds of fish they could catch, but also of the cockles, mussels, and scallops they could pick, the seals they could harpoon, the porpoises they could hook, and the stranded whales they could find along the shore. Concerning the latter, the *Annals of Connacht* recorded that in 1246 north of there a whale came ashore that "brought great relief and joy to the countryside." Resourceful islanders could also find edible seaweeds, for example, dulse (also known as dillisk and dillesk), a reddish-brown seaweed found along the west coast of Ireland. Coastal dwellers could also burn seaweed and use the ashes as an unrefined salt to preserve fish and meat. The presence of abundant fish, mollusks, and edible seaweed lessened the effects of the nineteenth-century famine, although the island still lost some five hundred people, dropping the population from 3,000 to 2,500 in 1845.

From the sixteenth century on, the Spanish sailed to the area and took away skins brought there by ranchers further inland and also auctioned off their salt and wine while the revenue officer stayed away, sometimes bribed with some liquid refreshment. As time passed and more and more ships met their doom on that coast, many people petitioned for navigational aids. Maurice Fitzgerald, the Knight of Kerry, in 1828 asked the Ballast Board for some kind of light to guide the ships going to and from the sea, but it took another nine years before an official went to the island and agreed that a lighthouse should be built on Cromwell Point. When approval was granted by the Ballast Board, workers used the walls of an old fort and erected a light that first shone in 1841. Lighthouse keepers manned it for over one hundred years, until officials automated it in 1947. Before the coming of the helicopter, the lighthouse relief vessel that serviced the offshore sites like Bull Rock, Skellig Michael, and Inishtearaght used to make calls at Valencia Island.

In 1857, visitors to the lighthouse would have seen large crowds of spectators arrive to see the first laying of the transatlantic telegraph cable that linked Valencia and Ireland with Newfoundland. Engineers had determined that the shortest distance between Europe and North America began at Valencia, and they needed such a straight line for speed and clarity of transmission. Those spectators to the historic event might have been somewhat dismayed had they known that the completion of the first cable laying would have to be delayed a year because the cable would break when workers were only about a third of the way across the Atlantic.

Officials showed up in April 1858 for the delayed, but successful, laying of the cable, and signals first passed between Newfoundland and Ireland in August of that year. The equipment broke down a few weeks later, but the arrival of the steamship *Great Eastern* in 1866 led to the successful laying of the cable and closer ties between the continents. As was true in many places in Ireland at that time, most of the early telegraph clerks were English and tended to live apart from the local, Irish-speaking farm community in "fancy" houses in the midst of tennis courts and a cricket field. Eventually, however, many of them married local girls and settled on the island to raise their families. Until the final transatlantic cable message from Valencia Island was sent in 1965, many of those clerks lived with their families on the picturesque island. The closing of the cable station, the lack of opportunities on the island, and the migration of the younger people to the mainland have reduced the island population to fewer than one thousand today.

The busy sea traffic in the area off the island necessitated the establishment of two unlighted beacons north of Valencia Harbour in 1891 that would guide ships during the day past Harbour Rock. Officials had them lit in 1913 as further navigational aids. Today the Commissioners of Irish Lights maintain those lights, called leading lights because of the way that mariners use them to help "lead" their ships into port. When pilots keep the lights, which are some distance apart, in line with each other, the mariners can avoid dangers and enter ports safely. The coast of southwest Ireland needs such aids because much of the coast consists of fjordlike inlets by which one can sail quite a distance inland. Those inlets formed because the

original land was softer, more soluble, and, therefore, more easily removed by the sea. The thousands of visitors who drive or ride the Ring of Kerry each year can testify to the grandeur and stark, breathtaking beauty of the inlets and sea.

Valencia Island assumed a new importance in the early part of this century when Irish officials relocated keepers' families from the more isolated sites, like Skellig Michael, and brought them to Knight's Town where special houses had been built for them. Living near other lighthouse families in Knight's Town was very comforting for the keepers' wives, especially since their husbands were on duty offshore and away from home for six weeks out of every eight in normal weather, and sometimes longer when rough weather would not permit relief boats to land at the isolated rock stations. The result was that many Irish lighthouse keepers have been born on Valencia, and a community exists there of former keepers and their families. One such descendant of lighthouse keepers is Des Lavelle, lifelong resident of Valencia, the author of a book on Skellig Michael and its lighthouse.

Lighthouse families on Valencia might include several members from one family who have served in the lighthouse service for generations. For example, the Higginbothams, who began serving in the country's oldest lighthouse (Hook Head), had three generations serving, including five sons from one generation alone. As has happened throughout lighthouse history, the female members of the family often either entered the service or married keepers. Isabella Higginbotham, the great-great-great granddaughter of a

Hook Head keeper in 1750, married Thomas Scanlon, who came from a long line of river pilots in the River Shannon and joined the lighthouse service. Both wife and husband served as keepers at Mutton Island Lighthouse in Galway Bay from 1943 to 1951. Their son, Bill, became a keeper, and nine other members of the Scanlons served Irish Lights.

From the early days of Trinity House, which was established in 1514 to handle the navigational aids around the British Isles, the lighthouse service attracted persons dedicated to the sea.

In more recent years, heavy technological demands have necessitated highly trained persons dedicated to the lighthouses and skilled in several important fields. The service has taken in prospective keepers at age nineteen after they have passed rigid qualifying exams and interviews. For the first few years these initiates traveled from tower to tower, learning how the different structures function and becoming adept in such skills as tower maintenance, meteorology, fog-signalling apparatus, communications (Morse, semaphore, International Code Flag signalling, radio), and the many duties expected of those in the lighthouse service. If they passed all of the tests along the way, would-be keepers could expect normal, but slow, advancement to assistant keeper and ultimately principal keeper.

That the Irish lighthouse service has had so many distinguished men and women, who sometimes had to risk their lives to carry out their duties, is a testament to the high regard their countrymen hold for that service.

Further Reading

Fallon, Niall. *The Armada in Ireland*. London: Stanford Maritime, 1978, 200-01: "Valentia Island, Co. Kerry."

Langmaid, Captain Kenneth. *The Sea, Thine Enemy: A Survey of Coastal Lights and Life-boat Services*. London: Jarrolds, 1966.

Long, Bill. *Bright Light, White Water: The Story of Irish Lighthouses and Their People*. Dublin: New Island Books, 1993, 127-28.

MacSweeney, Edward F. "When Ireland Linked Two Worlds" [about the laying of the transatlantic cable], *Ireland of the Welcomes*, 18, 4 (November-December 1969), 35-38.

Mitchell, Frank. *Man & Environment in Valencia Island*. Dublin: Royal Irish Academy, 1989.

Mould, Daphne D.C. Pochin. *Valentia: Portrait of an Island*. Dublin: The Blackwater Press, 1978.

O'Cleirigh, Nellie. *Valentia. A Different Irish Island*. Dublin: Portobello Press, 1992.

Ó Corráin, Donncha. *Ireland Before the Normans*. Dublin: Gill and Macmillan Ltd., 1972, 60 [about dulse].

Schulz, Walter. "Shannon River Pilgrimage," *Yachting*, 157, 2 (February 1985), 46+.

INISHTEARAGHT LIGHTHOUSE

16

County Kerry

On a fine fair day and I plying the sea to the west
I came upon the Tearacht far out into the bay,
Where was music of birds flying over the green grass
And little fish in hundreds frolicking in the nets.

— From a song entitled
"The Little Heather Hill"

The pleasant scene depicted in the "The Little Heather Hill" song disguises the fact that the Tearacht or Inishtearaght, as the rock is formally called, is treacherous for the unwary mariner. That island is one of the six main islands and stacklike rocks that make up the Blaskets about twenty-two miles north of Skellig Michael and just west of Slea Head on the Dingle Peninsula. Locals like to point out that the next land west is America, some three thousand miles away, which means that the Atlantic can build up tremendous power as it heads towards these isolated rocks.

The Blaskets consist of high ridges of purple sandstone with few, if any, trees because of the ceaseless exposure to the fierce Atlantic tides and winds. But the southwestern coast of Ireland has a unique beauty with its many inlets and majestic mountains. Between the stacklike Foze Rocks that lie further out in the Atlantic and the mainland are six islands: Inishtearaght (the island furthest out), Inishvickillaun, Inish na Bro, Beginish, Inish Tooshkert, and the Great Blasket Island. If one looks out from the tip of the Dingle Peninsula just north of Slea Head, one might mistake the Blaskets for a pod of basking, hump-backed whales, and, in fact, whales have come ashore along that coast — to the delight of villagers in need of food.

Those islands, four large ones and several smaller ones, are just a few of the hundreds along the country's long coast, but they have a literary tradition that few others can match. At least three island-born writers have written popular works about the Blaskets in Gaelic that have been translated into English: Tomás Ó Criomhthain's (Tomás or Thomas O'Crohan) *The Islandman*, Maurice O'Sullivan's *Twenty Years A-*

72

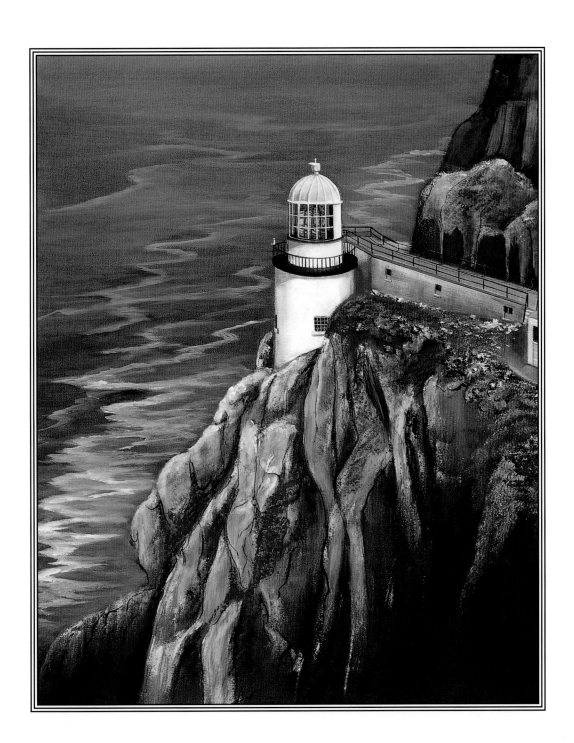

Growing, and Peig Sayers's *Peig* and *An Old Woman's Reflections*. The great poet Dylan Thomas wrote a film script of the first half of O'Sullivan's book. The islands were fortunate to have such chroniclers since even the local Tralee newspapers were more interested in giving readers details of life in London or Dublin than of the remote islands to the west.

Between the mainland and the Great Blasket Island lies the Blasket Sound, a very dangerous channel that has wrecked the boat of many an inattentive sailor. Just how dangerous the water is around the Blaskets became clear to those pilots of the ill-fated Spanish Armada in 1588 who were attempting to pass near the islands to safety. The remains of the Spanish *Santa Maria de la Rosa*, which divers found in 1968, may be just one of several that wrecked in the area.

The Great Blasket, now a national historic park with some of its buildings being restored, is four miles long and about a mile wide. People lived there until 1953, when they finally decided that life on the island was just too difficult. Some of those relocated families have visited their former homes on the islands on a regular basis and done their best to maintain them. A few former islanders returned to tend to the sheep they left behind, but the islands look more and more like an abandoned, wrecked site, reclaimed by the elements which have dominated the area for millennia.

The people who lived on the islands developed a hardiness, mutual interdependence, and communal identity that helped overcome the isolation, poverty, and constant harassment by the weather. One story, perhaps apocryphal, stated that no one died on the islands for decades, although some of those who became sick died when they went to the mainland. Island-born writer Tomás Ó Criomhthain maintained that none of the islanders died of starvation during the harsh 1800s when Ireland was hit by the potato blight, and that may have been true because Irish islands often did not suffer the harshness of the blight, aided to some degree by the westerly winds that kept away any airborne diseases from the

mainland. What definitely helped the people that century were the abundant fish and the shipwrecks which the islanders considered as sent by God to his long-suffering people. According to Gaelic law, the produce of such wrecks belonged to the local people, although English law stated that such wrecks belonged to the local landowners.

At first in the mid-1800s, lighthouse officials considered building a lighthouse on the Great Foze Rock to the west of Inishtearaght, but the Ballast Board of Dublin opposed that site because of the difficulty in constructing a strong tower there and because the Atlantic would buffet the low-lying Great Foze as it had done for thousands of years, making lighthouse life there disagreeable and dangerous.

Because Irish officials wanted a lighthouse on Inishtearaght, the most westerly of the islands, the government bought the island from the Earl of Cork in 1864 for two hundred pounds, much of which went to Miss Clara Hussey, a woman who had some kind of claim on the island and was the sister of the land agent who ferried men to some of the islands for sheep shearing. Building the tower there in 1864, on the western point with a white road snaking its way up from the sea through the black rocks, was very difficult since the rock was so uneven. Workers had to level a good deal of it to make a platform for the tower and quarters. Conditions during the winter were so harsh that officials found it more economical to lay off the workers and rehire them again in the spring, when more favorable conditions enabled them to ferry to and from the island. When the masons and stonecutters threatened to strike in 1866 for a slight increase in wages, the authorities gave in, concerned that more delays would threaten the construction and prolong the dangers to ships passing offshore.

Inishtearaght rises to a height of six hundred feet above the sea from a base of two thousand feet and, to some, resembles a fairy-tale castle rising up from the peaceful ocean. Visitor Robin Flower described Inishtearaght as "the gull-haunted pyramid" that "carries the last light that Irish emigrants see as they go on their long voyage to America"

(6). The reality of that isolated spot in the Atlantic, however, was far from bucolic. Any ship that hit its rocks would most assuredly meet an untimely end.

The island today is remote and barren, but, like the other Blaskets, once had people living there. Baptismal records in the parish of Ballyferriter on the mainland indicate that people lived on the islands in the nineteenth century, but today one has to search hard for even traces of the small terrace gardens that the inhabitants tended. In many ways the island resembles the formidable Skellig Michael to the south and, like that site, may have had a monastic settlement, but much archaeological work remains to be done to confirm this.

When the lighthouse began operating in 1870, the upper light on Skellig Michael twenty-two miles to the south was discontinued, an action that reduced the work force on the southern island by half. Being cut off from the mainland by the weather, sometimes for weeks at a time, must have been terrible for the families, especially during times of pregnancy and sickness. In 1896, the authorities finally allowed the families of the keepers at both rock stations to move to the town on Valencia Island where workers built comfortable,

two-story houses for the keepers and their families. The result of the move was a return to normalcy for the families; they could raise their children away from the confinements of the rock stations. The access to medical and educational facilities improved the life of those families immeasurably.

During World War I the Blaskets saw their share of shipwrecks, tragedies that provided the islanders with much-needed provisions, including food and clothing. The islanders gathered so much from the wrecks that many home owners built extra storerooms to hoard the material. At least one corpse from the torpedoed *Lusitania*, which sank south of Kinsale, washed ashore on the Blaskets. In another instance during World War I, a ship traveling from New York, being informed that an enemy submarine was waiting to attack it, changed course, but wrecked on the Blaskets.

Today hundreds of birds are about all that remain of living creatures on the island. One can see storm petrels, manx shearwaters, fulmars, razorbills, and thousands of puffins, but the trip out there may be too dangerous, even for the most avid of birdwatchers.

Further Reading

Dhomhnaill, Nuala Ní. "Bláithín" [about Robin Flower, who wrote about the Blaskets], *Ireland of the Welcomes*, 30 (1981), 28-30.

Fallon, Niall. *The Armada in Ireland*. London: Stanford Maritime, 1978, 154-78 [about the wreck of the Spanish Armada ship].

Flower, Robin. *The Western Island or The Great Blasket*. New York: Oxford University Press, 1945.

Long, Bill. *Bright Light, White Water: The Story of Irish Lighthouses and Their People*. Dublin: New Island Books, 1993, 128-33.

Martin, Colin. *Full Fathom Five*. New York: Viking Press, 1975, 23-135 [about the wreck of the Spanish Armada ship, *Santa Maria de la Rosa*, in the Blaskets].

O'Crohan, Tomás . *The Islandman*. Translated from the Irish by Robin Flower. Oxford: Clarendon Press, 1951.

O'Murchú, Liam. "'We shall not look upon their like again'" [about the writers of the Blaskets], *Ireland of the Welcomes*, 30 (1981), 18-20.

O'Sullivan, Maurice. *Twenty Years A-Growing*. Translated by Moya Llewelyn Davies and George Thomson. London: Chatto & Windus, 1933.

Ryan, F.J. "Down Memory Lane" [about experiencing the 1928 hurricane on Inishtearaght], *Beam*, 21, 1 (December 1992), 23.

Sayers, Peig. *An Old Woman's Reflections*, translated from the Irish by Séamus Ennis. Oxford: Oxford University Press, 1962.

Stagles, Joan & Ray. *The Blasket Islands: Next Parish America*. Dublin: The O'Brien Press, 1980.

Thomas, Dylan. *A Film Script of Twenty Years A-Growing*. London: J.M. Dent & Sons, Ltd., 1964.

Wilson, T.G. *The Irish Lighthouse Service*. Dublin: Allen Figgis, 1968, 59-62.

LITTLE SAMPHIRE ISLAND LIGHTHOUSE

17

County Kerry

England's danger is Ireland's opportunity.

— Irish proverb

The little town of Fenit (population 401) lies at the end of a small road west of Tralee in County Kerry. Although its half-mile-long, L-shaped pier is used for unloading fish and oil products, and acts as the harbor of Tralee, the town seems relatively unspoiled and offers the occasional visitor beautiful views of Tralee Bay. Just north of Fenit is the small town of Ardfert, site of one of the monasteries of the great sixth-century Irish navigator, St. Brendan, a holy man associated with Dingle Peninsula. One of the greatest mariners in ancient Ireland, Brendan is supposed to have led a small group of men westward and may have reached the New World. Modern-day adventurer Tim Severin reenacted that trip in 1976 with a crew of four by sailing from Brandon Creek, near Brandon Mountain and Brandon Head, to the east of Little Samphire Island, to Newfoundland and wrote *The Brendan Voyage* about the trip.

A half-mile west of Fenit is the Little Samphire Island Lighthouse, whose tower, which seems to peek out over the top of its cementlike wall and keepers' quarters, fills up most of the tiny island. There does not seem to be much available space around the outside of the walls, indicating that the lighthouse builders enclosed as much space as possible for the keepers and their families. One can barely make out the distant mountains across the bay facing the lighthouse, and, during fog or storms, the visibility goes down rapidly.

Although relatively protected at the end of its bay, Tralee is an important town at the northern approach to the popular Dingle Peninsula. It has had its share of troubles, having been destroyed during the seventeenth-century wars that raged in the area, but today it thrives as an important commercial center of north County Kerry. Each August the town sponsors the Tralee Races and the Rose of Tralee Festival, an international gathering in which any girl of Irish descent can compete for the title of "Rose of Tralee." William Mulchinock (1820–64), the man who wrote the song, "The Rose of Tralee,"

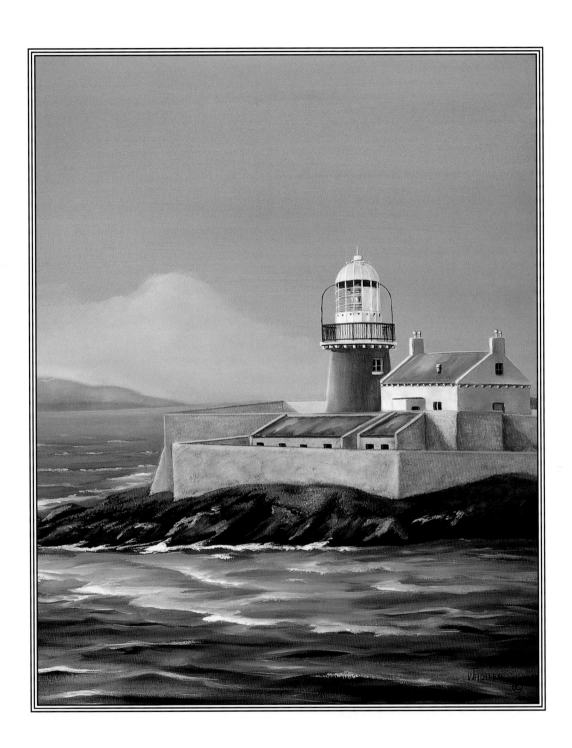

is commemorated by a statue in the Town Park.

When the Spanish Armada sailed south along the western coast of Ireland in 1588 returning to Spain after their unsuccessful encounter with the English Navy and their dispersal by fierce storms off Scotland, twenty-four Spaniards landed near Tralee, hoping for aid and food. Instead they were executed on the orders of Lady Denny, the wife of an absent planter. The Spaniards, when faced with a strong west wind, found it next to impossible to escape the rocks. To stop and then sail north-northwest around the Magharee Islands (also called the Seven Hogs) would have been very hard, especially in the fall when the winds can be very strong. Another major problem with the Spanish ships was that their commanders had panicked and cut their anchors off the French coast when they saw English fire boats sailing down toward them. Without anchors, the ships could not avoid being swept ashore onto the Irish coast during a fierce storm.

After local merchants petitioned the Ballast Board in the mid-1840s for help in lighting the way for ships going up toward Tralee, it took several years for officials to approve a lighthouse for Little Samphire Island. As happened so often in exposed sites, bad weather conditions delayed the construction, but the completion of the tower in July 1854 with its fixed light and red and white sectors helped ships navigate in Tralee Bay. The natural limestone of the tower made for an attractive structure.

When workers changed the light from oil to acetylene in 1954, the light flashed for one second every five seconds. It became automatic in 1956, and the keepers were withdrawn. The final change occurred in the 1970s when electricity began to power the light. Even then, the increase of lights behind the tower made it difficult for mariners to clearly make out the lighthouse. As more and more people have moved in and built homes, which are lighted in the evening, the lighthouse has become more and more difficult to make out. This is a common problem for those towers near growing towns.

The lighthouse keepers there in 1916 might have witnessed a scene of importance in the history of Ireland's involvement in World War I. In order to hasten Irish Home Rule and practice the sentiments of a famous maxim, "England's danger is Ireland's opportunity," a group of Irish nationalists planned to stage an anti-British rebellion in Ireland and, therefore, help Germany by forcing England to send troops from the Western Front to Ireland. Germany agreed to ship a large cache of arms to Tralee Bay in southwest Ireland aboard a ship, the *Libau* — renamed the *Aud* — disguised to look like a Norwegian steamer. British officials in London were aware of the ship's movements and deliberately let her pass through their blockade and reach Tralee Bay near Little Samphire Island.

There a sloop intercepted it, but allowed it to continue on its way south. When the German officer was unable to rendezvous with the Irish nationalists, he took his ship out of Tralee Bay and headed south, where he was intercepted near the Skelligs before finally scuttling his ship near Cork Harbour.

The lighthouse in Tralee Bay, while small and tucked away from the brunt of the Atlantic Ocean, does its job well and is part of the wide diversity of towers that Irish Lights maintains. It receives some of its funds from the Light Dues that ships using ports in the British Isles pay. The Light Dues are distributed among Irish Lights, Trinity House (for English lighthouses), and Northern Lights (for Scottish lighthouses). The three groups of officials distribute the money collected in proportion to the lights maintained. Because Ireland has more functioning lighthouses, it receives more of the money than the other countries.

The Little Samphire Island Lighthouse warns vessels passing offshore or those going into Tralee Bay of the rocks lying in wait for unsuspecting ships. As commercial shipping along the coast declines, especially as shipping companies choose to frequent a few, large ports rather than small ones, and as rail and truck transport carry the goods formerly taken by ship, smaller ports like Tralee will have to adapt to the new trends in order to survive. One way would be to develop

facilities for yachts, something that will once again give its lighthouse a new purpose: guiding the private sailor into safe harbor or past dangerous rocks.

One can argue since fewer seamen ply the ocean waters in relatively small boats looking for fish, so many lighthouses are unnecessary, but higher incomes and more leisure time have enabled private persons to take up sailing. The many quays around places like Little Samphire Island, built years ago to accommodate ships of various sizes, could once again become busy places if they can adapt to the smaller, usually private yachts of travelers who have time and money to travel by boat.

County Kerry, of which Tralee is an important town, lies far from popular places like Belfast, Dublin, and other busy sites. The county has struggled economically and has looked to tourism for help. Developing the harbor that Little Samphire Island Lighthouse serves may be just the ticket to prosperity. The protected site seems ideal for such a change. While too much development could spoil the beauty of a county that many thousands of tourists come to see, Tralee should be able to profit from the mistakes and progress of resort places like Cork, Kinsale, and Schull.

County Kerry has much to offer, not only in terms of business in the global world (New York Life Insurance Company processes its domestic claims from a Kerry village), but also in literature (native playwright John B. Keane lives there and well-known poet Nuala N' Dhomhnaill writes of her native Kerry) and film (David Lean set his very successful "Ryan's Daughter" on the Kerry coast). The Club Méditerranée established its first Irish facility in Kerry in 1992, not a splashy village, but a discrete hotel for golfers. The county and country have a modern telephone system with Alcatel equipment from France, replacing an antiquated system that used to close down at 2 P.M. on Sunday. Although one of the poorest countries in the Economic Union (with Greece and Portugal), Ireland has much going for it in its quest to become more economically independent. Developing more yacht-friendly facilities as at Tralee will help on that path.

Further Reading

Ardagh, John. *Ireland and the Irish: Portrait of a Changing Society*. London: Hamish Hamilton, 1994.

de Courcy Ireland, John. *The Sea and The Easter Rising*. Dublin: Maritime Institute of Ireland, 1966 [about the arrival of the German ship *Libau/Aud* off Fenit].

Fallon, Niall. *The Armada in Ireland*. London: Stanford Maritime, 1978, 196-200.

Long, Bill. *Bright Light, White Water: The Story of Irish Lighthouses and Their People*. Dublin: New Island Books, 1993, 133-34.

McIvor, Aidan. *A History of the Irish Naval Service*. Dublin: Irish Academic Press, 1994, 29-31 [for the story of the German ship in Tralee Bay in 1916].

Severin, Timothy. *The Brendan Voyage*. New York: McGraw-Hill, 1978.

Severin, Timothy. "The Voyage of *Brendan*," *National Geographic* (December 1977), 770-97.

TARBERT LIGHTHOUSE

18

County Kerry

It's hard to fight with the wide ocean.

— Irish proverb

Continuing north on the road from Tralee, passing the junction at Tarbert that heads east to Limerick, the traveler heads right into the Tarbert Lighthouse. A car ferry leaves near there for Killimer on the north bank of the River Shannon. Airline passengers flying into or out of Shannon Airport can look down on the south side of the River Shannon and catch a glimpse of this beacon working quietly through the day and night to guide ships up and down the great river. Tarbert Lighthouse may not be as stately as the rock tower on Skellig Michael or the monstrous Kish Bank or the massive Hook Head tower, but it, nevertheless, performs a necessary service to hundreds, maybe thousands, of travelers each year. It has definitely served as a welcome sight to many ships seeking shelter from the fierce Atlantic storms to the west, ships manned by sailors with a healthy respect for the ocean.

The white tower stands on the northern side of Tarbert Island on a tidal rock in the Shannon Estuary and has a two-hundred-foot-long, cast-iron footbridge to make the building more accessible by land. Built in the early 1830s at the request of Limerick merchants, first lit in 1834, and funded by a one farthing per ton fee paid by those using the river, the tower was deemed necessary to light a treacherous turn in the river and to help mark the southern entrance to Clonderalaw Bay to the northeast. Standing tall at seventy-four feet and easily seen by those using the river, the structure now seems small near the tall chimneys of a generating station behind it. The lighthouse helps guide ships to and from Limerick in an estuary that stretches sixty miles from the great port to the ocean and also helps thousands of pleasure boats and fishermen who use the river. Fishermen can still find such fish as bream, perch, pike, rudd, salmon, tench, and trout in the river, which has very few factories along its length and is, therefore, relatively pollution free. In 1981, the Commissioners of Irish Lights transferred to the jurisdiction of the Limerick Harbour Commissioners several lighthouses in

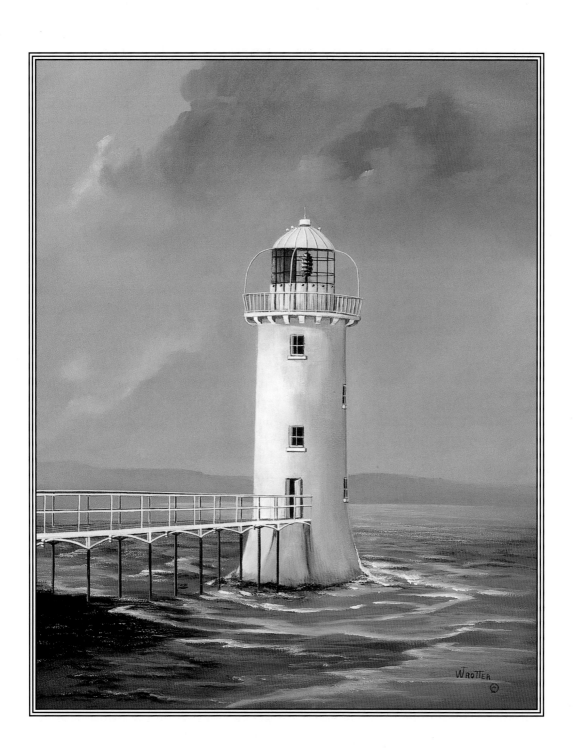

the Shannon, including Tarbert Island Lighthouse, which is officially considered a harbor light.

Several miles to the east of Kilcredaun Lighthouse (see Chapter 19) and located on an island is Scattery Island Lighthouse, a structure built in 1872 and tended by three generations of the McMahon family since then. The last McMahon keeper, Patricia McMahon, was born on the island and assisted her father, Austin. He had also been born on the island and served as lighthouse keeper there, first as an assistant to his father, also named Austin, and then as principal keeper. Until she retired in the mid-1990s, Patricia would go by boat to the island every two weeks from her home on the mainland. The lighthouse is unique in that, during the early days of operation, the lighting mechanism was put on a movable trolley in order to take it away from the British War Department Battery and firing range on the island.

The island has many old ruins and a 115-foot-tall round tower, the only such one in Ireland with its entrance door on the ground level rather than in a more elevated position. Vikings plundered the island monastery in the ninth century and seemed to have stayed there into the tenth century, at which time the great Brian Boru recaptured the monastery. Just how good a port area Scattery Island offers became clear when several ships of the ill-fated Spanish Armada anchored there in 1588 in an attempt to go ashore and seek water before returning to Spain. Now uninhabited, the island had a population of 120 before the islanders moved to the mainland in the 1960s in order to provide good schooling for their children and to have closer relationships with a wider group of people.

An old tradition has newly launched boats on their maiden voyage cruise around Scattery Island, considered by many to be a magic island, as a mark of respect. Also, sailors heading off on long voyages took pebbles from the shore of the island to keep themselves safe. Visitors who want to see the remains of a sixth-century monastery, the remains of five old churches, and the round tower can

reach the island by boat from Cappagh Pier in the town of Kilrush on the northern side of the river. Kilrush was also the base for a group of maritime pilots who would guide some eight hundred ships a year up the river. Irish Lights may build two leading lights in the area of Corlis Point near Scattery Island to help the ships entering the River Shannon, especially because the buoys near Beal Point on the southern part of the river tend to shift in the strong tides, a situation that could be dangerous for ships in the area.

To the east of Tarbert Lighthouse is a very unusual structure: Beeves' Rock Lighthouse. Located on a rock in the Shannon just southwest of the River Fergus, the structure resembles a large, stone lightship, especially when high tide covers the rock on which the tower stands. First constructed as an unlit tower in 1816, it remained so until workers built a lighthouse on the northern tip of Foynes Island some four decades later. At first, two keepers and their families lived in cramped quarters on the rock until officials finally built three shore dwellings in 1908 near Askeaton on the mainland. Today the lighthouse, controlled by the Limerick Harbour Commissioners, is automatic and unmanned.

River pilots living on the islands in the Fergus Estuary would row to the Beeves' Rock Lighthouse in their "ganalows," flat-bottomed boats that could easily slip over the shallow mudbanks, and then either swing the boats onto a larger ship to be piloted up the river or tow them behind. An island terminal near Foynes serviced ships as large as 60,000 tons; Foynes Island also served as the headquarters for oil exploration off Ireland's northwest coast.

These lighthouses guide ships to and from the mouth of the River Shannon, at 210-plus miles the longest river in the British Isles and one that flows through much of the Irish countryside. Its thirty-two tributaries take much of the country's excess water to the Atlantic and provide a beautiful river that more and more people are enjoying in private boats and even barges. The town of Birr, east of the top of Lough Derg northwest of

Limerick, was home to one of Ireland's greatest maritime inventors, Charles Algernon Parsons (1854–1931), who was tutored by distinguished scholars working in his father's astronomical observatory. Charles Parsons went on to develop the all-important steam turbine that powered the great ships of the world.

A memorial to one of Ireland's most famous navigators, St. Brendan (A.D. 484–577), is northeast of Shannon Airport at Craggaunowen Centre. Some believe that Brendan, who was born in County Kerry south of Tralee, may have been the first to reach the New World from Europe. Sailing in the sixth century in a light wooden boat covered with ox-hides, perhaps in search of an isolated island on which to set up a small sanctuary or oratory, Brendan may have reached the New World.

Finally, the islands in the Fergus Estuary, five miles west of Shannon International Airport, should be mentioned. Eleven main islands and numerous smaller, uninhabited islands are the first view of Ireland for thousands of air passengers to and from Shannon. The best-known of these islands is Canon Island, where Donal Mór O'Brien established an abbey for the Canons Regular of Saint Augustine in the twelfth century. In the following two centuries, hundreds of monks studied there, although today only a few stone ruins remain. When the builders of a large mansion on the mainland took stones from the ruined abbey in the early 1800s, they discovered that bad luck accompanied the stones. After apparently receiving warnings from ghosts about desecrating the abbey further, the builders returned the stones to the shore of Canon Island and simply dumped them there, not wishing to have anything more to do with them.

Other islands are Coney Island, Deer Island (so named because a herd of deer used to roam there), Horse Island, and Low Island. Families lived on the larger islands in the earlier part of this century, although today one can see only neglected houses overgrown with weeds. The families could visit each other on the different islands but had to keep track of the tides; staying too long at a dance or sing-along party might mean missing a high tide and a long wait overnight for the change of tides. Besides selling butter, gravel, limestone, and seaweed, the families made a living by piloting ships coming from the Atlantic up the Shannon to Limerick to the east or Clarecastle to the north. A few people still live on the islands, farming the land in the summer.

Further Reading

Blackwell, Meike. *Ships in Early Irish History*. Whitegate, County Clare: Ballinakella Press, 1992.

Costeloe, M.P.L. "Shannon Estuary," *Beam*, 13, 1, 25-31.

de Courcy Ireland, John. "2 Great Maritime Inventors: John Philip Holland and Charles Algernon Parsons," *Ireland of the Welcomes*, 24, 1 (January-February 1975), 31-34.

Fallon, Niall. *The Armada in Ireland*. London: Stanford Maritime, 1978, 149-53 [about the Spanish Armada in the Shannon].

Fisher, Jr., Allan C. "Where the River Shannon Flows," *National Geographic*, 154, 5 (November 1978), 652-79.

Ginna, Jr., Robert Emmett. "Cruising the Shannon," *The Connoisseur*, 219 (April 1989), 102-09.

Long, Bill. *Bright Light, White Water: The Story of Irish Lighthouses and Their People*. Dublin: New Island Books, 1993, 135-36 [Scattery Island], 136-37 [Beeves' Rock], 137-38 [Tarbert].

Nelson, Mrs. Elsie J. "Recollections of Life as a Lighthouse Keeper's Daughter" [partly about life at Scattery Island], *Beam*, 12, 2 (October 1981), 6-8.

Rowe, Veronica. "Offshore from Paradise" [about the islands in the Fergus Estuary], *Ireland of the Welcomes*, 37 (1988), 36-39.

Severin, Timothy. "The Voyage of *Brendan*," *National Geographic Magazine*, December 1977, 770-97.

LOOP HEAD LIGHTHOUSE

19

County Clare

Sailing the Irish coast, one quickly acquires a healthy respect for the power of the wind and sea.

— Walter Schulz,
"Shannon River Pilgrimage"

Several ships of the Spanish Armada sought refuge in the River Shannon in 1588 on their ill-fated attempt to sail south around Ireland to try to reach Spain. Those ships, possibly as many as seven, sought a respite from the wind and tides, and some also replenished supplies in towns along the Shannon, especially Carrigaholt and Kilrush. In September 1588, after the local Irishmen would not cooperate with the Spanish, either because the Irish feared retaliation from the English or because they mistrusted the Spanish, the six Spanish ships left, but not before burning and sinking one of their badly leaking vessels, the *Annunciada*, so as to keep it out of the hands of the Irish and English. The part of the Irish coast north of Loop Head is called Spanish Point because the local people hanged several captured Spanish from two of the Armada ships that wrecked nearby. The place of burial is called "Spaniards' (or Spanish) Graveyard."

Those Spanish wrecks and many others that occurred along the coast were often a means of survival for the Irish who were just eking out a survival from fishing and farming. However, throughout the British Isles, subjects of the Crown had to obey the Statute of Westminster (1295), which stated that a ship or its goods could not be adjudged a "wreck" if any man, dog, or cat escaped alive out of the ship. The local sheriff was supposed to keep the goods for a year and a day to see if anyone could prove title to them. If no one could, he was to do his best to make sure they went to the king. Official records are full of accounts of people laying claim to goods from wrecks even though the ship had survivors. Judges would have to clarify such cases and determine who had legal right to the goods from the ships. Sometimes the shipowner, shipper, those on the local scene engaged in the rescue of the ship's passengers and freight, and local merchants would all agree to

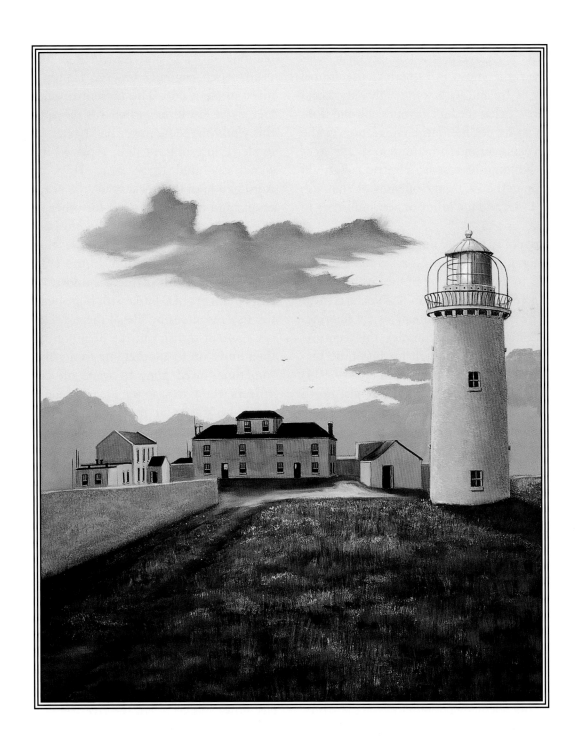

divide the freight among themselves.

The Shannon has long been of vital importance to Ireland, especially the west coast, but also far inland up its navigable parts. The city that relies on the river the most is Limerick, the fourth largest city of Ireland with some eighty thousand people. The city has seen its fortunes ebb and flow, sometimes to its decline (large emigration in the nineteenth century) and sometimes to its advancement (the building of a hydro-electric facility on the Shannon in the 1920s, the opening of Shannon Airport in 1945, and the influx of new industries in the 1960s).

The river has directly impacted the site, from the founding of Limerick by Norse coming up the river in 922 to the flourishing of the city as a frontier trading colony after the Anglo-Norman invasion in 1169 to the development of a Limerick-Shannon-Ennis industrial complex this century. Limerick, interestingly enough for maritime history, was where John Philip Holland (1841–1914) went to school. Born in Liscannor Bay just north of Spanish Point on the west coast above the Shannon, Holland eventually went to the United States, where he developed the submarine and became one of Ireland's great maritime inventors.

The land just to the north of the mouth of the Shannon at the Atlantic Ocean, on the County Clare side of the river, is called Loop Head, a site that has had a lighthouse since 1670. The first one, which resembled a cottage and housed the keeper and his family, had on its roof a platform with a coal-burning brazier. The original vaulted building that housed the brazier can be seen in the compound, a small building with thick masonry that supported the fire-platform above. Because the site was so distant from governmental oversight, supervision was lax, and maintenance of the facility was not adequate enough to keep the structure in good working condition. At the end of the seventeenth century the light was abandoned and remained so for almost twenty years.

When officials and merchants in Limerick demanded a new light at the mouth of the Shannon, the authorities reopened the structure in

1770, and King George III appointed Mrs. Mary Westby the lighthouse keeper the following year. A new, modern, sixty-foot-tall tower replaced the old one in 1802 and remained in service until 1854, when engineer George Halpin Sr. built a more modern one. The present tower stands 277 feet above sea level and guards the approaches to this vital river. The tower had a fixed light until a modern, intermittent light replaced it, and a fog signal operated there from 1898 until 1972. Automation of the tower made the keepers unnecessary, and in 1991 they left for other sites.

What the lighthouse has witnessed in the last few decades has not always been legal or good for the economy of the region. In the 1970s trawlers worked the mouth of the Shannon, scooping up large numbers of salmon with huge nets, depleting the fish resources by illegal means. Those poachers, content to fish out the Shannon's mouth and then move on to another site to do their damage, sometimes used guns to ward off conservation officers trying to stop the illegal practices.

The waters at the mouth of the Shannon have always been rich with fish. In the 1880s, over fifty fishing vessels out of Foynes were catching vast amounts of fish at Loop Head. In just one month in 1881 fishermen caught one thousand tons of mackerel from the Shannon and exported them to Britain, bringing in an income of forty thousand pounds. More recently the State Electricity Supply Board, which controls the fishing in the Shannon, encouraged different kinds of fishing by releasing millions of locally bred salmon, which would make their way to the Arctic and later return, ready to be caught. As the first lines of the song, "Limerick Is Beautiful," say: "Oh, then, Limerick is beautiful as ev'rybody knows./The River Shannon full of fish beside the city flows." Even today, the river remains remarkably pollution free, a condition its fishermen and boaters are determined to maintain. If the country can develop its fish industry, as maritime experts like Arthur Griffith and John de Courcy Ireland have been urging for decades, many people can prosper from the teeming fishing grounds to the

west of the country. The fishing research in which the Royal Dublin Society has engaged has spurred Irish interest in a field that rightly belongs to them.

Several other lighthouses in the Shannon east of Loop Head Lighthouse play a role in navigation. While one of these is mentioned in Chapter 18 (Tarbert Lighthouse), another one should be noted here: Kilcredaun Lighthouse, ten miles further east on the Shannon, a tower established in 1824. The solid-stone, white tower rose forty-three feet, with the lantern being 136 feet above high water and the keeper's house connected to the tower. Workers built a new house for the keeper in 1966 and converted the beacon to electricity in 1979.

Due south of Kilcredaun is the coastal town of Ballybunion, where in 1919 a young engineer named William Ditcham made the first east-west transatlantic radio-telephone call: "Hullo, America. Hullo, Picken, can you hear me? This is Ditcham of Chelmsford, England, speaking from Ballybunion, Ireland." His colleague in Nova Scotia, J. W. Picken, could not reply because he did not have any answering equipment, but Marconi long-wave transmission from the tiny Irish town had just connected Ireland and Europe to North America.

The Shannon is becoming more popular these days with boaters, who either take their own boats on the river or rent one of the many barges available. The river has 160 miles available for cruising, including two large lakes and many islands. All along the waterway one can see much of Ireland's past in the form of round towers, abbeys, monastic settlements, castles, and Georgian mansions of the Anglo-Irish. Ten locks in the Shannon system help the river drop five hundred feet from its source to the sea at Loop Head. The Grand Canal, beginning at the top of Lough Derg, links the Shannon with Dublin eighty-two miles away. Boaters on the canal: remember to keep to the right, unlike on Irish highways.

Further Reading

de Courcy Ireland, John. *Ireland's Sea Fisheries: A History*. Dublin: The Glendale Press, 1981.

de Courcy Ireland, John. "A Survey of Early Irish Maritime Trade and Ships," in *The Irish Sea: Aspects of Maritime History*, edited by Michael McCaughan and John Appleby. Belfast: The Institute of Irish Studies, 1989, 20-25.

de Courcy Ireland, John. "2 Great Maritime Inventors: John Philip Holland and Charles Algernon Parsons," *Ireland of the Welcomes*, 24, 1 (January-February 1975), 31-34.

Fallon, Niall. *The Armada in Ireland*. London: Stanford Maritime, 1978, 140-53 [about the Spanish Armada in the Shannon].

Fisher, Jr., Allan C. "Where the River Shannon Flows," *National Geographic*, 154, 5 (November 1978), 652-79.

Ginna Jr., Robert Emmett. "Down the Storied Shannon," *The New York Times*, June 12, 1994, sec. xx, 8+.

Hague, D.B. "Irish Brazier-Lighthouse" [about the first lighthouses at Loop Head], *The Keeper's Log*, 7, 1 (fall 1990), 24-25.

Long, Bill. *Bright Light, White Water: The Story of Irish Lighthouses and Their People*. Dublin: New Island Books, 1993, 138-39 [Kilcredaun], 139-40 [Loop Head].

MacSweeney, Edward F. "When Ireland Linked Two Worlds" [about the laying of the transatlantic cable and the call from Ballybunion, Ireland], *Ireland of the Welcomes*, 18, 4 (November-December 1969), 35-38.

O'Neill, Timothy. *Merchants and Mariners in Medieval Ireland*. Dublin: Irish Academic Press, 1987, 116+: about the Statute of Westminster.

Schulz, Walter. "Shannon River Pilgrimage," *Yachting*, 157, 2 (February 1985), 46+.

INISHEER LIGHTHOUSE

20

County Galway

The three main Aran Islands near the mouth of Galway Bay have become famous because of one of Ireland's best-known authors, John Millington Synge (1871–1909). The islands are just five miles northwest of the Cliffs of Moher in County Clare and six miles south of the islands off Connemara, but they seem far away from the mainland in many ways. The largest of the three Arans and the only one accessible by large craft, Inishmore ("Inis Mór" in Irish) or Aranmore, is about eight miles long by two wide, comprising 7,635 acres. The middle island, Inishmaan ("Inis Meáin" in Irish), is three miles long by two wide, comprising 2,252 acres. The smallest island, the most southerly, Inisheer ("Inis Oirr"), is nearly round in appearance, comprises 1,400 acres, and is just five miles from the mainland.

Although the pervasive sound around the Arans is of the ocean crashing on the rocks, the

How many people know that the infinite variety of patterns of Aran jerseys derive from the fact that each family originally had its own design, and that this was a way of identifying drowned Aran fishermen?

— T. G. Wilson,
The Irish Lighthouse Service

weather there is actually milder than that of the rest of Ireland. Occasionally, however, fierce weather can whip the islands, especially in winter, when storms can make passage to or from the Arans impossible for weeks at a time. While administratively part of County Galway, the Arans are historically and geologically close to the Burren in County Clare and rise from the flatness of the beaches facing Galway Bay to three-hundred-foot-high cliffs facing the Atlantic Ocean. More than four hundred different wildflowers grow on the islands, but there are few trees.

Among the historic sites that many visit are Inishmore's large, prehistoric stone fort (Dun Aenghus), early Irish churches, and a sixteenth-century castle; Inishmaan's prehistoric forts (Dun Conor and Dun Moher); and Inisheer's stone fort (Dun Formna) and medieval oratory. Because of their remote location off the west coast of the

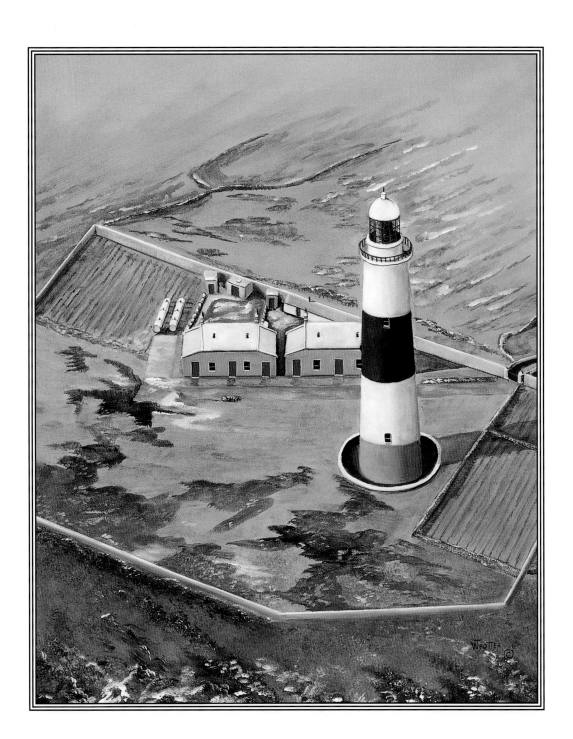

country, those islands have been for centuries a place of refuge for persons defeated in battle or fleeing danger, including Catholic priests escaping the mainland during Cromwellian times. The later, more abundant ruins date from the early and medieval Christian period (fifth century–sixteenth century) when the Aran monasteries were important cultural centers.

In order to put an end to tenant farming, an official body called the Congested District Board of Ireland bought those islands from their absentee Anglo-Irish owner in 1921 and distributed the land to the Aran Islanders at low cost. Changing circumstances have forced the islanders to adapt their means of earning a living over the decades, from farming to fishing to knitting sweaters to accommodating the one hundred thousand summer visitors a year, and many have done relatively well. The fishing improved in the early 1900s after a group of deep-sea fishermen from Arklow on the east coast showed the local fishermen how to fish for spring mackerel. As in much of Ireland, the lack of opportunities has led to a decline in the islands' population, from 3,521 in 1841 to about 1,400 more recently.

The little town of Rossaveal north of the Arans became the most important fishing port on Galway Bay after an expensive pier was built there in 1973. More and more Irishmen are beginning to realize that the country's offshore waters were the only European fishing grounds that were not over-exploited, that the Irish (rather than foreigners) should be the ones to fish those grounds, and that the country should become the chief fish processor for Europe. Whether the Irish as a whole come to the same conclusion and break away from their long-standing dependence on agriculture remains to be seen. For decades in this century, Irish politicians have come from an agriculture background and, therefore, have seemed reluctant to change the country's economic base to rely more on the sea. One man who, because of the great respect he had among the Irish, might have convinced the Irish to look more to the sea, Arthur Griffith, died soon after Irish independence and was, therefore, unsuccessful in changing the views of politicians.

The islanders are great musicians and storytellers, a fact that influenced the great playwright, John Millington Synge, to go to the Aran Islands in 1898 with the encouragement of another great Irish writer, William Butler Yeats. Synge went there to study the folkways and language of a people who had developed a unique way of life in years of isolation from the rest of Ireland. Although Synge visited the islands only four times between 1898 and 1901 and spent a maximum of only six weeks there, he drew much inspiration from the people and went on to write a diary, *The Aran Islands* (1907), and the play, *Riders to the Sea* (1904). Two of his other plays, *In the Shadow of the Glen* (1904) and *The Playboy of the Western World* (1907), were inspired from stories he had heard on Inishmaan. The writer Liam O'Flaherty was born on Inishmore, and Robert Flaherty's film, *Man of Aran* (1934), told the world about these islands.

The Arans have several lighthouses. Inishmore, the largest island, had an early lighthouse, from 1818 to 1857, when officials discontinued it because they had built it on the highest point of the island, too high to be seen by ships in heavy fog. Workers replaced it in 1857 with two structures: one on Inisheer (see below) and one on Eeragh (An tOileán Iarthach) off the northern tip of Inishmore. That small island is also called the Western Island or Rock Island and is separated from Inishmore by another small island, Brannock Island. Made of local hard limestone and painted with different colored bands, the structures were eventually automated and demanned in 1978. The Eeragh Lighthouse has a stone wall enclosing the tower and a long building in which keepers could stay. The rectangular wall that surrounds the complex seems designed to keep out the sea, which crashes on the nearby rocks during storms, rather than the rare visitor on a day-trip from one of the other islands.

Today on Rock Island one can walk across the deserted site and see several roofless outhouses, an old lime-kiln, and holes in the rock where workers took out the blocks for the building of the

tower. The tall, white lighthouse with its two horizontal bands of black stands 115 feet above high water. The keepers lived in a long, single-story building of gray limestone. Writer Tim Robinson wrote a description of the men there that may describe many such keepers: "The lighthouse keeper (I generalize) is of a phlegmatic and inward temperament, engendered perhaps by the tinned diet of baked beans and Irish stew or the restriction of exercise to left-handed ascents and right-handed descents of the corkscrew stairs" (112). After a month on duty, the men must have eagerly looked forward to their month off with their family on the mainland.

Another lighthouse is on Straw Island (Oileán na Tuí), a structure that local fishermen successfully petitioned to be built in 1878 to light Kilronan Bay. Keepers lived at Straw Island Lighthouse on the isolated island until the light was automated in 1926. Today a small wind-charger keeps the tower electrified, and one will see otters' pawprints on the damp sand around the little eleven-acre island where the keepers used to walk. The lighthouse board also had a directional light built in 1983 at Cashla Bay north of Inishmore to light the ferry lane to Rossaveal Harbour.

The southern island, Inisheer, has a lighthouse which was automated and the keepers withdrawn in 1978. Inisheer's lighthouse (pictured here), also known in the service as South Aran Lighthouse, is a massive tower with a white light of 79,000 candelas and a red sector of 16,000 candelas. The two-mile walk to the lighthouse allows the visitor to pass through primitive agriculture, boat-building and other industries in progress all around. There one sees currachs being built, to be used for off-shore fishing, propelled either by manpower or nowadays by the ubiquitous outboard engine. On the way to the lighthouse one passes between stone walls that demarcate the different plots of land. One can also see on the island, which is seldom visited by most visitors because of its relative inaccessibility, O'Brien's Castle, a fifteenth-century fort on the highest point of the island, from which one can see the great Cliffs of Moher in County Clare on the mainland. Also on the island is the sunken church of Teampall Chaomhain, the church of St. Cavan. Once a year the island hosts a festival that includes the sport of hammer-throwing; people arrive by currach or motorized boat from the other islands and the mainland.

Finally, Inisheer is the site of a school that teaches Gaelic, the speaking of which is encouraged with financial incentives by the Irish government. Ireland has some 50,000 people who speak Gaelic as their first language and another 50,000 who know it as their second language. Some of those who speak Gaelic as their first language live on the Aran Islands, although the islanders also speak English, partly because the people of the mainland, for example, many from Galway, looked down upon non-English-speakers, especially during England's domination of Ireland. Once Ireland gained its independence, Gaelic flourished again on the islands and at other places like Connemara, Donegal, southwest Kerry, Meath, and Waterford.

Further Reading

de Courcy Ireland, John. *Ireland's Sea Fisheries: A History*. Dublin: The Glendale Press, 1981, 86 [about the fishing].

"Eeragh," *Beam*, 11, 1 (no date), 14-15.

Harvey, Brian. "Changing fortunes on the Aran Islands in the 1890s," *Irish Historical Studies*, 27, 107 (May 1991), 237-49.

Long, Bill. *Bright Light, White Water: The Story of Irish Lighthouses and Their People*. Dublin: New Island Books, 1993, 146.

Mould, Daphne D.C. Pochin. *The Aran Islands*. Newton Abbot, Devon, U.K.: David and Charles, 1972.

O hEithir, Breandan and Ruairi, eds. *An Aran Reader*. Dublin: Lilliput Press, 1991.

Robinson, Tim. *Stones of Aran: A Pilgrimage*. Gigginstown, Mullingar, Ireland: The Lilliput Press, 1986, 111-13, 273-74.

Síocháin, P.A.Ó. *Aran: Islands of Legend*. New York: Devin-Adair Company, 1962.

Smith, Dennis. *Aran Islands: A Personal Journey*. Garden City, N.Y.: Doubleday Company, 1980.

Synge, J.M. *The Aran Islands*. Oxford: Oxford University Press, 1979.

Wilson. T.G. *The Irish Lighthouse Service*. Dublin: Allen Figgis, 1968, 65-69.

BLACKHEAD (CLARE) LIGHTHOUSE

21

County Clare

The Burren is a country where there is not water enough to drown a man, wood enough to hang one, nor earth enough to bury him.

— English saying

County Clare's squat lighthouse, standing at the edge of Ireland's most unique geological formation, seems dwarfed by the two tall mountains behind it: Slieve Elva (1,134 feet) and Gleninagh Mountain (1,045 feet). To the south lie the immense heights of the Cliffs of Moher, rising six hundred feet above the ocean, extending five miles along the coast, and offering nooks and crannies to thousands of screeching seabirds flying in and out of hidden nests in the sheer rock face. Tradition has it that local emigrants heading for America would have one last meal at a large stone table near the cliffs, a sight they could see when they headed out from Galway the next day for a new life. The nearby O'Brien's Tower, one of many such lookout posts along the coast of Ireland, has offered a magnificent view of the ocean since 1853. It is emblematic of the many watchtowers along the Irish coast that sentries have used in looking for friend and foe coming from the ocean.

Bing Crosby fans know this area from the words he sang about wanting to "watch the sun go down on Galway Bay." Far more important for the maritime history of Ireland were the notes that Christopher Columbus, who stopped in Galway in 1477 on his way to Iceland and heard stories about lands to the west, scribbled in his copy of Aeneas Sylvius's *Historia Rerum*: "We have seen many remarkable things, especially in Galway of Ireland." While in Galway, Columbus supposedly learned of the corpses that washed ashore with faces different from those of European Christians. If the great navigator assumed from the description that the bodies were those of an Asian princess and her bodyguard and that Cipango (Japan) lay out there to the far west, who knows how much that Galway experience may have encouraged him to set sail in 1492 for the New World?

Today Galway with its 37,000 residents is one of the largest cities in Ireland and attracts some one hundred thousand visitors a year, many on

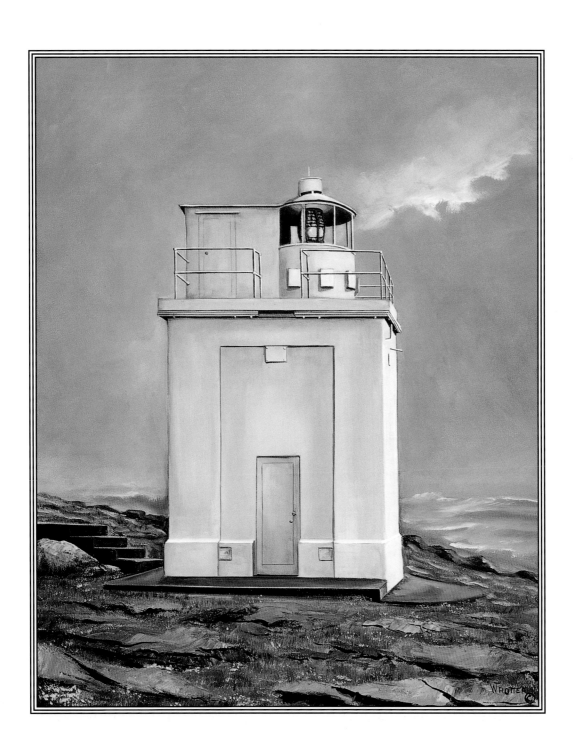

their way to visit the Aran Islands, but many to visit the local university, Kennedy Park (which honors the late president's visit there in 1963), and such unusual sculpture as the steel sculpture of the Galway hookers, traditional area boats that ferried goods across Galway Bay. The city celebrated the five hundredth anniversary of its city charter in 1984, at which time urban renewal efforts were undertaken to rebuild the long-neglected docklands.

On the way out of Galway Bay stands Blackhead Lighthouse on a promontory in County Clare at the edge of one of the most unique geologic sites in Europe, The Burren, a rocky landscape of eroded limestone hills and rock fissures. The barren nature of the place once inspired a seventeenth-century English general to damn the treeless site: "It is a country where there is not water enough to drown a man, wood enough to hang one, nor earth enough to bury him."

The loss of the *Pomona* near Tuskar Lighthouse in 1859 raised again the serious question of whether Ireland, specifically Galway, would be able to operate a packet service to America. Such a service would take away the necessity of having to travel first to Dublin and then across the Channel to Liverpool. *The Irish Times*, in urging all Irish cities to pull together for the Galway service, pointed out the dangers of Liverpool for the Irish:

> Here [in Liverpool] a thousand dangers and temptations await them. They are set upon by an army of touters, crimps, and lodging-house keepers, who bring them, wearied with sea sickness, into the worst of purlieus of the town, ply them with drinks, and, if they do not take the whole, seriously diminish their little capital. The records of the Liverpool Police Courts disclose a fearful amount of robbery and turpitude committed upon the Irish peasants. The Galway station would at once put an end to this nefarious system.

The most fearful and disastrous wrecks are those which take place annually in the passage from Liverpool round the coast of Ireland. The single wreck of the unfortunate Pomona threw into the sea [cargo worth] double the cost of a year's subsidy to Galway, besides the loss of life. (August 26, 1859)

Such arguments helped to convince authorities to allow Galway to establish its transatlantic service, but numerous bureaucratic and competitor-contrived obstacles, a lack of capital, and the dearth of decent ships eventually killed the venture.

Galway Bay has played a major role in the maritime history of western Ireland, partly because its location, east of the exposed Aran Islands away from the direct onslaught of the fierce Atlantic, offered protection for passing ships seeking shelter. As a result, the water in front of Blackhead Lighthouse became, in the 1920s and 1930s, the anchorage for transatlantic ships which would wait for smaller ferries to take passengers into Galway and over to the Aran Islands. To increase their maritime desirability, the people and officials of Galway agreed to pay for the building and maintenance of the Blackhead Lighthouse on the promontory overlooking the bay. With such local cooperation and a willingness to commit their financial resources for a necessary navigational aid, the lighthouse service built the structure in a relatively short time. The white concrete tower, built in 1936, is sixteen-feet, nine-inches high and thirteen-feet, four-inches square, with the focal plane of the light sixty-seven feet above high water. The name Blackhead, instead of the more appropriate Burren Head (Ceann Boirne in Irish), may have something to do with the appearance of the promontory in foggy, murky weather.

The fortunes of the lighthouse have fluctuated in the past five decades, depending on the economic fortunes of Galway. The start of World War II in 1939, for example, ended the practice of transatlantic liners calling at Galway. Even after the war, the traffic never reached its pre-war levels, and conditions looked bleak for the contin-

uance of the light. It survived a threat to have it discontinued in 1952, but when the Galway Harbour Commissioners announced that they were considering discontinuing the light, Irish Lights agreed to take it over in 1955. The attendant keeper at Blackhead since its establishment, John Casey, was kept on with an increase in wages, until he finally retired in 1980, after forty-five years service at the station. Until workers installed a clock timer at the site, keeper Casey had had to cycle six miles a day every day for nineteen years in order to turn the light on one hour before sunset and then turn it off one hour after sunrise. When he retired, his son, Joseph, took over from him and continued a long tradition of Caseys at Irish lighthouses.

Two other nearby lighthouses deserve mention, the first northwest of there: Slyne Head Lighthouse on Oileanaimid Island. The island had two lighthouses from 1836, when they were finished, until 1898, when one of them was darkened in favor of a red light built on the mainland. The other light was eventually automated and demanned in 1990. The structures there had a long tragic history, both from several drownings of workers and keepers and also from the 1859 poisoning of a newly assigned replacement keeper by the wife of the sick keeper being replaced; the wife thought that her son should have been the replacement and apparently poisoned the new keeper.

East of those lighthouses, in a bog on the mainland, is the Marconi station, where, in October 1907, the first commercial wireless message had been sent across the Atlantic. Also in that bog is the place where aviators John Alcock and Arthur Whitten-Brown crash-landed their plane in 1919 after flying from Newfoundland on the first nonstop transatlantic flight. Today a monument at Errislannon, overlooking Derrygimla bog near Clifden, marks the site of the landing of the 16 1/4-hour flight, which the two men made to win a newspaper prize. In 1928, the lighthouse keeper at Slyne Head would have seen the German airplane *Bremen* passing overhead on its way to make the first successful east-west transatlantic flight.

The other structure to be noted is the former Mutton Island Lighthouse on a small island in Galway Bay near Salthill. The island is so low that during high tide the water will sometimes breach the wall surrounding the lighthouse compound, and in low tide one can walk out to the island on weed-covered rocks. One can sometimes see pickers from Salthill walking out to gather their periwinkles. The number of vessels that have grounded in the area points out how well one must know the channel and sandbars. A lighthouse has stood on the island since 1817.

Living there was so hard on a family that the lighthouse service in 1923 finally granted the keeper an education allowance whereby he could educate and board his three children in Galway. The light became unwatched in 1958, but a solar mechanism at the top turned the light on and off, depending on the time of day. The light was finally extinguished in 1977 because of all the bright lights of Galway in the background, but two new lighted buoys nearby helped mariners entering and leaving the harbor. The Galway Harbour Commissioners are now in charge of Mutton Island. A ferocious controversy in the 1990s deals with a proposed plan to build a large sewage plant on Mutton Island. Whether environmentalists or government officials will win is still not clear.

Further Reading

Costeloe, M.P.L. "Blackhead (Clare)," *Beam*, 14, 2 (October 1985), 18-22.
Costeloe, M.P.L. "Mutton Island," *Beam*, 10, 1 (no date), 6-9.
Long, Bill. *Bright Light, White Water: The Story of Irish Lighthouses and Their People*. Dublin: New Island Books, 1993, 143-45, 147-52.
Sweeney, Maxwell. "Prelude to the ATLANTIC SKYWAY" [about the east-west flight of the *Bremen*], *Ireland of the Welcomes*, 27, 5 (September-October 1978), 33-37.
Villiers-Tuthill, Kathleen. "Ditched in Derrygimla: the first transatlantic flight of Alcock and Brown," *History Ireland*, 2, 4 (winter 1994), 42-47.
White, Sean J. "The Burren of Clare," *Ireland of the Welcomes*, 27, 3 (May-June 1978), 24-28.

INISHGORT LIGHTHOUSE

22

County Mayo

. . . Every currach on the west coast carries inside the prow a small bottle of holy water and also, in many cases, a small medallion of St. Christopher, the patron saint of travellers.

— Thomas Mason,
The Islands of Ireland

This is the story of three lighthouses in Clew Bay (Clare Island, Achillbeg Island, and Inishgort) and of Granuaile (also known as Grace O'Malley), one of the most remarkable, colorful women in Irish maritime history. Clew Bay is near one of the most isolated parts of western Ireland, has many islands, and nearby on the mainland is the mountain of Croagh Patrick, the site of yearly pilgrimages and the place where some people believe that St. Patrick lured all the snakes in Ireland to their death.

Throughout these waters roamed the famous Grace O'Malley (1530–1603) ("Gráinne ni Mháille" in Gaelic, or "Granuaile"), after whom the flagship of the Irish Commissioners of Lights is named: *Granuaile* (pronounced "gran-YOU-whale"). Granuaile was a very pragmatic leader, fighting for or against England, depending on the issue in the mid-sixteenth century and how it affected her Clew Bay. The many islands of that bay, some say as many as 365, enabled her to elude capture and roam at will after her pirates had plundered passing ships in and near Galway Bay to the south. Although much of her story is unknown, she may have spent her childhood in a castle on Clare Island, which also may be the site of her grave in the Carmelite friary, founded on the island in 1224 by her family, the O'Malleys. So confusing were the allegiances at any one time and so important were local alliances compared to broader connections to the nebulous "state" that some of the family assisted survivors of the wrecked Spanish Armada ships, while others slaughtered as many as they could find. As noted in *The Great O'Neill*, "A stranger walking among them went barefoot in a field of basilisks."

Clare Island, which sits at the western entrance to Clew Bay and protects it from the force of the Atlantic Ocean, was her headquarters

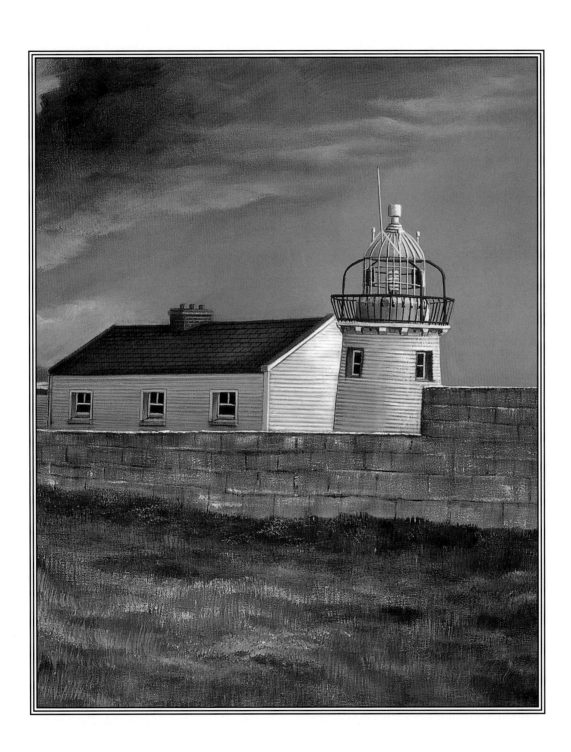

during Elizabethan times. She ruled with a strong hand, exacting tolls on ships passing by and attacking those that ignored her. Once, when Queen Elizabeth I wanted to make her a queen or a countess, Granuaile refused, saying that she was already a queen and of equal rank with Elizabeth. One story about Granuaile is that, when she visited Queen Elizabeth in London, the queen, who was shorter than the Irish pirate, had to raise her hand in salutation. Granuaile may also have shocked the English court by appearing topless, a fashion that so delighted the onlookers that many of them adopted it, including Elizabeth.

On her way back home, Granuaile stopped off to see Lord Howth at Howth Castle, but when he was rude to her, she kidnapped his son and sailed away. She eventually released him after obtaining a promise from Lord Howth that he would never commit such an outrage again, and, according to legend, an extra place is always set at dinner at Howth Castle. One can see in the ruined abbey on Clare Island a mural slab with the O'Malley arms and motto, which translates as "O'Malley powerful on land and sea." Granuaile demonstrated that power in many ways. She married twice, the second time to Sir Richard Burke, who agreed that after one year of marriage either party could dissolve the union. After she placed her own men in her husband's castles along the coast, she then severed the union, keeping the castles instead of the husband.

Clare Island is different from other islands on the west coast. First of all, so much water and bog fill the island that farmers have to cut many drainage ditches in order to dry out enough land to grow oats and barley. Although many farmers have donkeys to carry the turf which the people cut, the farmers also have horses because the larger animal can carry much more than a donkey can. Also the bog, from which the people cut the turf, is at a distance from their farms. Among the strange sights on the island is that of domestic geese eating alongside the sheep on the mountain slopes. Farmers can identify their own geese by inspecting the holes cut in the birds' webs between the claws of the feet.

The farmers cut seaweed from their own particular, claimed rocks at low tide, float it to shore at high tide, and then collect and spread it over the crops for a type of manure. Basking sharks cruise the waters looking for fish and have been known to attack the small currachs that the fishermen use. On the western tip of the island is an eighteenth-century coastal lookout tower, one of many that dot the Irish coast.

Just how rough a coast these western islands provide the seafarer is clear from a description in *The Irish Times* (February 2, 1860) of a shipwreck in the area:

> During the terrific storm which raged on Saturday, the 21st inst., [January 21, 1860], the barque Neptune, Captain Wimble, was driven ashore under the cliffs of Neenawn, Achill. The sails had been previously blown away, and the ship thrown on her beam end. In this condition she was driven on the rocks at about ten P.M. One of the crew and an apprentice were washed overboard. The rest, with the captain, succeeded in gaining a ledge of rock, by means of the mast and spars, which leaned against it. The captain showed the greatest coolness throughout. They remained in that position during the night, and in the morning were discovered by some of the inhabitants of a neighboring village, who showed them a pass up the cliffs. One poor fellow who had a compound fracture of his leg managed to crawl with the rest. Had the vessel gone ashore 100 yards to the right, not a soul could have been saved, as the cliffs are 1,000 feet high, and almost like a wall. . . . Such a gale has not been known on the Western coast [in] twenty years.

Clew Bay definitely needed at least one lighthouse to help ships maneuver among the islands and to avoid being wrecked on the shore, and so the Marquis of Sligo built one on the northern

extremity of Clare Island in 1806. The Dublin Ballast Board took over the lighthouse in 1810 and operated it until fire destroyed the tower in 1813; the fire was the result of throwing the snuffings of the used wicks into a tub, to be disposed of later. When the wicks fell out of the tub, they ignited the lantern and burned down the tower. It took several years for another tower to be built and lit in 1818. Fire was just one of the dangers of light-keeping in the early 19th century, as was the threat of lightning hitting the tower, which happened there in 1834. One can still see the ruins of the old tower and keepers' quarters at the site. A minor crisis occurred in 1837, when the local priest accused the principal keeper of trying to convert the Roman Catholics on the island to another sect, but nothing came of the accusations when the priest could not produce any affidavits from the persons affected.

The Clare Island Lighthouse, which sits on a high, sheer cliff at the western entrance to Clew Bay and commands a magnificent view of a rugged part of the Irish coast, may have the most picturesque location on the whole coast, and the keepers spent much time searching the horizon for ships and schools of fish; one of them noted that he saw a beluga whale in 1948. The light was finally extinguished in 1965, after 159 years of good service, on the grounds that the tower was superfluous to the maritime needs of the area.

In 1966 a family bought the premises for use as a holiday home, but allowed it to deteriorate. An American family, the Conlons, then acquired the property and set about waterproofing the buildings and ending the deterioration. More recently Robert Timmermann of County Cavan acquired it and transformed it into apartments and a dining area, including a museum with artifacts from the history of the lighthouse there. Today, the Clare Island Lighthouse is a holiday activity center, providing a different kind of service to people than was originally planned, but nevertheless adapting to the changing times.

A new, unwatched electric light on Achillbeg Island to the north of Clare Island replaced the Clare Island light. The Achillbeg Lighthouse, which stands 180 feet above sea level, has been in operation since 1965. As is true at many places along the coast, the height of the tower allows a relatively small structure, one that is less immune to the fierce winds whipping off the ocean.

The third lighthouse, Inishgort (pictured here) is a Harbour Light which can be seen ten miles away in clear weather and guides ships into and out of Clew Bay. After the Marquis of Sligo and the merchants and shipowners of Westport petitioned for a lighthouse for the bay, the great engineer of Irish lighthouses, George Halpin Sr., designed the structure, using coarse limestone. Workers finished it in 1827.

Further Reading

Chambers, Anne. "'A Most Famous Feminine Sea Captain,'" *Ireland of the Welcomes*, 33, 3 (May-June 1984), 38-42.

Costeloe, M.P.L. "Cliara - Clare Island," *Beam*, 1, 1 (December 1969), 14-16.

de Courcy Ireland, John. *Ireland and the Irish in Maritime History*. Dublin: The Glendale Press, 1986, 108-09.

Long, Bill. *Bright Light, White Water: The Story of Irish Lighthouses and Their People*. Dublin: New Island Books, 1993, 152-54.

Mason, Thomas H. *The Islands of Ireland*. London: B.T. Batsford, Ltd., 1950, 41-47: "Clare Island."

McIlwaine, Peter. "Back to the Future — at Clare Island Lighthouse," *Beam*, 22, 1 (December 1993), 27-28.

O'Faolain, Sean. *The Great O'Neill: A Biography of Hugh O'Neill, Earl of Tyrone, 1550-1616*. New York: Duell, Sloan and Pearce, 1942, 150, 235-36.

Viney, Michael. "Clare Island," *Ireland of the Welcomes*, 41 (1992), 10-15.

Wilson, T.G. *The Irish Lighthouse Service*. Dublin: Allen Figgis, 1968, 70-72.

BLACKSOD LIGHTHOUSE

23

County Mayo

The glorious scenery of mountain, sea and cliff with their exquisite colouring forms a combination which I have never seen equalled elsewhere and which an artist told me caused him intense delight and also despair — delight at the magnificence of the colouring, and despair at his inability to record on canvas the everchanging beauty which he saw.

— Thomas Mason,
The Islands of Ireland

In the southeast corner of the Mullet Peninsula above Achill Island in County Mayo on Ireland's west coast at the end of a long road stands the Blacksod Lighthouse. More protected than other such structures, especially the isolated Blackrock Lighthouse to the west out in the Atlantic, this tower lies just north of Achill Island. The squat, two-story building consists of a square tower with the lantern on top and the keepers' quarters in the building below. Used in conjunction with Blackrock Lighthouse off the coast, the tower, built in 1865 with locally quarried reddish-gray granite, began operating in June 1866 to make Blacksod Bay relatively safe for mariners.

That lighthouse became even more important when a mackerel fishery was opened in the area at the turn of this century. The development of the fishing industry helped the large, poverty-stricken population of the area by providing both food for the families and income from the sale of the fish. The structure also served as a post office (1969–1972), while a new building was being built, and thus became possibly the only Irish-lighthouse-turned-post-office. Nearby were quarries that produced high-quality red granite that was shipped all over the world, providing much-needed work for local residents.

The lighthouse keeper there gave the weather forecast that enabled General Eisenhower to make the decision to land Allied forces in Normandy, France, on D-Day, June 6, 1944. Some meteorologists had predicted a week of bad weather for France at the beginning of June. The Germans believed this forecast and Field Marshal Rommel left the front lines in France to visit his

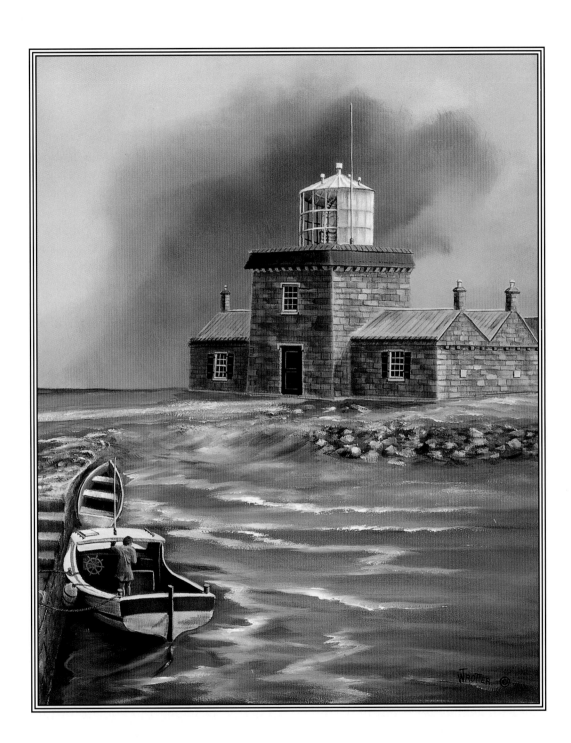

family in Germany. The observer at Blacksod Bay predicted a mid-week break and Eisenhower acted on that prediction. The fact that the lighthouse keeper at Blacksod made the forecast is significant in light of present-day cutbacks in the number of manned lighthouses in Ireland and throughout the world. Because lighthouse keepers have often been relied on to provide accurate weather reports on a daily basis, the decreased use of manned towers has necessitated such groups as the Meteorological Office in the United Kingdom to issue a call for volunteers to make the daily weather reports that the keepers used to do. Lighthouse keepers have also served as lookouts watching for submarines in times of war.

The lighthouse keeper at Blacksod Bay was also one of the first to help Tom McClean when the sailor landed in July 1969 after rowing across the Atlantic Ocean in seventy-two days to become the first person to perform the feat alone from west to east. That keeper, Ted Sweeney, was like many Irish keepers in that he had three sons who also entered Irish Lights to serve at installations around the coast or on one of the service's tenders. One of his sons, Vincent, was stationed at the Blacksod Bay tower when huge waves crashed over the four-foot-thick wall surrounding the lighthouse, broke down the door, and flooded the first floor. Such storms have plagued the area, especially the offshore islands, for centuries. Some of the many boulders in the area around Blacksod Bay were tossed there by the sea in one of its many angry moods.

The Blackrock (Mayo) Lighthouse to the west, at 282 feet above high water, is one of the tallest in Ireland, topped only by Mine Head Lighthouse east of Youghal on the southern coast. The Blackrock tower, with the highest derrick landing of all Irish lighthouses, is one of the most inaccessible sites, even by helicopter, because of the inclement conditions prevalent so much of the year. Its proximity to the continental shelf and its lonely position out in the ocean make it a formidable place to live and work. The fifty-foot-tall tower, operational since 1864, is made out of stone from the rocky island on which it stands and faces the west, from where the Atlantic Ocean can roar in with brutal force. Mariners twenty-two miles away can see the light from the tower on a clear night.

Next to the tower is the keepers' dwelling, where bad weather kept many a keeper from leaving and where families lived for an amazing twenty-nine years, without benefit of formal schooling and without gardens to tend or animals to raise. Living conditions for the keepers and their families were very difficult until cottages were built on the mainland. In 1893, workers finished quarters for the keepers' families in Blacksod on the mainland, at which time the families moved to the safety of shore. When the tower was automated in 1974, the keepers left the island for good. Today, in order to inspect the apparatus and make sure all is working well, an occasional attendant will spend a night there, flying by helicopter in a time relatively short compared to the long, arduous trip in former days. From 1969 on, a helicopter base at Blacksod has serviced the towers at Blackrock and Eagle Island, ending the dangerous reliance on boats to ferry men to and from the rocks. As is true in all Irish lighthouses, in order to prevent sun damage to a stationary lens, a slow-moving mechanism keeps the optic rotating during the day.

That particular lighthouse, usually called Blackrock Mayo to distinguish it from Blackrock Sligo, sustained gunfire from a hostile force. In World War II a German plane attacked the SS *Macville* in the deep water near the lighthouse, and stray bullets shattered panes in the lighthouse lantern, but the keepers were unhurt.

A writer in *The Irish Times* in 1860 pointed out that "it is impossible to conceive any position in which a lighthouse could be of more service than on the Black Rock," not only because that area is the first seen by many people coming from North America, including those going to Liverpool by the northern route around the top of Ireland, but also because of the many dangers awaiting unsuspecting mariners on the nearby coast.

Finally, Achill Island to the south needs to be mentioned, although the lighthouse on Achillbeg off its southern coast was described in conjunction with Inishgort Lighthouse of Clew Bay (Chapter

22). Achill Island, Ireland's largest, is connected to the mainland by a bridge. The waters off its shores can be very dangerous, as became clear in 1979 when the fishing boat *Lios Carra* wrecked off Dooega Head and three local fishermen lost their lives.

As elsewhere, the islanders engage in fishing and agriculture, but tourism is playing an increasing role in the island's economy. One rather unusual fishing practice there is the netting and spearing of basking sharks by fishermen in tiny currachs in the summer; the sharks are harmless to swimmers, but provide oil for use in pharmaceutical products. Living on such islands has often been fortunate during times of famine since islanders could not only fish for their sustenance, but could also find limpets, oysters, periwinkles, and scallops, as well as porpoises, seals (which could also be used for their skins), and the occasional stranded whale.

Visitors should be aware that many villagers there do not want their photographs taken, especially because photographers in the past have made posters of scenes from the island in a demeaning fashion. One visitor in 1974 found that so many of the people had an O'Malley or Gallagher last name that they used nicknames to distinguish each other, nicknames like "little Tony" and "small Tony" and "wee Tony" for three different people. The seven-hundred-foot-high cliffs along the northwestern edge of the island give a magnificent view of the Atlantic Ocean. Two impressive peaks, Croaghaun and Slievemore to the north of the cliffs, each rise some 2,200 feet from the ocean.

The idyllic beauty of this part of Ireland hides the fact that it witnessed some fierce battles in the past. In 1798, for example, French forces landed in Killala Bay to the northwest and tried to join up with Irishmen fighting against English rule in what came to be known as the Rebellion of the United Irishmen; the English defeated the invaders and killed some thirty thousand Irish rebels. One of those hanged was Father Manus Sweeney of Achill Island. As a curate in the nearby town of Newport, the young priest was accused by the English of sympathizing with the rebels and was hanged in Newport. A monument on Achill Island memorializes this gentle man who died in the long fight for Irish independence.

Further Reading

"The Black Rock, Blacksod Bay, Galway," *The Irish Times*, September 14, 1860, 3.

Costeloe, M.P.L. "Blackrock - Mayo," *Beam*, 6, 2 (no date), 5-6.

Costeloe, M.P.L. "Blacksod," *Beam*, 11, 2 (no date), 6-8; 12, 1 (no date), 14-16.

de Courcy Ireland, John. *Ireland's Sea Fisheries: A History*. Dublin: The Glendale Press, 1981, 86 [about the local mackerel fishing].

Long, Bill. *Bright Light, White Water: The Story of Irish Lighthouses and Their People*. Dublin: New Island Books, 1993, 154-56 [Blackrock, Mayo], 156-57 [Blacksod Bay].

MacNally, Kenneth. "Achill Island," *Ireland of the Welcomes*, 23, 6 (November-December 1974), 8-12.

Mason, Thomas H. "Achill Island." *The Islands of Ireland*. London: B.T. Batsford, Ltd., 1950, 34-41.

"Trooper rows the Atlantic," *The Times* [London], July 28, 1969, 1, 2; also July 29, 1969, 2. Also "British Rower Crosses The Atlantic in 72 Days," *The New York Times*, July 28, 1969, 8. [Articles about Tom McClean]

Zimmer, Naomi. "Sagart Aroon" [about Father Sweeney], *Ireland of the Welcomes*, 40 (1991), 32-33.

EAGLE ISLAND LIGHTHOUSE

24

County Mayo

It is not the tree that is a long time shaking that is the first to fall.

— Irish proverb

A person on Eagle Island in present-day County Mayo watching the sea in the fall of 1588 would have seen a strange, unexpected sight: ships carrying a foreign flag sailing southward looking for a safe harbor and a way to get around Ireland as quickly as possible. Those were the remnants of the Spanish Armada after it had escaped a beating by the English to the east of England and had escaped by going north around Scotland and then south along Ireland's west coast. If any of those ships reached Eagle Island, they had a good chance of continuing on their way south and maybe back to Spain. The problem was that the Spanish charts were incorrectly drawn and did not show the long bulge of the Erris Peninsula.

Where the Spanish pilots expected to find open sea, they instead found forty miles of menacing cliffs in their direct line of flight south. That miscalculation may have caused more wrecks among the Spanish ships on their way home than any other factor. Some historians estimate that approximately one-third of those twenty-six or twenty-seven Armada ships wrecked around Ireland were wrecked along the Erris coast. The strong, westerly wind would be deadly for the square-riggers trying to sail into it and did not allow them to change course easily. The commander of the Armada, the Duke of Medina Sidonia, was himself well aware of the dangers of the Irish west coast and strictly ordered his ships to keep fifty miles out to sea, but a fierce west wind and/or the need for fresh water led some of his commanders to disobey his order.

Eagle Island to the north-northeast of Blackrock Lighthouse used to have two lighthouses (Eagle Island East and Eagle Island West), which were built in 1835, but now has only one on its very isolated, buffeted site. Eagle Island East at a height of sixty-four feet and Eagle Island West at a height of eighty-seven feet were 132 yards apart and had their lanterns at the same level: 220 feet above high water. Mariners would line up the two towers in order to guide their ships past Blacksod

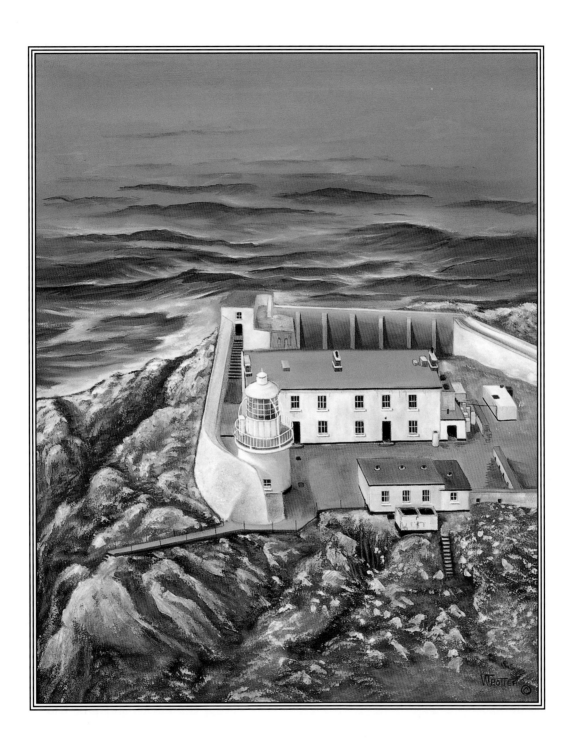

Bay and Broadhaven. The white towers were visible twenty miles away in clear weather.

Lying just to the west of Mullet Peninsula in northwest County Mayo, that fourteen-acre island on the edge of the continental shelf is frequently hit by huge ocean waves. A three-foot-thick stormwall provides some protection, but in fierce gales waves have actually broken over the tower, sprayed the lantern 220 feet high, and sometimes even extinguished it. During one bad storm, so much water poured over and into the tower that the keepers could not open the door, but had to drill holes into it to let the water out before they were able to open it. The ability of the tower to move, even if only a little, during the storm, instead of remaining rigid, has saved that structure and other lighthouses buffeted by strong winds.

During a very bad storm in 1894, the dwellings at the East Tower were irreparably damaged, and the women and children had to take refuge in the structure itself. They must have been very frightened, indeed, when the waves crashed into the tower where they were and poured into the lower part. When the storm eventually subsided, seamen ferried the women and children to the relative safety of Belmullet on the protected side of Mullet Peninsula. In time, more permanent dwellings were built at Corclogh closer to Eagle Island but still on the peninsula. The East Tower was abandoned the next year when the West Tower (pictured here) received a stronger, first-order light.

One of the most difficult days in the history of that lighthouse occurred in November 1940 when one of the keepers spotted a tanker, the *San Demetrio*. A German pocket battleship had attacked it along with the rest of a convoy making its way in the North Atlantic. While most of the other ships in the convoy were destroyed, the *San Demetrio* was so severely damaged the crew abandoned the burning ship. However, the ship did not sink, and after several days five crew members returned to the ship, extinguished the flames, restarted her engines, and headed for Eagle Island, where the keepers spotted her and notified a tug and a destroyer to come to the ship's aid.

The tower, automated and demanned in 1988, has a 1,400,000 candlepower lantern that can be seen twenty-six miles away on a clear night. Very few visitors ever go to the isolated island other than those of the Irish Lighthouse Service on their periodic maintenance trips. County Mayo's position at the west of the country is very isolated as any Irish road map will show. The county has produced some impressive people, for example, William Brown of Foxford (the founder of Argentina's navy in 1814) and Irish President Mary Robinson from Ballina; it also has some of the highest proportions of its youth entering universities (30–33% of the age group), but the economy is hurting.

The Eagle Rock Lighthouse may be the first part of Ireland that pilgrims see as they fly in their jumbo jets to the international airport at the little town of Knock in County Mayo. The pilgrims are making their summer trip to the shrine at Knock, the so-called "Lourdes of the North," where in 1879, fifteen villagers claimed that the Virgin, St. Joseph, St. John, and angels appeared. Each summer as many as 1.5 million pilgrims make the trip there, as did the Pope himself in 1979. The local priest, Monsignor James Horan, raised more than two million Irish pounds to build a modern airport and helped to bring some economic relief to the county.

At such isolated locations, before the lighthouse families were moved to the mainland, everyone would usually pitch in to help, especially in the early days before several keepers were assigned to a tower. The families sometimes suffered the consequences of dangerous lighting mechanisms, especially those that relied on coal or gas. That danger became apparent at a Scottish lighthouse in 1791 when seven members of one family perished. The keeper and his whole family had carried coal from the beach to the top of the island and then to the top of the tower, but they did not properly dispose of the ashes which accumulated around the base of the tower. When observers on shore did not see the light from the tower for three consecutive nights, they took a boat out to see what the problem was. The keeper, his wife, and five

children had been suffocated from the ashy fumes which had seeped into their bedroom. When the mainlanders removed the bodies of the dead, they found that a sixth child was still alive, lying in her dead mother's arms. The youngster, who was rescued and raised by someone associated with the lighthouse, emigrated to America, raised a family, and eventually died in 1845. Her friends inscribed on her tombstone the fact that she had been found as an infant, still nursing from the corpse of her mother.

One early story, used to explain why Irish rock towers had three keepers, concerned the death by natural causes of one of two keepers. Fearful that he would be accused of murder, the lone survivor decided to keep the corpse of his friend until authorities from the mainland could see it and determine that the man died of natural causes. The survivor put the corpse of the deceased in a rough casket and hung it from the ceiling to await the arrival of officials. Bad weather delayed the arrival of those officials so that, by the time they finally arrived, the surviving keeper was close to insanity. That episode may have led to the stationing of three keepers at rock towers.

The keepers at remote rock towers have been known not to speak to one another for months at a time or complain about each other to officials. The advent of television in this century greatly alleviated the boredom of towers, especially because the keepers used to get only monthly mail with an occasional newspaper. The demanning of the towers and the switch to automatic control, while criticized in many places as merely a means to save money and get rid of lighthouse keepers, have meant that families can stay together on the mainland far more than they did in the past, although fewer people will be entering the lighthouse service in the future. Changing from the old reliance on boats to the servicing of the offshore towers by helicopter has also added an efficiency and timeliness.

A harbor light a little to the east of Eagle Island is Broadhaven, just at the northern tip of Mullet Peninsula. It guides ships into the relatively protected confines of Broadhaven past a sunken rock and into the channel up to Belmullet. Established in 1855, the fifty-foot-tall, gray stone tower, today painted white, stands eighty-seven feet above high water and can be seen at a distance of twelve miles in clear weather. It served well as a fixed light until 1924, when it became occulting, that is, having long periods of light alternating with short periods of darkness. In 1977, it was electrified. Compared to the tremendous battering that the Eagle Island Lighthouse has endured over the years, the Broadhaven tower seems snug, secure, and peaceful.

Further Reading

"Ancient Irish Mariners: William Brown," *Beam*, 7, 1 (no date), 19.
Ardagh, John. *Ireland and the Irish: Portrait of a Changing Society*. London: Hamish Hamilton, 1994.
Costeloe, M.P.L. "Broadhaven," *Beam*, 5, 1 (July 1973), 5.
Costeloe, M.P.L. "Eagle Island," *Beam*, 4, 2 (December 1972), 8-10.
Fallon, Niall. *The Armada in Ireland*. London: Stanford Maritime, 1978.
"Green Seas at Eagle Island 1894" [about the December 1894 storm], *Beam*, 7, 2 (no date), 43-44.
Hague, Douglas B. and Rosemary Christie. *Lighthouses: their architecture, history and archaeology*. Llandysul Dyfed, Wales: Gomer Press, 1975, 252-53 [for the story about the Scottish lighthouse].
Long, Bill. *Bright Light, White Water: The Story of Irish Lighthouses and Their People*. Dublin: New Island Books, 1993, 157-59.
Roche, W.P. "A Day to Remember" [about the *San Demetrio*], *Beam*, 5, 2 (December 1973), 8-9.

BLACKROCK (SLIGO) LIGHTHOUSE

25

County Sligo

The section of Ireland from Eagle Island on the west over to Sligo on the east is the longest part of the country to face north. The main port in this stretch is Sligo (population 17,250), a very picturesque town nestled on the Garavogue River between Lough Gill to the east and Sligo Bay to the west. Considered by many to be one of the best shopping towns in western Ireland, it also has a claim to erudition and culture with its annual Yeats Summer School that attracts professors and students from around the world. The fishing in the sea off the coast has improved dramatically this century as more and more ships, many of them from other European countries, comb the area for the best sites. In 1969, a Danish ship left the area with three thousand barrels of salted herring, the first such shipment of its kind from Sligo in decades, maybe centuries. In the late Middle Ages, fish from Sligo was famous in Bristol, then England's second largest city.

Among the major points of the area's maritime

I never did a painting without putting a thought of Sligo in it.

— Jack Yeats,
brother of William Butler Yeats

history were the sacking of the settlement by the Vikings in A.D. 807 and the wreck of at least three ships from the Spanish Armada in 1588. The ancient settlement of this part of Ireland is attested to by the Stone-Age cemetery at Carrowmore, with its sixty passage graves, some dating to 3200 B.C., the largest such cemetery in Ireland. Tradition also associates this area with Queen Mab or Maeve, the first-century A.D. Celtic Queen of Connaught who is the subject of many Irish legends.

Three of the Spanish Armada ships that wrecked here in 1588, with a loss of approximately 1,300 men, were *Juliana*, *La Levia*, and *La Santa María de Visón*. As described in T. P. Kilfeather's *Ireland: Graveyard of the Spanish Armada*, the Armada sailed safely and very skillfully to the Straits of Dover, was routed out of Calais by fireships, but reorganized off the Flemish coast and proceeded in good order and unpursued to Scottish waters. There the weather broke, making

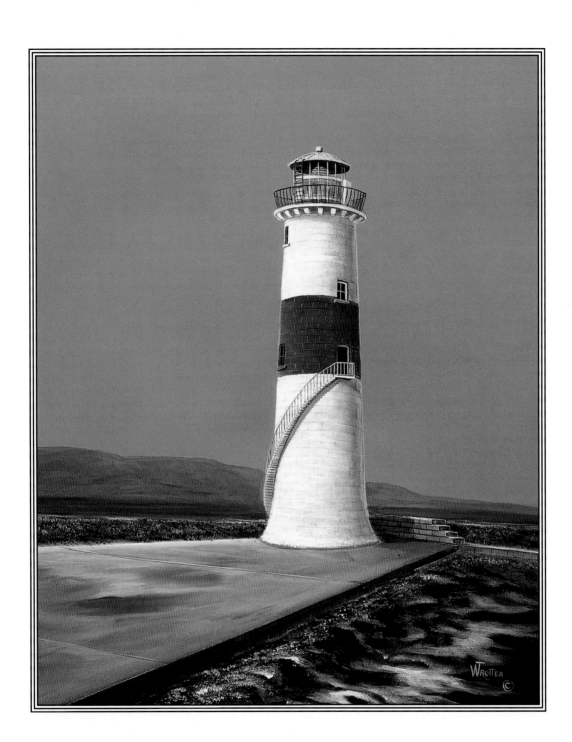

the rounding of northern Scotland and Ireland a nightmare. Many of the ships eventually made their way to Ireland, but the poor condition of the ships, the weakened condition of the sailors, and another harsh storm wrecked a number of the ships along the Irish coast.

English and Irish soldiers living in the area killed many of the survivors of the shipwrecks and plundered their ships and corpses — thus the relevance of the Irish proverb: "Bare is the shoulder that has no kinsman near,/And woe to him who lacks a brother dear." Part of the reason why the ships wrecked along the straight coast here is that the maps the Spanish pilots were relying on were very inaccurate, shortening the coast there by forty miles and putting the massive bulge of the Connaught in the path of vessels sailing south.

North of Sligo Bay just beyond Roskeeragh Point is the island of Inishmurray, site of an ancient monastery still visited by devout pilgrims. St. Columcille (Columba) (A.D. 521–97) once retired to Inishmurray to make amends for a sin he had committed. St. Molaise advised him to go to Scotland to preach the Gospel to the Picts and Scots, which is exactly what St. Columcille did, converting many Scots to Christianity and founding a monastery at Iona in A.D. 563. Thomas Mason in his *Islands of Ireland* wrote that, because of St. Columcille's distrust of women, Inishmurray had separate graveyards for men and women. Also, bodies washed ashore from wrecks were not buried in consecrated ground, but apart from the regular gravesites.

Inishmurray is so low in the water that an Allied Forces destroyer, mistaking the outline of the island at night for an enemy German submarine, once fired a torpedo at it, startling the inhabitants, but causing relatively little physical harm. The one hundred or so islanders who had eked out a living finally left their home for a new life on the mainland in 1948.

West of Sligo is the small port town of Killala on Killala Bay. There in 1798, the Republic of Ireland was first proclaimed, with John Moore named its first president. These events were reen-

acted there in 1981 during the filming of Thomas Flanagan's novel, *The Year of the French*. The late arrival of French troops in 1798 to aid in the Irish insurrection inspired many stories and songs, including "The Men of the West," with these words: "The hill-tops with glory were glowing,/'Twas the eve of a bright harvest day,/When the ships we'd been wearily waiting/Sailed into Killala's broad bay."

A beacon on Blackrock guided ships into and out of the Sligo and Killala harbors since the eighteenth century, but a storm in 1814 washed it away. Five years later, after repeated requests from local authorities, workers built a solid limestone, unlit beacon that stood fifty-one feet high. At first, authorities wanted to place on top of the tower a Metal Man, but ship owners convinced them to put the Metal Man on Perch Rock off Oyster Island in Sligo Harbour. A painting by Jack B. Yeats entitled *Memory Harbour* includes the Metal Man in the background.

The Metal Man off Oyster Island and the one at Tramore south of Waterford (see Chapter 6) are fairly unique. One piece of folklore that has arisen around these beacons is that a maiden who could hop on one leg three times around the Tramore statue would be married that year. The hatless Metal Man in Sligo Bay at Rosses Point has a blue jacket and white trousers, and his right hand has pointed the way to Sligo since 1835. A red lantern rests by his side to help ships navigate. Sailors say that the Man can be heard chanting, "Keep off, good ship, keep off from me, for I am the Rock of Misery." "Metal Mickey," as some call him, was one of four made in Dublin. Besides this one and the one at Tramore in Waterford, there is one at Dalkey Hill, Dublin, and a fourth at the entrance to Sydney Harbour, Australia.

Finally in 1835, Blackrock got a new lighthouse (pictured here), built on top of the base of the solid, old beacon tower. An outside staircase spiraled up to the entrance door above the high-water mark. Eighteen years later workers built outside panniers, an addition that makes this lighthouse unique in Ireland. These two panniers each

contained a bedroom and storage space that simply could not have been put into the more constricted addition raised on the solid tower. The two bedrooms were built on cast-iron brackets jutting out from the tower at the level of the entrance about forty feet above the rock. The tower was demanned in 1934, and the panniers were removed.

This rock tower at sea had the keepers' accommodations built into the structure, contrasting with shore stations, which usually have the houses separate. The latter case can provide larger rooms, less cramped space, and the ability to expand, a necessity in the nineteenth century as the lighthouse service hired more keepers, who were often accompanied by their families.

The more recent maritime history of Sligo records that many emigrants for the New World left from there and would see, as one of their last views of Ireland, the Blackrock Lighthouse. That tower or one like it in the area was probably the inspiration for a poem by one of Ireland's most distinguished poets and playwrights and founding member of Dublin's great Abbey Theatre, William Butler Yeats (1856–1939), who lived in the area and is buried in the churchyard at Drumcliff to the north of the city. The poem that William Butler Yeats may have written about the lighthouse there, "The Black Tower," was the last one he wrote, finished about one week before he died in 1939. A reference in the poem to upright dead ("There in the tomb stand the dead upright,/But winds come up from the shore;") may be to the legend of a warrior king who is buried standing upright on a nearby hill. The Sligo Museum and Art Gallery on Stephen's Street in Sligo has a collection of manuscripts, photographs, press clippings, and letters of Yeats; next door, in what had been a Congregational church,

is the town library, with an art gallery upstairs containing the largest collection of the paintings of Jack B. Yeats, the brother of William Butler Yeats.

Several other nearby lighthouses need to be mentioned, the first one because of its unique power source. The Rathlin O'Birne Lighthouse to the northwest of Donegal Bay is a sixty-five-foot-tall tower that stands 116 feet above high water. Built in 1856, the white tower represents the efforts of Irish Lights to use atomic energy, becoming in 1974 Ireland's first nuclear-powered lighthouse, using the radio isotope known as Strontium 90. Because the fuel has very strong radiations, officials have used hermetically sealed containers and heavy biological shielding to enable personnel to work in the vicinity of the generator. Strict controls and safeguards ensure that the lighthouse is safe, but whether Ireland or other nations will use nuclear-powered lighthouses on a large scale remains to be seen. In the 1990s, the Rathlin O'Birne Lighthouse has become solar powered, the first and only tower so far in Ireland, although all of the country's buoys will be solar powered by the end of the 1990s.

Other nearby lighthouses are Oyster Island Lighthouse, which became a rear leading light in 1932 in conjunction with the Metal Man mentioned above; Lower Rosses Lighthouse, a lighted beacon on top of timber piles that was built in 1908; St. John's Point Lighthouse, built in 1831 on the north shore of Donegal Bay to guide ships to Killybegs Harbour; the Rotten Island Lighthouse, built in 1838 to help ships pass the dangerous rocks there; Aranmore Lighthouse on the island of Aranmore to the north of Rathlin O'Birne, which has operated since 1865; and Ballagh Rocks Lighthouse, a structure that has been warning the many ships that pass along this coast south of Tory Island since 1875.

Further Reading

Costeloe, M.P.L. "Rathlin O'Birne," *Beam*, 6, 2 (no date), 41-43.

Heraughty, Paddy. "Inishmurray — Sligo's Sacred Isle," *Ireland of the Welcomes*, 42 (1993), 27+.

Heraughty, Patrick. *Inishmurray: Ancient Monastic Island*. Dublin: The O'Brien Press, 1982.

Ives, Burl. *Irish Songs*, edited by Michael Bowles. New York: Duell, Sloan and Pearce, 1958, 108-10 ["The Men of the West" song].

Kilfeather, T.P. "Chieftains with Mercy." *Ireland: Graveyard of the Spanish Armada*. Dublin: Anvil Books, 1988, 73-92:

Long, Bill. *Bright Light, White Water: The Story of Irish Lighthouses and Their People*. Dublin: New Island Books, 1993, 163-66.

Mason, Thomas H. *The Islands of Ireland*. London: B.T. Batsford, Ltd., 1950, 25-33 [Inishmurray Island].

Stallworthy, Jon. *Between the Lines: Yeats's Poetry in the Making*. Oxford: The Clarendon Press, 1963, 223-42: "THE BLACK TOWER."

*I*NISHTRAHULL LIGHTHOUSE

26

County Donegal

Half a cow's grass,
a donkey,
and some potatoes.

— Irish proverb

About six miles northeast of Malin Head at the northern tip of Ireland lies the island of Inishtrahull, a desolate, uninhabited site buffeted by the fierce Atlantic Ocean and home today to birds and occasional yachtsmen sailing over from Scotland. The name of the island may mean "island of the big strand," referring to a long beach caused by the receding of the sea in the glacial age. The island, one mile long and six hundred yards at its widest breadth, lies east-west in the middle of a busy seaway.

Inishtrahull marks the northern entrance to the North Channel, the body of water leading into the Irish Sea, the major sea link between Ireland and Great Britain. That section of Ireland, the most remote of the country, was the least affected by English rule, not only because of its distance from Dublin, but also because Scottish mercenaries settled there centuries ago and took pride in their independence. The poor soil, the inclement conditions for much of the year, and the bellicosi-

ty of the local clans kept the English government, and even the Irish central government, distant in influence and power.

The coastline, especially southwest to Tory Island, has long been known as a dangerous one, even in the few mild months of summer. The fierce winds, strong currents, hidden rocks and reefs, in addition to the thick fogs and sea mists, make navigating these waters a nightmarish experience, even for the skilled local pilots. The fact that at least one ship of the Spanish Armada, *La Trinidad Valencera*, wrecked in Kinnagoe Bay south of there in 1588 would surprise no one familiar with the area.

When *La Trinidad Valencera* neared Inishtrahull, a storm arose and caused a serious leak in the forward part of the ship. As the crew passed between Malin Head and the island, they mistook the island for the Blaskets, actually 250 miles to the southwest, an error due to the Spaniard's reliance on poorly drawn maps. After the ship wrecked on that coast, troops loyal to the English

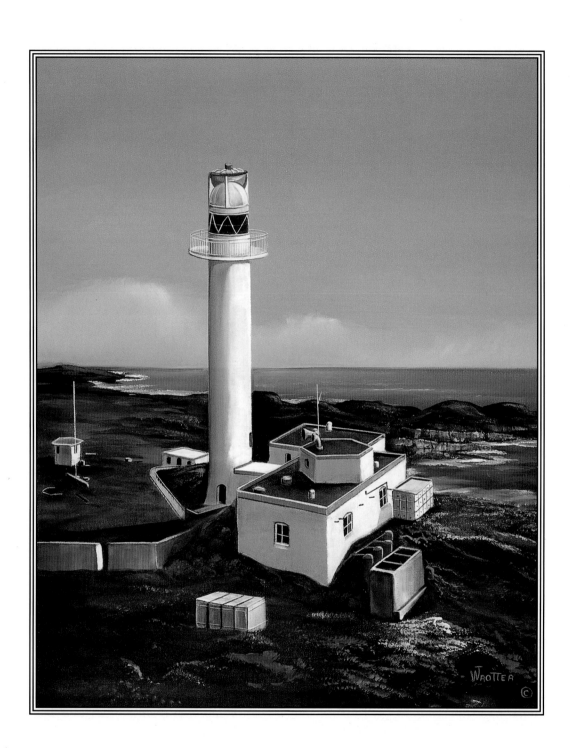

crown massacred over three hundred of the survivors. Another hundred escaped, but many of those died of exposure and starvation. Ironically, the ship was actually Venetian, *La Balanzara Veneziana*, which the Spanish authorities had seized in Sicily and on which they placed Spanish soldiers and supplies. The Venetian crew had no quarrel with England, but were kept on board to handle the vessel. The use of a Spanish name on the captured ship hid the whole poignancy of the incident — that the crew, from a state friendly to England, were mistaken by English forces as Spanish and massacred along with the Spanish officers who had seized them.

The only regular visitors to the island these days are ornithologists interested in the colonies of eiders, fulmars, and barnacle geese; sailors seeking refuge from a passing storm; or geologists trying to determine the make-up of the unusual rocks there. Those geologists have pointed out that the island, considered the oldest piece of land in Ireland, is actually part of the southern tip of Greenland and is not related geologically to the Irish mainland. With several other pieces of land, the island separated from Greenland over a billion years ago and drifted eight hundred miles to its present position.

Remains of prehistoric occupation and more recent, sixth-century settlements by Celtic monks make one wonder why anyone would want to live in such an isolated place. Like their counterpart monks on the islands off southwest Ireland, the monks were probably seeking isolation from the secular world and a place to pray without distractions. Historians speculate that the Vikings plundered the island monastery in the ninth and tenth centuries and effectively drove off the island inhabitants until other hardy souls ventured back in the eighteenth century.

Strangely enough, when the potato famine of the 1840s led to the mass emigrations of thousands of Irish, a number of them went to Inishtrahull, perhaps hoping that the isolation of the island would keep it safe from the blight. They may have believed an Irish proverb associated with such islands as that one and the nearby Tory Island: "Half a cow's grass, a donkey, and some potatoes," meaning that a person does not need much to survive at such outposts, and land is measured according to the amount needed to graze a cow.

The barely legible headstones in the small, isolated cemetery at the eastern end of the island, near the remains of the old lighthouse, bear witness to the many infants who died at a time when the remoteness of the island prevented medical help from arriving in time to minister to the sick. A fish-curing station set up in the 1890s gave some employment to the islanders, but in 1928 they departed their isolated island for the mainland.

The history of the island lighthouse is actually the history of two lighthouses, one at either end. The Ballast Board first had a lighthouse built in 1813 on the island's eastern hill, partly because ships of the Royal Navy used to sail from Lough Foyle around Malin Head to guard the North Atlantic. The men who built that tower came from a disastrous experience while they were building the Tuskar Lighthouse off the southeast coast of Ireland. The previous year, while working on the Tuskar Rock, ten of the workers were drowned by a large storm that covered the rock with a huge wave. The survivors clung to the rock for two days and nights without food or shelter before finally being rescued (see Chapter 4). Instead of giving up their profession and retiring to the mainland, the survivors went on to Inishtrahull to build that structure.

Among the changes to the lighthouse over the years was a modification to the character of the light. Several months after one such change, in 1873, officials discovered to their great chagrin that the new flashing sequence was identical to that of the Scottish lighthouse at Skerryvore, sixty-one miles to the north. Apparently no ships mistook one lighthouse for the other in those months when both towers had the same lighting sequence, but officials quickly changed the Inishtrahull tower to one flash every thirty seconds.

In the early part of this century the island

became important for ships of the British Navy using Lough Swilly to the southwest as a major base. Naval officials then asked lighthouse authorities to install a fog-signal on the island, not on the east end, where the lighthouse was, but at the west end of the island. And so for the next five decades the island had two operations, one for the lighthouse and one for the fog-signal, at opposite ends of the island, necessitating the use of six keepers instead of the four keepers at other facilities. Besides helping the mariner, the lighthouse keepers at Inishtrahull also aided the aviators stationed at the Royal Air Force base of Ballykelly west of Coleraine. Squadron 204, which used that air base for many years, presented a plaque to the lighthouse keepers at Inishtrahull in 1971, expressing their gratitude for a job well done.

One man who served nine years there as principal keeper was D. J. (Danny) O'Sullivan, a published poet and short story writer. His grandfather, father, and three sons have served in the Irish lighthouse service, continuing a tradition of having several generations of one family work at towers throughout the country. Danny O'Sullivan's poem, "Dawn in Inishtrahull," has two lines that describe one of the few visitors to the place these days: "An otter seeking rest on rock remote/Glistens with phosphorescence on his coat."

By the middle of this century, the lighthouse at the east end of the island had deteriorated so badly that workers in 1958 built a new one at the site of the fog-signal station on the west end. The most modern lighthouse in Ireland, it is the first major one built by the lighthouse service since 1919. The workers then razed the old tower. Helicopters took keepers to and from the tower, and avoided the problems of relying on boats being able to land on the island, something that dense fog and storms prevented. Those training to be trawler skippers and fishermen at Greencastle's fishery training college, which opened to the southeast of Inishtrahull in 1973, might be expected to rely on the lighthouse when they venture out into the ocean, as are the skippers of the large

ships, stationed at Downings to the southwest, who are involved in the drift-net herring industry.

The island's new, reinforced-concrete tower, made automatic and demanned in 1987, has an electric light of 1,750,000 candelas with a range of twenty miles. The fog-signal is actually situated above the lantern, thus giving it a range it might not otherwise have had. The light atop the seventy-four-foot-high tower stands 195 feet above sea level. Today, the rare visitors there will find the tower beaming its light to offshore ships from an island with dilapidated houses, weed-filled paths, and fallen walls — all signs of former residents who have long since left for better opportunities elsewhere.

West-southwest of Inishtrahull is Tory Island, a windswept, ocean-beaten island seven miles offshore and the site of settlements since early Christian times. The island has provided only a meager existence to its inhabitants, and yet its location and the direction of the prevailing winds prevented airborne spores from reaching the island and destroying the potato crop, as happened in much of Ireland in the mid-1800s. The nearest land on the mainland has an ominous-sounding name, Bloody Foreland, so called for the reddish rocks there, the color of which is enhanced more by the setting sun.

Today the island, which consists of only 785 acres and is about two-and-a-half miles long by a half-mile wide, is home to several hundred people, many of whom speak Gaelic. The town has a small round tower, at the base of which are what are called cursing stones, which the people have used against those they dislike. According to local legend, the people used the "cursing stones" in 1884 to curse the gunboat HMS *Wasp* that had gone there to collect overdue rates after the islanders refused to pay them. The ship was wrecked and all aboard her save six were drowned.

Since 1832, Tory Island Lighthouse has marked the northwest corner of Ireland. The complex also has a radio-beacon and a fog signal to help mariners offshore. Many shipwrecks have occurred in the area, and, while historically a ship-

wreck could provide the islanders with necessary supplies, the islanders always did their best to save the people on the sinking ship. One item from a ship that proved unexpectedly beneficial was an elephant, which had probably once been part of a circus, but died on board the ship and was thrown overboard. When natural gases inside the carcass caused it to rise to the surface and float onto the island, the islanders obtained from the Donegal County Council enough concrete to build a gravesite above the ground since, the islanders argued, the soil was too shallow for a proper grave. In the next few months, progress on the above-ground mausoleum proceeded very slowly, but quite a few island houses had new concrete.

The large compound at the lighthouse has been home to many keepers from all around Ireland, many of whom return for their summer holidays. Islanders generally respected the light-housemen because their official salaries enriched the island economy, but some islanders always considered such people outsiders who would return to the mainland once their tour of duty was over. The last keeper left the tower when it was automated in 1990.

Three lighthouses lie in or near Lough Swilly southwest of Inishtrahull: Fanad Head, Dunree, and Buncrana. The first one, Fanad Head, faces the North Atlantic and has been guiding ships in and out of Lough Swilly since 1817, having been built after the total loss of the *Saldana*. The other two towers began lighting the waterway in 1876. Finally, Inishowen Lighthouse to the east near the entrance to Lough Foyle and Londonderry began operating with two structures in 1837, but the confusion that resulted from having two lights at the same elevation eventually (in 1957) convinced authorities to have only one light there.

Further Reading

de Courcy Ireland, John. *Ireland's Sea Fisheries: A History*. Dublin: The Glendale Press, 1981.

Fallon, Niall. *The Armada in Ireland*. London: Stanford Maritime, 1978.

Fox, Robin. *The Tory Islanders: A people of the Celtic fringe*. Cambridge: Cambridge University Press, 1978.

Long, Bill. *Bright Light, White Water: The Story of Irish Lighthouses and Their People*. Dublin: New Island Books, 1993, 168-70; 174-78.

Martin, Colin. *Full Fathom Five*. New York: Viking Press, 1975, 189-224 [about the wreck of the Spanish Armada ship, *La Trinidad Valencera* in Kinnagoe Bay].

Martin, Colin. "The Spanish Armada Wreck *La Trinidad Valencera* in Kinnagoe Bay, County Donegal," in *The Irish Sea: Aspects of Maritime History*, edited by Michael McCaughan and John Appleby. Belfast: The Institute of Irish Studies, 1989, 60-69.

McNally, Kenneth. *The Islands of Ireland*. New York: Norton, 1978, 32-35.

Muir, Roderick J. "Inishtrahull — the Oldest Rock in Ireland," *Beam*, 18, 1 (December 1989), 5-6.

Wilson, T.G. *The Irish Lighthouse Service*. Dublin: Allen Figgis, 1968, 119-20.

MAIDENS LIGHTHOUSE

27

County Antrim

When wind and water come to grips
Their wrath is wreaked upon the ships.

— Irish proverb

Based on archaeological evidence of midden heaps along the Antrim coast, maritime historians have concluded that the first settlers in Ireland were probably fishermen who braved the winds and currents of the North Chan-nel to settle along the country's northwest-ern coast, certainly the closest Irish land to Great Britain. The offshore area in the vicinity of the Maidens can be hard to navigate for the unwary because the North Channel leading from the Atlantic Ocean enters the Irish Sea near this point. Mariners heading south into the Irish Sea for the first time may not notice that this body of water differs from the Atlantic Ocean in temperature, salinity, and types of plant and animal life it supports, but more important for safety purposes is the fact that the smaller Irish Sea, the most enclosed sea around the British Isles, has its own tides, currents, winds, and waves. The fact that the Irish Sea is relatively shallow at a usual depth of 150 feet or less and that high tides can range between eighteen and twenty-four feet on the west coast of England make this sea a danger-ous body of water for mariners.

The narrowness of the channel between Benmore or Fair Head on the Irish coast southeast of Rathlin Island and Mull of Kintyre on the Scottish coast results in very strong tides from the Atlantic, tides which can easily reach speeds of up to five knots. Therefore, although the sea distance between Ireland and Great Britain is the shortest there, it can also be the most danger-ous, depending on winds and tides. A strong tide flowing south can hinder a sailing ship headed north and can hide the rocks lurking beneath the surface. One has to admire an Irish missionary like St. Columcille (Columba) (A.D. 521–97), who crossed over to Scotland on a currach or skin-cov-ered boat to establish a religious center.

One of the significant points about ancient Irish history is that for centuries the remoteness of the country attracted monks seeking peace and quiet to meditate and study. One result was that

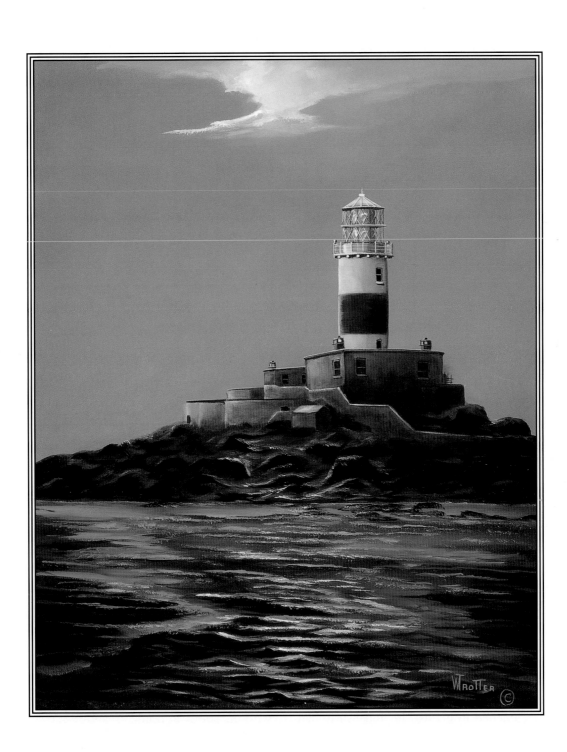

the monasteries established in the country became some of the most literate places in Europe, and in time those pastoral monks exported their learning and religion back to Europe. Europeans returned the favor by sending waves of invaders, from the Vikings to the Normans to the English.

The Maidens are two rocky islets in the North Channel about six miles northeast of Larne in County Antrim. In addition to those two rocks, which rise about twenty-five feet above high water, are three other, smaller ones in the vicinity: the Allan, Highland, and Russell. Those smaller ones, which lie about a mile and a half north of the lighthouses, are barely above the water level at low tide and, therefore, present a serious threat to ships in the area, as proven by the many wrecks that have occurred there. Added to the danger of all five rocks is the fact that the two largest ones, and the lighthouses on them, used to be white-washed regularly, making them difficult to see in hazy weather. An officer who was surveying the Irish Sea convinced the lighthouse authorities to change that practice and paint the towers in red and white stripes.

Two of the islets, the East Maiden and the Allan (which is the central rock in the northern group of three small ones), have dangerous reefs that could wreck an unsuspecting ship. Other than the reefs, the waters between the two large islets is clear for ships to run through, except that strong tides can push less-powerful vessels, for example, sailboats, onto the rocks. Among the many vessels that met their doom there was the the *Alert*, which in 1826 ran into the Russell Rock with such force that her bottom fell out along with the ballast and cargo. Another boat eventually towed her into Larne, where examiners found the corpse of one of the crew members still in his berth with a spike-nail firmly clenched in his fist; he apparently had been trying to scrape a hole through the deck after the vessel hit the rock.

The East and West Maidens have had other names, like the Hulins or the Whillans, names which are still on some maps and sea charts. The merchants and mariners of Larne began request-

ing a lighthouse on the Maidens in the early nineteenth century and finally convinced the Corporation for Preserving and Improving the Port of Dublin to build twin towers, one on the Northern Rock (West Tower or West Maiden) and one on the Southern Rock (East Tower or East Maiden), 824 yards apart, at a cost of almost 37,000 pounds in 1829. After sixty years of faithful service, the lights were augmented by an auxiliary light, built into a window at the East Maiden structure, to cover Highland Rocks nearby. Today, of the two Maidens only the one on East Maiden (pictured here) still functions; the West Maiden Lighthouse, which stood eighty-four feet above high water and was visible for thirteen miles, was discontinued in 1903, when the East Maiden Lighthouse received a more powerful light. That particular structure, a seventy-six-foot-tall white tower with a wide, black band painted midway up the structure, has its light ninety-four feet above high water; the tower has a 325,000-candle-power lantern visible fifteen miles away on a clear night. In 1977, engineers converted the oil light to electrical power.

While families lived on the two Maidens, a young man at one of the Maidens fell in love with a young woman who lived at the other Maiden. They conducted their courtship with messages sent between the two islands and became known as the Maiden Lovers.

The keepers' families lived in buildings at the base of the tower, but had very little space outside for their children to play, especially during high tide. The families received supplies twice a week from Larne, where the lighthouse service finally built dwellings for the families to remove them from the rock. After that, the keeper would spend four weeks at the lighthouse and then two weeks with his family at home, in addition to twenty-one days' annual leave. Such a rotation enabled at least one keeper to always be ashore.

The lighthouse there has seen more than its share of vessels since ships passing to and from North America and Africa for such major ports as Glasgow and Liverpool use the North Channel.

The busiest time for such shipping was at the end of the nineteenth and beginning of the twentieth century, and then in World War II the area saw a huge number of merchant ships and their naval escorts before or after venturing into the hostile Atlantic.

Finally, Rathlin Island to the north on the Antrim coast and just fifteen miles away from Scotland has lighthouses at the three points of the nine-mile-long, boomerang-shaped island: Rathlin East, Rathlin West, and Rue Point. Because it lies between Scotland and Ireland, Rathlin has been claimed by both countries, and its national identity has been debated for centuries, sometimes on very tenuous bases, for example, the lack of snakes proving that the island must be Irish. The busy seaway there, called the Waters of Moyle, has strong currents and powerful tides which have combined to wreck many a ship, the salvaged nameboards of which one can still see in the island's pubs. The high caves near Bull Point are filled with pieces of iron and steel from wrecks that the mighty sea has brought up from the depths.

Rathlin West or Bull Lighthouse is one of the most unconventional structures on the whole Irish coast. In order not to repeat the mistake of other sites — of building the tower on too high a site — officials positioned it about one-third of the way down the cliff and about 250 feet above the sea. It looks as if someone decapitated the lantern house from the tower and placed it at the foot of the tower, below the keepers' quarters. Rue Point has an octagonal, concrete tower painted in alternating black-and-white bands at the southernmost point of the island, only two miles from Benmore or Fair Head on the mainland. Rathlin East had

two lights: a higher, occulting one (in which long periods of light alternate with short periods of darkness) and a lower, fixed one. This pattern of lights was meant to prevent confusion with other towers in the North Channel. Among the important shipwrecks near the island are the *Girona* from the Spanish Armada (1588) and the *Andania* of the Cunard Line (1918).

Archaeologists point out that people have been living on the island for at least eight thousand years, in part because of the valuable flint that they could fashion into tools and export to other places, including the mainland. One of the most famous residents was the great Robert (the) Bruce, who, according to local legend, while staying in a cave on the island in the early fourteenth century, learned, from watching a spider slowly and perseveringly spin its web, the patience that would eventually gain for him the Scottish Crown. Today, ornithologists often visit the island, the only one in northern Ireland that is permanently inhabited, especially to see the large numbers of breeding puffins, guillemots, razorbills, and shearwaters. The sheer cliffs of the island, some rising three hundred feet high, offer spectacular views of the sea.

Rathlin was the scene of one of Marconi's most convincing experiments when he set up a wireless transmitter there very early in his career. An observer sent the names of passing ships to the mainland, whence they were telegraphed to Lloyd's in London, revolutionizing the speed of information about incoming shipping. Rathlin was also the scene of a fatal accident involving one of Marconi's workers, when he fell off a cliff to his death.

Further Reading

"Family at the Lights (1803-1971)" [about the Maiden Lovers], *Beam*, 3, 3 (December 1971), 23.

Long, Bill. *Bright Light, White Water: The Story of Irish Lighthouses and Their People*. Dublin: New Island Books, 1993, 179-81 [Rathlin Island], 182-84 [the Maidens].

Mason, Thomas H. *The Islands of Ireland*. London: B.T. Batsford Ltd., 1950, 7-8.

Pickford, Nigel. *The Atlas of Ship Wrecks & Treasure*. London: Dorling Kindersley, 1994, 50-51: "The *Girona*" [about the Spanish Armada shipwreck].

FERRIS POINT LIGHTHOUSE

28

County Antrim

Beauty will not make the pot boil.

— Irish proverb

Lighthouses can take many forms, depending on the topography of their sites, their purposes, and their dates of construction, and one cannot judge the towers simply by how they look. Towers built in the last several decades may not always be the tall, stately, brick structures long associated with parts of England and America, but one should judge them by their purposes and performance. The lighthouse at Ferris Point in County Antrim was a good case of how builders used modern technology to design a state-of-the art building. Resembling a control tower at an airport, having a long, narrow window reaching up near the observation floor, and attached to a building where the keepers could work and live, the building had many purposes, all related to navigational aids. The name of the lighthouse, Ferris Point, honors the Ferris family, who lived on the land where the lighthouse was built and still reside in the area. The Ferrises supplied the lighthouse keepers with butter, eggs, and milk until the end of World War I and maintained close contacts with the keepers.

Larne Lough lies at the southern edge of County Antrim, the part of Ireland closest to Scotland and, therefore, probably the earliest settled by mesolithic fishermen because the mean heights of spring tides in that part of the Irish coast are quite low in comparison to parts further south, although the Atlantic tides, constricted by the narrowness of the passage from Fair Head to Kintyre, Scotland, can be rough. Those intrepid souls came across the North Channel, then probably narrower than today, by currachs of some sort around 6000 B.C.

The Cretaceous flint available in northeastern Ireland, which early residents used for making tools, and the fact that Larne Lough is one of the few sheltered havens along the sea induced them to settle along the Antrim coast. The plentiful game (deer, wild boar, wild fowl, wolf, and bear), the abundant fish offshore, and the pleasant climate enabled the relatively few numbers of people

there to live well although the lack of a rich agricultural inland region would have discouraged a cross-channel trade. Scientists label that mesolithic culture Larnian because of the many worked flints found at Curran Point south of the harbor at Larne.

Antrim's proximity to Scotland and its antipathy to England enabled shipwrecked survivors from the Spanish Armada of 1588 to travel across Ireland to Antrim and then across the North Channel to safety on their way home. In more recent times, the short distance to Stanraer across the Irish Sea led to the development of quick crossings by fast, turbine steamers, with connecting railway services to speed people and goods on their way, although the 1953 loss of the *Princess Victoria* car ferry on that route indicated how dangerous the crossing could be. Even when railway traffic was replaced by road transport, the live-cattle trade by the transport of refrigerated meat, and passenger traffic by the airplane, the emphasis on short crossings of the Irish Sea led to the opening of the Larne-Cairnryan service. Of significance to the New World were the many nonconformists from this area who emigrated to New England, including those on the small ship, *Friends Goodwill*, which crossed the Atlantic in 1717.

At the northern tip of Larne Lough is the town of Larne (population 18,000), a busy port that used to have regular ferry service to both Cairnryan and Stanraer in Scotland. The Vikings recognized the strategic location of that Irish site as they landed there in the ninth and tenth centuries. One of the important towers in the area is Olderfleet Castle, a square, four-story, sixteenth-century tower house that lies south of the harbor at Curran Point. That castle was one of three that guarded the Lough entrance in the seventeenth century.

The town began a period of rapid growth after regular rail-connecting steamship crossings to Scotland began in 1872. Larne became Northern Ireland's second largest port (after Belfast) when it adapted itself to accommodate container traffic, something emulated by such other ports as Londonderry, Coleraine, and Portrush. Larne also became one of the major sites for the exporting of cattle and managed to replace Donaghadee to the south as a cross-channel port.

At the northern entrance to the harbor is the Chaine Memorial Tower, a replica of the traditional Irish round tower. Unlike most early (tenth to twelfth centuries) round towers in Ireland, which were inland and near monastic settlements, that tower on the coast served as a navigational aid to ships passing offshore. Before the building of lighthouses in Ireland, those round towers near the coast gave mariners a fixed point by which they could steer their ships. The slender towers, only found in Ireland, marked early monastic settlements and offered a place to store treasures and possibly refuge from attack since the door was usually seven to ten feet above the ground. When the defenders pulled the ladder inside and bolted the huge door, they could drop large objects on the intruders and feel safe indeed. One can still see examples of these unusual structures throughout Ireland.

James Chaine, whom the tower memorializes, was a local benefactor and Member of Parliament for North Antrim in the early nineteenth century. When he died at age forty-three, after a life spent in the service of his community, friends buried him upright near Sandy Point overlooking his beloved lough. Local officials at first petitioned the Commissioners of Irish Lights to help in the construction, or at least the maintenance, of the Chaine Tower, which could then be used as a lighthouse. Because the Commissioners of Irish Lights in 1885 deemed the tower to be of local interest only, they declined the request.

Locals then decided to change their construction plans slightly and in 1888 built the round tower — with the approval of Irish Lights and the local Board of Trade — without a light at Sandy Point Bay across from the lighthouse at Ferris Point. The officials at Larne Harbour maintained the unpainted, natural-stone tower, and mariners were informed of its position for daylight reckoning. Eight years later, with an increase in shipping traffic and with growing concern over the dangers

posed by the unmarked Hunter Rock near the entrance to Larne Harbour, local officials transferred the Chaine Tower to the jurisdiction of the Commissioners of Irish Lights, who installed a fifth-order condensing lens in the tower in 1899. An assistant keeper, officially assigned to the Maidens Lighthouse, was put in charge of the Chaine Tower and allowed to live in Larne. The light was converted to "unwatched" in 1905 and converted from oil to coal gas. The maintenance of the light was transferred from an assistant keeper at the Maidens Lighthouse to the principal keeper at Ferris Point. In 1935, the light at Chaine Tower was changed from gas to electric.

After ten years of petitions by ship owners and Larne merchants for a lighthouse on either Sandy Point or Ferris Point, officials finally agreed to build a lighthouse at the latter place in 1838. The Ferris Point Lighthouse (pictured here), which first exhibited its light in 1839, stands on the eastern side of the entrance to Larne Lough. Workers converted the lighthouse from oil to electric in 1957. The building of the Ferris Point Lighthouse, in addition to those at the Maidens, and the development of steam-powered vessels, led to greater safety in the area, especially in the crossing of the sea. However, in its move to modernize its services, Irish Lights demanned the Ferris Point tower in 1994 and later discontinued it. What remains at that facility are a helicopter base for the rock stations and island stations of Northern Ireland, workshops for the repairing of buoys, and a store for gas bottles. Another lighthouse in the vicinity that the Commissioners of Irish Lights maintain is Blackhead Lighthouse (Antrim), which is on the north shore of the entrance to Belfast Lough. The tower was built in 1901, converted to electricity in 1969, and converted to automatic unwatched in 1975. Irish Lights also maintains the Barr Point Fog-Signal Station in the area.

Nearby Larne is the scene of an old Irish legend dealing with the sea. A mermaid, Lí Ban, roamed the seas for three hundred years, during which time she met a monk and told him of her sad life. She promised to meet him in one year at Larne. The next year another monk caught her in a fishing net, and the two monks argued as to which of them should have charge of her. In the end she had a choice: die immediately and gain heaven or stay in the world for another three hundred years. She chose the former and thus fulfilled a common motif in medieval Irish literature: a legendary pagan figure lives long enough to meet Christian missionaries. Stories associated with St. Patrick also have this motif.

At Ferris Point, Ireland had at its most ancient settled area its most modern lighthouse. If the mesolithic explorers who first set foot there eight thousand years ago could have seen today's futuristic structure at Larne, they would have marveled at its form but understood how necessary such an aid to navigation was at that point along

Further Reading

Costeloe, M.P.L. "Chaine Tower," *Beam*, 8, 1 (no date), 20-25.

Hamilton, W.R. "Chaine Memorial Tower," *Beam*, 18, 1 (December 1989), 14-21.

Long, Bill. *Bright Light, White Water: The Story of Irish Lighthouses and Their People*. Dublin: New Island Books, 1993, 181-82, 184.

Niblock, Alec. "Ferris Point," *Beam*, 12, 1 (no date), 65.

O hOgan, Dr. Daithi. *Myth, Legend & Romance: An Encyclopedia of the Irish Folk Tradition*. London: Ryan Publishing Co., 1990: 271 [about Lí Ban].

Orme, A.R. *Ireland*. Chicago: Aldine Publishing Company, 1970: 76 [about the Larnian mesolithic culture].

Pearsall, A.W.H. "Steam in the Irish Sea," in *The Irish Sea: Aspects of Maritime History*, edited by Michael McCaughan and John Appleby. Belfast: The Institute of Irish Studies, 1989, 110-19.

MEW ISLAND LIGHTHOUSE

29

County Down

Adventurers who dare not sail their ships till wind and tide are fair will make few trips.

— Irish proverb

The largest port in Ireland today and a major shipbuilding center is Belfast. Its location near the fertile Lagan Valley and the coal fields and industrial centers of Britain, plus the wide, deep opening of Belfast Lough have made it an important city for shipping. The support of the local population in making land available for the necessary port facilities has encouraged merchants and shipbuilders there.

Centuries ago, Belfast was the target of Vikings who raided its monasteries. Later the city developed close ties to Scotland because of geographical proximity and because of the many Presbyterians in both countries. In a city where the ill-fated *Titanic* was built, the Harland and Wolff Shipyard became the largest shipbuilding and repair yard in the United Kingdom. The early nineteenth century saw an increase in the number of ships using the port of Belfast, much of it due to the textile and shipbuilding industries thriving there. Today, this industrial city, which has been the capital of Northern Ireland since 1920, has a population of around 330,000, many of whom are hoping that the sectarian conflict between the Protestant majority and Catholic minority ceases.

The location of the city on the River Lagan, which flows into Belfast Lough, has been ideal for maritime activities, including shipbuilding, which has flourished there for several centuries. Hills on both sides of the lough protect the water, and the Copeland Islands at the southern entrance to Belfast Lough in County Down have had several lighthouses to protect shipping to and from the port. The Copelands consist of three islands: Great Copeland, also called Big Island (308 acres); Old Lighthouse Island, also called Cross Island or Isle, John's Island, and Lesser Copeland Island (forty-three acres); and Mew Island (thirty-one acres), so named for the common gull or sea mew which used to nest there in great numbers.

The Copelands were the site of early experiments in using gunpowder explosions as fog signals. To see if the loud noise produced by gun-

powder would be heard better than a bell in thick fog, Captain James Ross in 1760 exploded gunpowder, enclosed in one-pound linen cartridge cases, at half-hour intervals. When mariners gave the experiment favorable comments, others began using similar guns, especially the eighteen-pounders with a three-pound charge as a fog signal. Irish officials used guns at Carlingford Bar Lighthouse in 1823 and on Rathlin Island in 1865; workers fired the guns every ten minutes at the first site and every fifteen minutes at the second site. Other Irish lighthouses that used guns for signalling during the fog were Hook Point, Bull Rock, Fastnet, Kinsale, Kingstown (Dún Laoghaire), and Tuskar Rock. Lightships off the Irish coast, for example, at Daunt's Rock, Kish Bank, South Rock, and Skulmartin, also used guns.

In the early part of the nineteenth century, as part of their efforts to protect ships passing along the northeastern coast, the authorities built lighthouses in County Down. The first lighthouse in the area was on the South Rock reef off the Ards Peninsula in 1797. Even before that, from the early eighteenth century, a beacon tower on one of the Copeland Islands helped guide ships to and from Belfast Lough. South Rock Lighthouse was also known as Kilwarlin Light in honor of Lord Kilwarlin, Marquess of Downshire who petitioned for the tower. The building of this structure on its wave-washed rock is considered one of the greatest accomplishments in pharology, the science of lighthouses. Although abandoned in 1877 because officials realized they had built it in the wrong place, the tower is still in good condition. The lightship which replaced it was situated further out in the Irish Sea to be of more use for passing ships. That lightship was replaced by an automatic lightfloat in 1981.

Two of the Copeland Islands also had lighthouses from early on. Old Lighthouse Island had the first light, a coal-burning brazier, which was set up in 1714. The open fire used there was an early, primitive light source for passing ships. The light attendant, after reaching the roof by an interior staircase, would place the material to be burned, whether coal, turf, or peat, in a stone bowl on a small platform. The brazier lighthouse on Old Lighthouse Island is one of four that can still be seen in Ireland; the other three are at the Old Baily on Howth Head in County Dublin, the Old Head of Kinsale in County Cork, and Loop Head in County Clare. Those open fires were suitable for isolated towers, but they could not be used in harbors where the wind might blow the fire's sparks and embers into the flammable rigging and cargo of nearby ships. In such places, glazed lanterns using candles or oil lamps could be used. Because Old Lighthouse Island was uninhabited, workers had to install more living and storage facilities inside the tower on the first floor. The lighthouse built around 1714 replaced one on Island Magee to the north-northwest, which had been abandoned around 1668. The Copeland Lighthouse had two keepers who lived with their families at the site and had a self-sufficient complex complete with goats, sheep, pigs, and even a donkey. The walled garden provided vegetables to the families, and their chickens provided eggs.

One can still see on Old Lighthouse Island the ruins of that first lighthouse, as well as the keepers' quarters and the beacon tower. The tower, which stood on the highest point of the island, was twenty-six square feet with walls five feet thick and an interior set of stone steps to reach the top. When workers built keepers' quarters and a forty-six-foot-tall lighthouse in 1813–16, they used the old tower to house a bell. When authorities replaced the lighthouse with a new, 115-foot-tall one on nearby Mew Island in 1844, workers apparently demolished the old lighthouse. The Copeland Bird Observatory, established in 1953, has made use of the abandoned buildings on Old Lighthouse Island, which now belongs to the National Trust, the organization that one must contact in order to visit the island.

When the Dublin Ballast Board took control of the lighthouse in 1810, George Halpin Sr., the Board's inspector, designed and constructed a fifty-two-foot-high tower and lantern with a fixed oil-fired light, placed next to the old beacon tower,

oil-fired light, placed next to the old beacon tower, which in 1851 received a fog bell. That bell did not always protect ships in trouble. For example, in 1859, the steamer, *Prince Patrick*, bound from Belfast to Fleetwood ran aground on Old Lighthouse Island during a thick fog; the passengers claimed they could neither see the lighthouse nor hear the fog bell. The new light, which first shone in 1815, stood 131 feet above sea level.

This combination of towers lasted until 1884, when the Mew Island Lighthouse (pictured here) on the northeastern point replaced it because ship owners and the Belfast Harbour Commissioners asked for a new lighthouse better situated for the increased commercial traffic to and from Belfast. The change became desirable in the age of steamships, which needed to round the point there on their way to Belfast Lough much more closely than sailing ships had been able to do. For the tower and houses, workers used rubble masonry, quarried on Mew Island itself, thus keeping the cost lower than if they had had to go elsewhere for the materials. The tower was electrified in 1969.

One tragic wreck near Mew Island that proved how courageous Irish lifeboat crews can be was that of the *Princess Victoria* in 1953. As the ship was heading for Larne in Northern Ireland, a very severe storm, accompanied by gale-force winds, high waves, sleet, and snow showers completely disabled it and forced the "Abandon Ship" order that seamen dread. The crew of the lifeboat at Donaghadee, right below Mew Island, headed out on the *Sir Samuel Kelly*, found the disabled ship, and rescued thirty-one of the 176 passengers and crew who had to abandon ship. Other vessels rescued another twelve. That action was typical of the long history of superhuman efforts by Irish lifeboat crews.

Near the town of Donaghadee is Donaghadee Lighthouse, built in 1836 when the port there was the Irish terminal for ships heading to and from Portpatrick, Scotland, twenty-two miles away. That lighthouse was the first Irish one to be converted to electric power (1934).

Finally, Belfast gave to the world one of the greatest lighthouse engineers ever: Alexander Mitchell (1780–1868), a blind designer who had been born in Dublin and who invented the Mitchell screw-pile and mooring, an effective means to build durable lighthouses on mudbanks and shifting sands and in deep water. In Ireland, he designed the Dundalk Bay pile light and the structures at Carlingford Lough and the Spit Bank at Cobh. Also, in 1844, he and his son built a screw-pile lighthouse, which doubled as a pilot station, in Belfast Lough at Carrickfergus Bay west of Mew Island. He was less successful at Kish Bank, where his piles are sometimes despairingly referred to today by fishermen as "Mitchell's bloody piles," but his revolutionary design was important in placing lighthouses in such seemingly impossible locations as the Florida Keys. The fact that those lighthouses are still standing one hundred or more years after he built them is a lasting legacy to this former Belfast brickmaker.

Further Reading

DeWire, Elinor. "Screwpile Lighthouses" [about Alexander Mitchell], *Lighthouse Digest*, October 1995, 22-23.

"From Open Fires to Headlamp Arrays," *Country Life*, 181 (April 30, 1987), 134-35 [about the old peat-burning lighthouse].

Green, E.R.R. *The Industrial Archaeology of County Down*. Belfast: Her Majesty's Stationery Office, 1963, 61-62, 77-79.

Hague, D.B. "Irish Brazier-Lighthouses," *The Keeper's Log*, 7, 1 (fall 1990), 24-25 [about the first lighthouse on the Copelands].

Hague, Douglas B. and Rosemary Christie. *Lighthouses: Their Architecture, History and Archaeology*. Llandysul Dyfed, Wales: Gomer Press, 1975, 88-89.

Hamilton, Reggie. "Mew Island," *Beam*, 24, 1 (December 1995), 9-13.

Langmaid, Captain Kenneth. *The Sea, Thine Enemy: A Survey of Coastal Lights and Life-boat Services*. London: Jarrolds, 1966: 203-06 [about the wreck of the *Princess Victoria*].

Long, Bill. *Bright Light, White Water: The Story of Irish Lighthouses and Their People*. Dublin: New Island Books, 1993, 184-86.

"Mitchell, Alexander" [about the blind designer of the screw-pile lighthouse], *The Dictionary of National Biography*, edited by Sir Leslie Stephen and Sir Sidney Lee. London: Oxford University Press, 1917, 509-10.

"The Sightless Lighthouse Engineer" [about Alexander Mitchell], *Leading Lights* [The Journal of Pharology, Pilotage and Seamarks], Milford Haven, Pembrokeshire, Wales, 1, 2 (1995), 38-39.

Sweetnam, Robin. "The Development of Belfast Harbour," in *The Irish Sea: Aspects of Maritime History*, edited by Michael McCaughan and John Appleby. Belfast: The Institute of Irish Studies, 1989, 100-09. See also in the same book T. John Parker, "Aspects of Shipbuilding in Belfast, Past and Present," 156-62.

Haulbowline Lighthouse

30

County Down

Sailor bold, be not too bold;
The ship is young, the sea is old.

— Irish proverb

When the lighthouse attendant answered the ringing telephone in his quarters on the mainland near Carlingford Lough, he might have heard the following from a machine: "This is Haulbowline Lighthouse. The main light is not operating. The emergency light is in operation. The battery voltage is correct. The fog detector indicates clear weather. The air pressure is normal." Automation has reached such an advanced state in Irish lighthouses that the lighthouses themselves seem to be speaking. The two fog detectors also show how modern technology is aiding mariners. One of the fog detectors has a beam of light sent from a tower near Cranfield Point to a photocell in a window of the lighthouse. If fog diminishes or obscures that light beam, the fog-signal starts operating. The second detector sends out a high-intensity flash from a window in the lighthouse itself. Droplets of water vapor in the air will reflect the beam of that light back to a telescope, which focuses on a photocell and operates the fog signal.

The problem with such advanced technology is that officials, ever conscious of the "bottom line" and of keeping costs down, may opt for such automation, not mindful of the fact that machines break down and cannot really replace human beings. Plus, sometimes humans can be essential in a rescue. For example, in 1903, when watchers saw two steamers approaching Carlingford Lough in the wrong channel, the lighthouse keepers were able to hoist a warning signal in time for the vessels to turn away from each other. Such a service will not be available when lighthouses are automated and visited maybe once a month by helicopter. The motto of Irish Lights, "In Salutem Omnium" ("For the Safety of All"), refers to the important lifesaving benefits the lighthouse keepers and their towers have performed over the centuries: for ships offshore, for shipwrecked sailors, even for airmen shot down during wartime. The withdrawal of the keepers from their towers, while considered necessary in a time of tightening budgets,

gets, means that those men and women will not be available to rescue mariners as they have done in the past.

But even lighthouse keepers can be helpless at times, as, for example, in 1916 when the keepers at Carlingford Lough witnessed one of the worst disasters in Irish maritime history. Wartime restrictions, which required ships to display only weak navigational lights at night, were partly responsible for the collision of the 1,200-ton *Connemara* with the 500-ton *Retriever* on a stormy night as the ships were entering the narrow channel there — with the loss of ninety-three and the rescue of only one person from the ships.

The rich fishing grounds in the relatively shallow waters near Carlingford Lough have over the years attracted countless fishing boats looking for herring and mackerel. The Boyne Valley to the south might have led to the increased importance of the Haulbowline Lighthouse, but the sandbars and shoals offshore, which make access to and from the sea difficult for deep-draft ships, and the fact that the Vikings established an important settlement further south on the River Liffey, made the Dublin area more important.

Carlingford Lough, about seventeen miles long and two miles wide at its entrance, offers a long, sheltered body of water for ships seeking shelter during a storm in the Irish Sea, as well as a conduit for ships going to Warrenpoint at the head of the lough. Because this waterway is on the border between the Republic of Ireland and Northern Ireland, it has seen much smuggling of contraband, weapons, and men into Northern Ireland. The Royal Navy established a presence there in 1971 in order to prevent the Irish Republican Army (IRA) from engaging in smuggling, with the result that the IRA attacked Royal Navy patrol vessels several times in the mid-1970s.

Haulbowline Lighthouse (pictured here), a tall rock tower rising up out of the lough on a rock that lies exposed only at low water, is just one of three that operate in Carlingford Lough, the other two being Vidal Bank and Green Island, both screw-pile structures marking the channel. A fourth tower, Greenore, was discontinued in 1986

after almost 150 years of service. Workers built the Haulbowline Lighthouse in 1824 after the commercial interests in Newry, up Carlingford Lough, requested a new tower to replace the Cranfield Point Lighthouse, built in 1803. The latter tower was not in a good position to warn ships of the treacherous rocks leading into the lough, and, in fact, it eventually toppled because of coastal erosion in the 1860s.

Workers took down the Cranfield Point tower and built the new one on Haulbowline Rock in 1824. The two leading lights, situated some distance from each other to enable ships' pilots to line them up in order to sail safely into the harbor, became necessary when authorities began deepening the Carlingford Lough channel in 1868. Placed five hundred yards apart, the twenty-eight-foot-tall Vidal Bank tower in the front and the forty-five-foot-tall Green Island structure at the rear were set up in 1873. The Haulbowline keeper was responsible for the main lighthouse as well as those two fixed lights and local buoys.

Another light in the area, a harbor light established in 1830 at the town of Greenore on the south side of Carlingford Lough, was thirty feet above the high-water mark and visible for nine miles in clear weather, a fact that might have been of great importance if the port had developed the way its planners had hoped. Officials of the London Northwestern Railway Company (L.N.W.R.) had plans to develop the little town into an important port and, in fact, had a ferry service to Holyhead, Wales, from 1873 until a strike in 1926 curtailed the use of steamers out of the town. The cattle trade also failed to materialize there, and eventually in 1951 the local railway and steamship services closed down. For the last thirty years the port has handled freight, but its potential as an important east-coast port never really materialized.

On the northern shore of Carlingford Lough are the small ports of Kilkeel and Annalong. When those sites developed into important fishery centers in the nineteenth century, especially for herring and mackerel, the many boats using those ports benefitted from the lighthouse at the

entrance to the lough. Today, Kilkeel is the chief fishing port in Northern Ireland. Instead of developing into a commercial port, the area around the lough, including Carlingford on the western shore, established by the Vikings and later settled by the Normans, is developing into a popular resort and thus adapting to the reality that the lough will never be as important a commercial port as other Irish ports.

The old quarters at Cranfield Point were used as dwellings by the keepers and their families from 1824 until 1922, at which time they moved to newer houses at Greencastle. Officials restored the original stonework in 1946 after it had been painted white for over one hundred years. The tower was somewhat unusual in that keepers there would hoist a large ball on a mast over the lantern to indicate the tide during daylight hours. In fog, a machine would strike a bell every thirty seconds to alert mariners. Later an explosive signal replaced the bell, and still later an electric horn did the job. The lighthouse eventually became electric and was demanned in 1965.

The building of other lighthouses to the north and south of Carlingford Lough indicated how important and treacherous the coastline was there. Northeast of Carlingford Lough and to the east of Dundrum Bay and Newcastle is St. John's Point Lighthouse, which has warned mariners of the dangerous coast since 1844. Southwest of Carlingford Lough in Dundalk Bay, workers erected pile lights, screw-pile structures developed by the great Belfast engineer, Alexander Mitchell. The spindly, many-legged tower with a light on top was very effective in sandy-bottomed bays like Dundalk with its dangerous sandbar. Dundalk Bay is the western edge of the widest part of the Irish Sea, extending 150 miles between Dundalk and Morecambe Bay near Liverpool.

Wartime restrictions greatly affected this coast of Ireland, for example, in the prohibition against all nonmilitary shipping at night. Navigational lights outside harbors were extin-guished to hinder maritime movements of the enemy. Lighthouses had their power reduced. If an important ship had to sail into an Irish port at night, the lighthouse keeper would be informed of its estimated time of arrival or departure, so the keeper on shore could make it to the lighthouse and light the tower for a brief time for the benefit of the passing ship.

The area of the Irish coast from Ardglass to Dublin has been one of the busiest in the country for centuries and has therefore needed beacons to light the way for mariners. The River Boyne that runs past Drogheda has two lighthouses at its mouth, Drogheda East and Drogheda West, both under the jurisdiction of Irish Lights; a third lighthouse is under the jurisdiction of the Drogheda Harbour Commissioners. All three lights, which have functioned since 1842, help mariners pilot ships over the bar at the mouth of the river. The Rockabill Lighthouse is southeast of Balbriggan, which also has a lighthouse, but that one is under the jurisdiction of the Dublin Port & Docks Board. The Rockabill Lighthouse, which Irish Lights maintains near Lambay Island, was built six years after an 1854 wreck of an Australian ship, *Tayleur*, on her maiden voyage, with the loss of 290 passengers and crew. The Rockabill, which was totally automated in 1989, has near it an important bird sanctuary.

Finally, this is a good place to mention another Irish lighthouse that is actually inland, yes, inland, southwest of Haulbowline at the small town of Kells, west of the city of Drogheda. The Tower of Lloyd, whose top stands over one hundred feet high and sits on a five-hundred-foot hill, was built in 1791 by a local nobleman in honor of his father. Workers placed lanterns on top of the tower, not for the ships which were many miles away on the ocean, but for hunters who were late or lost on one of their forays. Known as the "hunting lighthouse," it guided lost hunters back to their home base.

Further Reading

Bennett, Jim. "Landlocked Lighthouse" [about the "hunting lighthouse"], *Country Life*, 181, 42 (October 15, 1987), 184.

de Courcy Ireland, John. *Ireland's Sea Fisheries: A History*. Dublin: The Glendale Press, 1981.

de Courcy Ireland, John. *Wreck and Rescue on the East Coast of Ireland*. Dublin: The Glendale Press, 1983, esp. 140-41.

Long, Bill. *Bright Light, White Water: The Story of Irish Lighthouses and Their People*. Dublin: New Island Books, 1993, 21-22.

McCaughan, Michael. "Dandys, Luggers, Herring and Mackerel" [about the herring and mackerel fishing in Kilkeel and Annalong], in *The Irish Sea: Aspects of Maritime History*, edited by Michael McCaughan and John Appleby. Belfast: The Institute of Irish Studies, 1989, 120-33. See also the following two articles: Vivienne Pollock, "Change in the County Down Fisheries in the Twentieth Century," 134-44, and Reginald Byron, "The Social Anthropology of an Irish Sea Fishing Community" [about Kilkeel], 146-55.

Wilson, T.G. *The Irish Lighthouse Service*. Dublin: Allen Figgis, 1968, 128-30.

INDEX

If you enjoyed reading this book, here are some other books from Pineapple Press on related topics. For a complete catalog, write to: Pineapple Press, P.O. Box 3899, Sarasota, FL 34230 or call 1-800-PINEAPL (746-3275).

Georgia's Lighthouses and Historic Coastal Sites by Kevin M. McCarthy with paintings by William L. Trotter. Histories, anecdotes, and visiting information for thirty historic structures on Georgia's coast, including lighthouses, forts, plantation houses, and more.

Guardians of the Lights by Elinor De Wire. Stories of the men and women of the U.S. Lighthouse Service. In a charming blend of history and human interest, this book paints a colorful portrait of the lives of a vanished breed.

Guide to Florida Lighthouses by Elinor De Wire. Its lighthouses are some of Florida's oldest and most historic structures, with diverse styles of architecture and daymark designs.

The Florida Keys: A History of the Pioneers by John Viele. As vividly portrayed as if they were characters in a novel, the true-life inhabitants of the Florida Keys will capture your admiration as you share in the dreams and realities of their daily lives.

Key Biscayne: A History of Miami's Tropical Island and the Cape Florida Lighthouse by Joan Gill Blank. This is the engaging biography of the southernmost barrier island in the United States and the Cape Florida Lighthouse that has stood at its southern tip for 170 years.

Legendary Islands of the Ocean Sea by Robert H. Fuson. From the diaries and charts of early explorers comes the intriguing story of the real and imagined islands of what we now know as the Atlantic and Pacific Oceans.

Lighthouses of the Carolinas by Terrance Zepke. Eighteen lighthouses dot the coasts of North and South Carolina. Here is the story of each, from origin to current status, along with visiting information and photographs.

Search for the Great Turtle Mother by Jack Rudloe with illustrations by Marty Capron. Intrigued by turtle legends from many cultures, Rudloe travels the globe observing the silent rituals of sea turtles and learns timeless lessons about conservation and respect for the earth.

Shipwrecks of Florida: A Comprehensive Listing by Steven D. Singer. General information on research, search and salvage, wreck identification, artifact conservation, and rights to wrecks accompanies a listing of 2100 wrecks off the Florida coast from the sixteenth century to the present.

The Spanish Treasure Fleets by Timothy R. Walton. The story of how the struggle to control precious metals from Spain's colonies in Latin America helped to shape the modern world.

Thirty Florida Shipwrecks by Kevin M. McCarthy with paintings by William L. Trotter. Sunken treasure, prison ships, Nazi submarines, and the Bermuda triangle make what the *Florida Historical Quarterly* calls "exciting history."

Twenty Florida Pirates by Kevin M. McCarthy with paintings by William L. Trotter. Notorious Florida pirates from the 1500s to the present include Sir Francis Drake, Black Caesar, Blackbeard, and José Gaspar — not to mention present-day drug smugglers.